The Sense of Pleasure

The essay by Maurizio Fagiolo dell'Arco that appears in this volume is the last text that this great author and friend of the house wrote for Skira.

His death deprives us of an art historian as atypical as he was extraordinary, but also an exceptional man of books: books written, of course, but also books planned, discussed, constructed and laboured over page by page with his publisher.

Maurizio lived and breathed his books. He contributed to all decisions and shared with his publisher the passion and the stress of this profession.

When he came to our offices to examine the proofs of this catalogue, four days before his death, he reminded us that this was the twentieth title that we had worked on together over the years.

It is difficult to believe and even harder to accept, now that this book is about to be published, that he is no longer with us and that there will be no twenty-first title to work on together.

We are therefore sure that John T. Spike, the author of the book, and Paolo Sprovieri, who vigorously supported it, will join us in dedicating this volume, with affection and deep sorrow, to an extraordinary friend who none of us will ever forget.

The Publisher

John T. Spike

The Sense of Pleasure

A Collection of Still-life Paintings

With an essay by
Maurizio Fagiolo dell'Arco

Art Director
Marcello Francone

Editorial Coordination
Franco Ambrosio

Editing
Tanja Beilin
Silvia Carmignani

Layout
Sara Salvi

Translations
Neil Davenport

Cover
Jacopo Ligozzi
*A Pair of Terracotta Vases
with Bouquets of Flowers*
(detail)
Oil on canvas, 50 × 62 cm
(cat. no. 5)

Back cover
Pittore della Vendemmiatrice
*Young Woman with Harvest
Fruits* (detail)
Oil on canvas, 94 × 73.5 cm
(cat. no. 35)

General co-ordination of the work
Maurizio Fagiolo dell'Arco
with the assistance of
Isabella Fischetti

Photograph credits
Claudio Abate
Marcello Fedeli

First published in Italy in 2002
by Skira Editore S.p.A.
Palazzo Casati Stampa
via Torino 61
20123 Milano
Italy

© 2002 John T. Spike
for texts

© 2002 Paolo Sprovieri
for illustrations

© 2002 Skira editore, Milano

Printed and bound in Italy.
First edition
ISBN 88-8491-360-8

Distributed in North America
and Latin America by Rizzoli
International Publications, Inc.
through St. Martin's Press,
175 Fifth Avenue, New York,
NY 10010.
Distributed elsewhere in the
world by Thames and Hudson
Ltd., 181a High Holborn,
London WC1V 7QX. United
Kingdom.

Contents

Introduction

John T. Spike

The aim of this exhibition is to illustrate some of the ways that still life paintings of the seventeenth and eighteenth centuries expressed the variety, abundance, nourishment, pleasures and mysteries of Nature. Still-life paintings, then as well as now, were used as decorations throughout the house, from triumphant floral bouquets in the antechambers to allegories with figures in the Gallery on the *piano nobile*, from hunting and game pictures in the dining room to intimate pastel-tinted flowers in the bedchambers. We find these paintings described simply as *cose naturali* or *frutti e fiori* in the old inventories of palaces and villas. In the mid-eighteenth century the French academy declared them *natures mortes*, a sad expression that eventually prevailed in Italian as well, despite its inaptness for an art that celebrates the life-giving fecundity of the natural world.

As far as still life painters are concerned, God gave us the faculties of Sight, Touch, Hearing, Taste and Scent so as to enhance our enjoyment of flowers and fruits and all the other good things to eat. Indeed, the pleasures of the senses have always been the central theme of this artistic genre since its origins in the Renaissance. The title of our show, "The Sense of Pleasure", is intended to recall that fact and also to suggest that the collector's point of view will be our main focus.

In recent years there has been no shortage of shows devoted to the regional styles of Italian still lifes. While every effort has been made to arrive at precise identifications (with notable contributions, we believe, towards distinguishing the hands of Giovanni and Niccolò Stanchi), the paintings in this show were not selected on the basis on attribution alone. Instead of the *abecedario* approach, we have elected to group the pictures according to six different interpretations of man's relationship to Nature. Although these six rubrics are only roughly defined, and have nothing to do with traditional art history, they probably come closer than most theories to encapsulating most viewers' first instinctive response to the meaning of these pictures, assuming, again, that Nature is the common thread that binds the most dissimilar still lifes of the seventeenth and eighteenth centuries. If

so, then our show may perhaps be recalled for having addressed a most important question that is usually left unasked, namely, what is the reason for the enormous and enduring appeal of this comparatively unsophisticated genre of art? Another advantage to our plan is that it allows us to exhibit many interesting still lifes that have not previously been studied because of the unlikelihood that their painters will ever be identified. The vast majority of Italian still lifes will never emerge from anonymity – a somewhat unpopular observation that I have already made in a 1992 essay on this subject. Finally, it is hoped that the untraditional hanging of this show will engage our viewers in a stimulating and even pleasurable encounter with these fine paintings.

The Rediscovery of Nature

For Renaissance artists, picturing the world meant penetrating its inner workings. Leonardo da Vinci made far more drawings in his notebooks than he did on canvas. Towards the end of the sixteenth century, the Medici initiated still life painting in Florence when they employed Jacopo Ligozzi to illustrate botanical and zoological specimens. Independent still life paintings by Ligozzi are exceedingly rare; this show opens with two delicate canvases executed with the miniaturist precision and detail we associate with him.

Generic descriptions no longer sufficed for the empirical age of Aldrovandi, Galileo, and Kepler. Carl Ruthart's sketches of animals and birds, for example, have the accuracy of zoological and ornithological textbook illustrations. There is a poignant disparity between Ruthart's mastery and the technical naïveté by the anonymous painter of two early still lifes (cat. nos. 2–3), but their works share their emphasis on careful observation above all else. Still lifes by Caravaggio and his followers would fall naturally into this category. By the same token, we have included a picture of a boy playing with his pet beetle which offers a remarkably sensitive portrayal of a child's behavior.

8

The Flavors of Nature

This section contains the paintings of kitchens, markets, and sideboards laden with fresh game and fish, that make the most direct claims on our sense of taste. Out of the myriad ways that foodstuffs can be depicted, these artists have opted to make their pictures open invitations to good eating. The execution can vary from the subtleties of the Flemish painters and of Cerquozzi to the exuberant liberties of Paoletti and others; the idea is the same: to make mouthwatering pictures that look as though the fish are about to be grilled upon a brazier and the dewy fruit is ready to be tasted. A certain kind of realism is necessary to achieve this effect, which was eventually replaced during the seventeenth century by an emphasis on natural abundance, as we will find in the section *Nature harvested*, below.

Nature in Flower

'Consider the lilies... even Solomon in all his glory was not arrayed like one of these'. (Luke 12:27)

The evanescent beauty of flowers has fascinated humanity throughout the ages. Although floral motifs of purely ornamental value can be found on the earliest surviving jewelry and fabrics, the custom of having flowers for decoration in the house arose considerably later. By the time that flowers appeared in medieval miniatures and paintings a vast repertory of symbolic meanings had been assigned to them, like the Marian lily in a vase that appears in Annunciations by Duccio and Simone Martini in the first quarter of the fourteenth century.

More accurate renderings of herbs and flowers were greatly stimulated by the publication of illustrated herbals in the sixteenth century, which were extensively copied by painters. The *Florilegium* printed by Plantin in Antwerp in 1564 was the first herbal designed specifically for the use of artists. Independent flower-pieces were painted by Netherlandish artists after this date; Jan Bruegel's visit to Rome at the end of the century was influential on awakening the interest of Italians.

Early seventeenth-century Italian flower-pieces, starting from the new *scuola caravaggesca*, are distinguished for their archaic reliance upon motifs and patterns copied from engravings. Even after 1610, when artists began to rely upon their own studies from nature, floral specialists like Mario de' Fiori, Pier Francesco Cittadini, and Bartolomeo Bimbi, never entirely abandoned the practice of assembling their bouquets from an existing stock of patterns. Many examples of their canvases comprising 'sample motifs' have survived until the present day. On the other hand, Abraham Bruegel wrote in January 1666 from Rome to Don Antonio Ruffo, his patron in Messina, that he had not been able to send a small picture as promised because the most beautiful flowers were not yet in season: *li fiori belli ancora non sono venuti.*

Nature's Harvest

In the same letter of January 1666, just cited, to Ruffo, Bruegel added that he had a small picture of fruit that he had painted the previous autumn: *Ho un quadretto di frutti che ho fatto quest'Autunno passato.* None of the still life specialists in Italy, not even a transplanted Netherlander like Bruegel, could ignore the heightened sensuality of the autumn harvest. The vast majority of Italian fruit pieces are dedicated to fruits that do not ripen until late summer and early autumn, especially grapes, figs and pomegranates. Painting fruits from differing seasons was not uncommon in Northern still lifes, whereas it was rarely done in Italy. Cherries, peas and artichokes might seem a strange composition to any except to Italian eyes, who will immediately recognize a Spring still life. Watermelons send a summery message, grapes and game are autumnal, and nuts and medlars are the sure signs of a lean winter harvest.

In Italy, where fig trees bend down to offer their fruits to any passer-by, the depiction of garden and orchard produce heaped and scattered on the bare ground became immensely popular. Nature is portrayed in these still lifes as an inexhaustible cornucopia of life-enhancing delights within the reach of everyone. By contrast, Dutch and Flemish painters were wont to serve their oranges and lemons on silver platters as was fitting for imported delicacies.

Nature Ennobled

The dark palette and sometimes awkward realism of the earliest Italian still lifes lost favor rather quickly in comparison with the pleasing decorations by Flemish painters, of whom countless numbers came to work in Italy. The colorful still lifes of Frans Snyders and Jan Roos, for example, offered an embellished vision of Nature, in which the juicy, sleek and spotless peaches, grapes and apples are almost too good to eat. Cittadini was one of the first native painters to respond to this trend. By the second half of the seventeenth century, Niccolò Stanchi was painting fruits with such refinement that they seem made of silk. With few exceptions, the preference for an idealized, 'ennobled' Nature would pervade Italian still lifes until the nineteenth century. The Netherlandish sensibility for exquisiteness also manifested itself in the popularity of still lifes of fine objects – crystal glasses, Delftware, and *vertu* – arranged in calculated disorder on tablecarpets or brocades, exactly as Jan de Heem painted them.

The Mysteries of Nature

The *Vanitas* allegories that claimed such a large chapter in Dutch still life painting never caught on in Italy, which had little sympathy for such a dire vision of the natural world. Italian painters usually found ways to address mystical themes without relying upon a heavily literary symbolism. Evaristo Baschenis, a Bergamasque priest, was the spiritual heir of Caravaggio; he used chiaroscuro and suppressed details in order to evoke an aura of timelessness, on the one hand, and earthly transience, on the other. Two anonymous still lifes in this show by Neapolitan painters (cat. nos. 68–69) similarly use a Caravaggesque chiaroscuro to imbue their compositions with meditative overtones as if inviting the viewer to contemplate the fragility of life in the midst of enveloping darkness. The great master Paolo Porpora painted many still lifes along these same lines; in this show he is represented collaborating with Bernini's favorite painter in a sacred allegory that employs splendid colors to express the glory of the Resurrection.

THE REDISCOVERY OF *Nature*

1

Allegory of Summer

Francesco Zucchi

(Florence 1562 – Rome 1622)

Oil on canvas, 95 × 78.5 cm

F̲rancesco Zucchi was the younger brother of Jacopo Zucchi (1542–96), the favorite painter of Cardinal Ferdinando de' Medici, who employed Jacopo for frescoes in the Palazzo Vecchio and then in various Florentine residences in Rome. Francesco Zucchi was trained to decorate the borders of his brother's frescoes with festoons of fruits and flowers. By the end of the sixteenth century, he was the most esteemed specialist in this kind of work in all of Rome, and was chosen by Cavalier d'Arpino to participate in the project to paint new frescoes in the transept of San Giovanni in Laterano in time for the 1600 Jubilee. According to Giovanni Baglione, however, who must have worked alongside him, Zucchi left off painting frescoes after his brother's death in order to work as a mosaicist at St Peter's and in other churches.

Baglione (1642, p. 102) is also our sole source with regard to Zucchi's paintings of comical figures composed of fruits and such: 'Francesco was the one who invented the paintings on canvas in which he composed the heads of the Four Seasons out of the fruits, flowers, and other things produced by Nature in each season. He arranged the motifs so well that these heads seemed from a distance to have all their normal features. One sees everywhere his renditions of this idea.'

It is doubtful that Baglione thought he could pass the credit to Zucchi for the invention of the *testa composita* (as Lomazzo called them in 1590) for which Giuseppe Arcimboldi (1527–93) was famous the world over, then as now. Baglione's point was quite specific: Zucchi was the originator of numerous pictures of this kind that were a common sight in Roman collections. Three signed examples of Zucchi's 'composite heads' are known today: a pair representing *Autumn* and *Winter* (Galleria Gasparrini, Rome) and a very similar *Composite Portrait of a Woman* in the Capodimonte Museum, Naples. Claudio Strinati (1987, p. 4) speculated that Zucchi had painted the pair after Arcimboldi's return to Italy in 1587; indeed, it is surely significant that these three pictures all betray the artist's knowledge, presumably through a copy, of Arcimboldi's *Portrait of Rudolph II as Vertumnus* painted in Milan in 1591. They share the frontal pose, many of the same choices of fruits to substitute for facial features, and even a dark Lombardish tonality.

Perhaps Zucchi was the author of four Arcimboldesque *Four Seasons* that are cited without attribution in the 1600, 1638, and

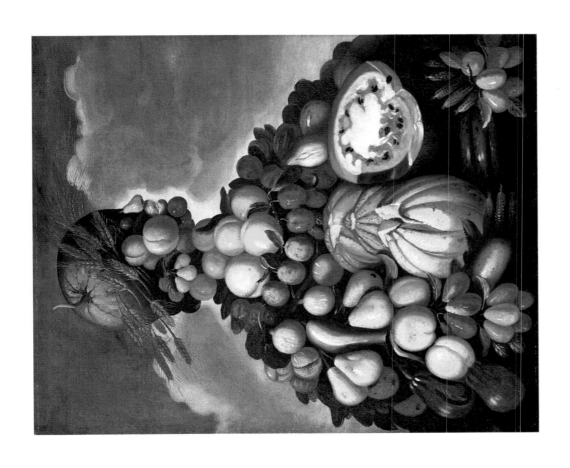

1649 inventories of the collection of Cardinal Benedetto Giustiniani in Rome (Danesi Squarzina 1998, p. 279). If the signed *Autumn* and *Winter* belonged to the Giustiniani series, however, it is not immediately clear (in the absence of any known copies) as to how Baglione could have seen them *da per tutto*.

This recently rediscovered *testa composita* of *Summer* is important for a separate, but related, chapter in the story of Francesco Zucchi. The painting was originally part of a series of *Four Seasons* that appears to have pre-dated the *Autumn* and *Winter* cited above – not least because of its greater archaisms, but also because the profile poses and pyramidal bases of the figures are derived from earlier Arcimboldi's *Seasons* and *Elements* of 1563–64.

This earlier series, which is generally assigned to Zucchi, presents unusually difficult problems and has yet to be studied in depth. An unsystematic survey of museum and auction catalogues turned up signs of at least four analogous series of the *Four Seasons*, whose canvases are scattered among collections in several different countries. Luigi Salerno (1984^b, p. 55) published the photographs of a complete set of four. Baglione's observation of the ubiquity of these pictures comes inevitably to mind.

Parts of two distinct series remain in Florentine collections (Museo Bardini, cf. Chiarini 1987, nos 1–3; Conti Guicciardini Corsi Salviati, cf. Gregori 1960, nos 84–85, who cites further replicas). The Medici were the prime protectors of the Zucchi brothers, a fact that lends significance to the citation of four Arcimboldesque *Four Seasons* in the Villa Artimino in 1609. These are the only still lifes cited in Medici inventories of the early seventeenth century according to Elena Fumagalli (1995, pp. 67–68). The description of *Winter* mentions his *foggia di barba d'albero*, which accords well with the paintings of this subject still in Florence and in the set illustrated by Salerno.

Preliminary research into this problem appears to indicate that Zucchi designed this *Four Seasons* at a relatively early date in his career, and then subsequently replicated it in response to its extraordinary popularity. For example, the fruits depicted in the Bardini *Spring*, *Summer* and *Winter* are noticeably less naturalistic than in the present *Summer*, which I consider Zucchi's most accomplished rendition of this theme, datable to the 1590s.

Future research into this problem should bear in mind that this *Four Seasons* cycle was repeated by other painters, who introduced their own refinements. A complete set that was sold at Christie's, Rome, on May 20, 1974 (nos 51 a–d) appears from the photographs to have been executed by a highly accomplished painter, possibly Michelangelo Cerquozzi. This Roman Baroque update of this Mannerist invention was itself copied in numerous canvases that I have seen. Small wonder, then, that Baglione took pains to credit Zucchi, long deceased, with its invention.

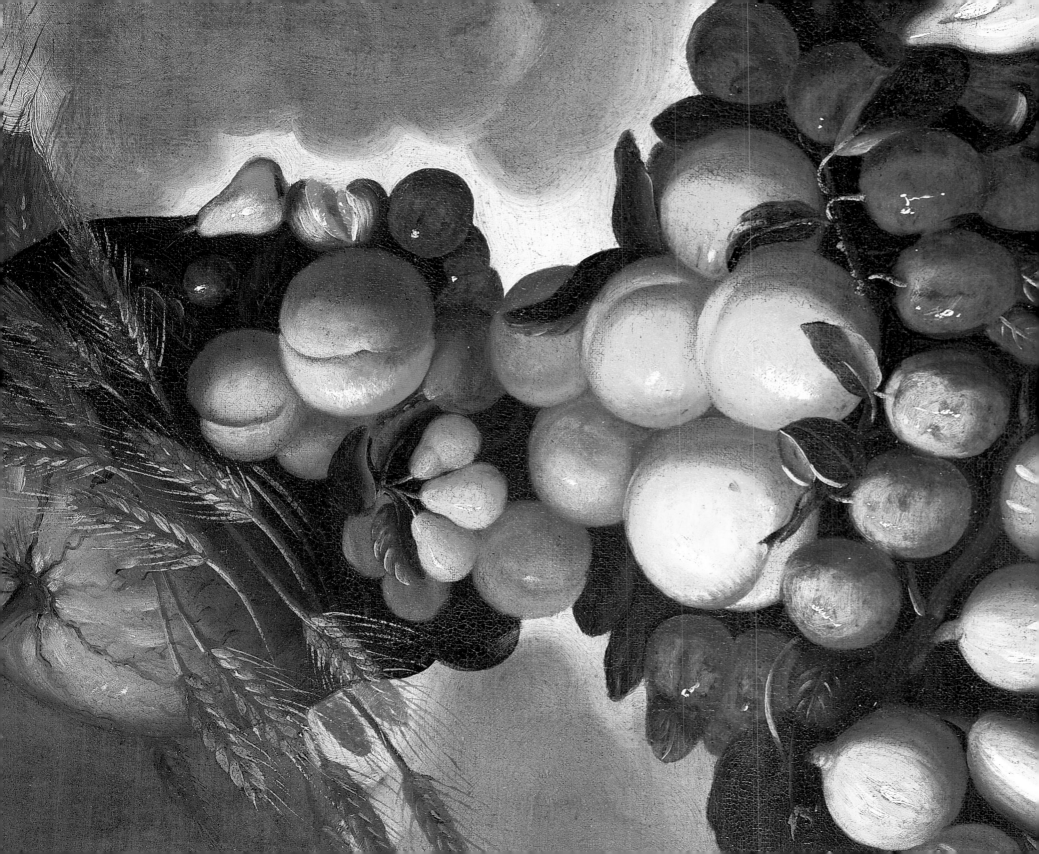

A Basket of Fruit, a Watermelon, and a Bird Eating a Cherry; Still Life with a Basket of Lettuce, Celery, Cucumbers, and Figs

Roman Painter

(1600 ca.)

Oil on canvas, 54 × 66.5 cm; 54 × 67.5 cm

A t the turn of the seventeenth century, Caravaggio was the protagonist of an anti-academic conception of art, which argued that beauty derives from naturalness and from visual truth, as opposed to an idealized aesthetic. These two still lifes, which have an old provenance from the noble Crescenzi family of Rome, are appealing examples of the difficulty that even skilled painters experienced in their efforts to abandon the old habit of viewing nature in a generalized way. The pictures are replete with naïve incongruities that call to mind the contemporary still lifes by the Master of Hartford and Francesco Zucchi. As compensation for the artist's difficulties with the receding perspective of the table top, and with describing the lattice of the basket, we can share the artist's delight in his unpretentious assortment of fruit and greens. And we can appreciate the rapid, energetic strokes of his brush as he solidly models the pair of peaches in the foreground of one canvas and paints a deep shadow around the cucumbers in the other. On the other hand, the green figs do not have the freshness of fruits observed from nature: such discordancies are commonly found in this initial, adventurous, moment in the history of still lifes.

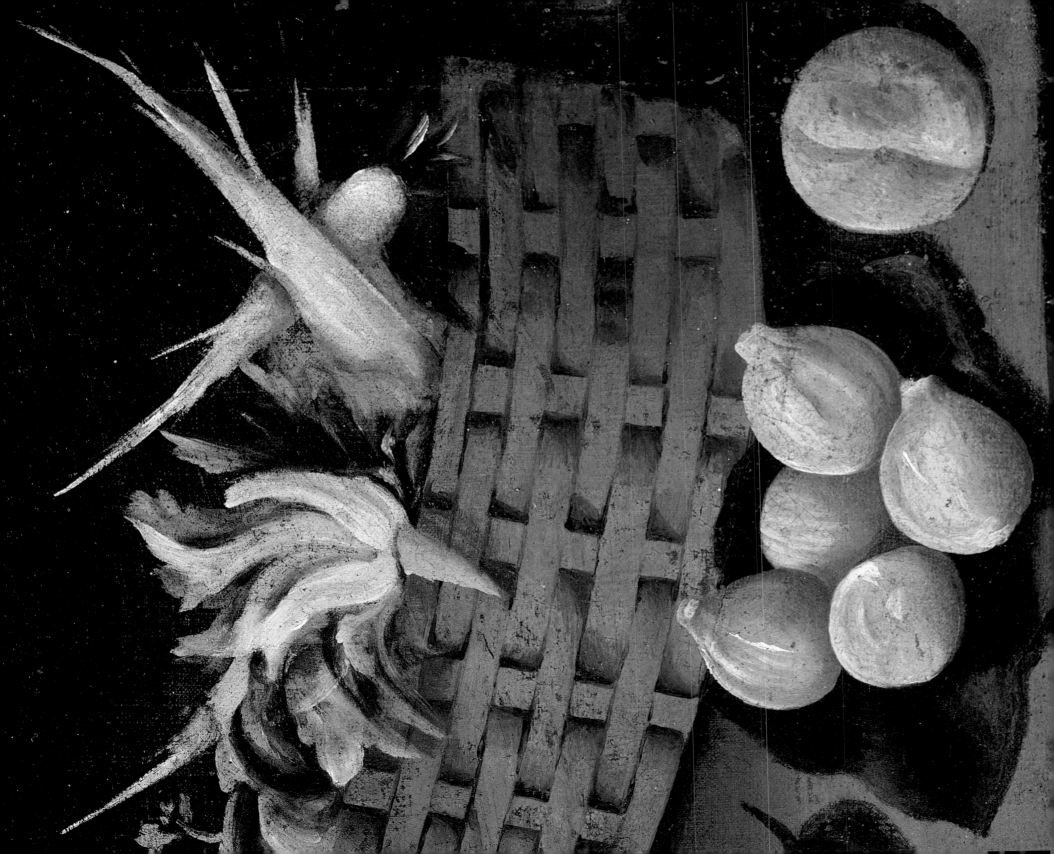

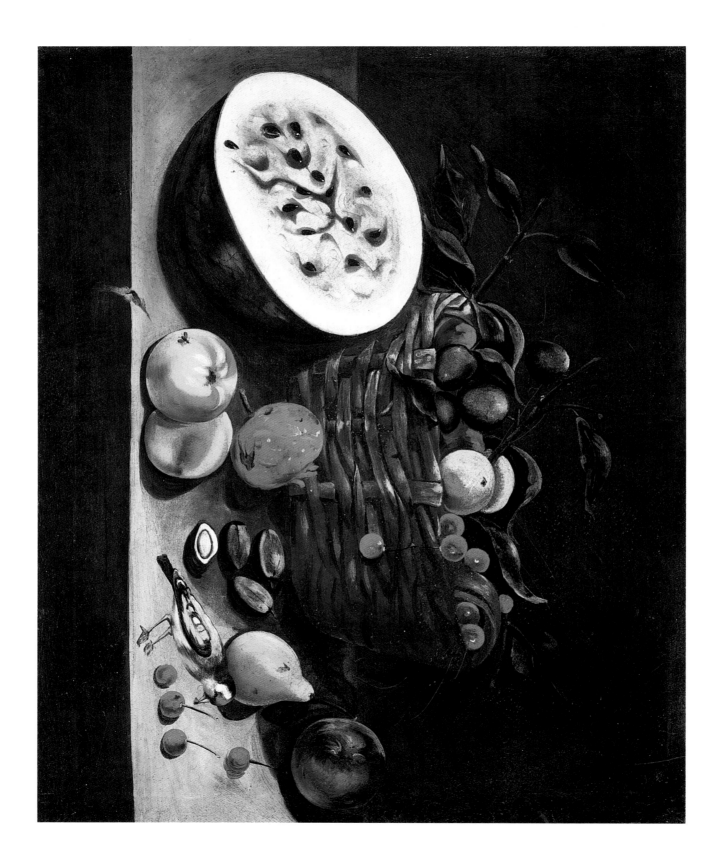

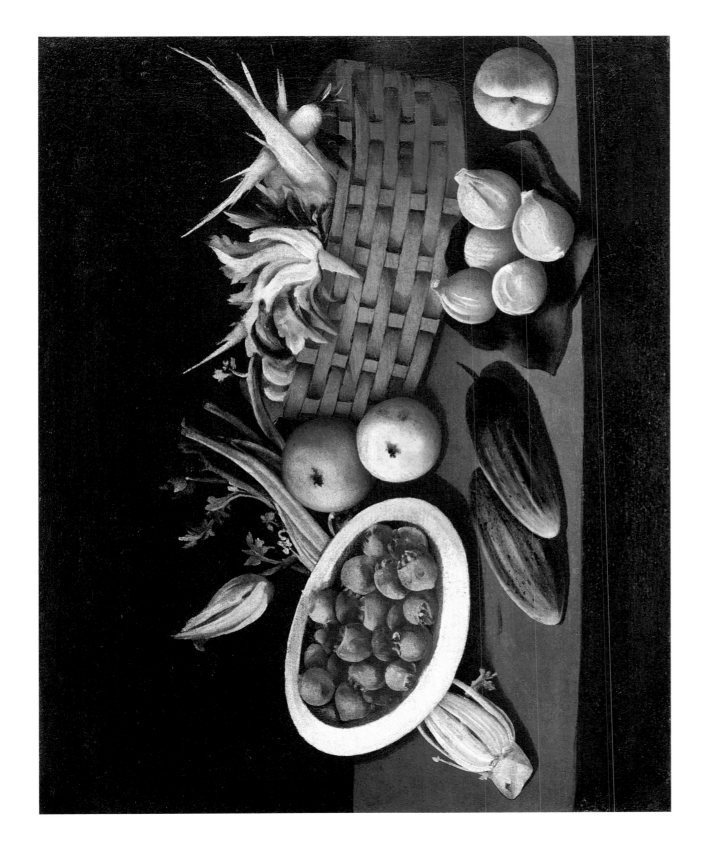

4

A Farmer Bringing Baskets of Fruit to a Table with a Large Fruit Basket and Sliced Watermelons

Pseudo Pietro Paolo Bonzi
(active in Rome ca. 1600–10)
Oil on canvas, 133 × 171.5 cm

Fig. 1
Pseudo Pietro Paolo Bonzi,
*Page Slicing a Watermelon
and Other Fruits on a Table*
private collection

Pietro Paolo Bonzi (Cortona 1576 – Rome 1636) was trained in the classical style of the Carracci, but soon established himself as a specialist in the new genres of landscape and still life. Baglione (1643) writes that 'he joined the household of the Crescenzi family, and dedicated himself to painting fruits from life [...] his genius was to depict a veritable Autumn of every sort of lovely fruits.' As Bonzi's still life compositions are rare, his stylistic development remains to be reconstructed. His most famous work in this genre is a series of decorative festoons of flowers and fruit that he painted as borders to Pietro da Cortona's frescoes in the Palazzo Antici Mattei in Rome in 1622.

The early development of Italian still life painting, starting from 1580 ca. was based upon the market scenes and butcher shops that artists such as Vincenzo Campi and Bartolomeo Passerotti had painted. This *Farmer Bringing Baskets of Fruit* represents a precocious attempt by a Roman artist to expand the traditional repertory. Caravaggio's influence is clearly evident (if incompletely understood) in the background which is divided between light and dark zones and in the deep shadow on the farmer's face. The fruits are described with an archaic, partial realism that is reminiscent of the awkward compositions of the Hartford Master, another early follower of Caravaggio, who is known to be active before 1607. This *Farmer Bringing Baskets of Fruit* was unknown to the still life literature until 1994 when it was exhibited with an attribution to Pietro Paolo Bonzi. As a Car-avaggesque transition between the fruit vendors of Campi and the grape harvests that would be painted by Cerquozzi a generation later, this large composition makes a major contribution to our knowledge of early Roman still lifes.

The rediscovery of additional pictures by the same hand has revealed that the artist of this *Farmer* was an independent personality close to Bonzi. Until the day his proper name come to light, it may be convenient to identify him as the Pseudo Bonzi. Someone has recently suggested a more amusing name, to wit, the 'Master of the Watermelon Slices' in respect of the painter's evident attraction to that delicacy and distinctive way of describing it. The same pyramidal wedges of watermelon, not to mention the same polished apples and green melons with thick green rinds, are found in an unpublished *A Page Slicing Watermelon and Other Fruits on a Table* (private collection, fig. 1). Indeed, the large dimensions and symmetrical composition of the *Page Slicing Watermelon* are so analogous as to raise the possibility that the two pictures were originally pendants. One could even read an element of social commentary in that the portrayal of the young farmer is by no means less dignified than that of the elegantly attired young man, whose work is essentially the same: the preparation of a feast of sweet fruits.

The archaic handling of the dark purple figs and fig leaves, and the indispensable watermelon (but no slices) are grounds for ascribing a third picture to the Pseudo Bonzi. This interesting *Still Life of Fruits and Flowers with Butterflies* was published in 1992 by Gianluca and Ulisse Bocchi in their valuable publication, *Naturalia*, with a correct and prudent assignation to an 'Anonymous Caravaggist'. The representation of the deeply shaded fruits on the front edge of a stone ledge was imitated by Bonzi and by all the painters of Caravaggesque still lifes. While the pioneering anonymous painter Pseudo Bonzi is less realistic than his namesake, he does respect the representation of butterflies, a characteristic of Bonzi.

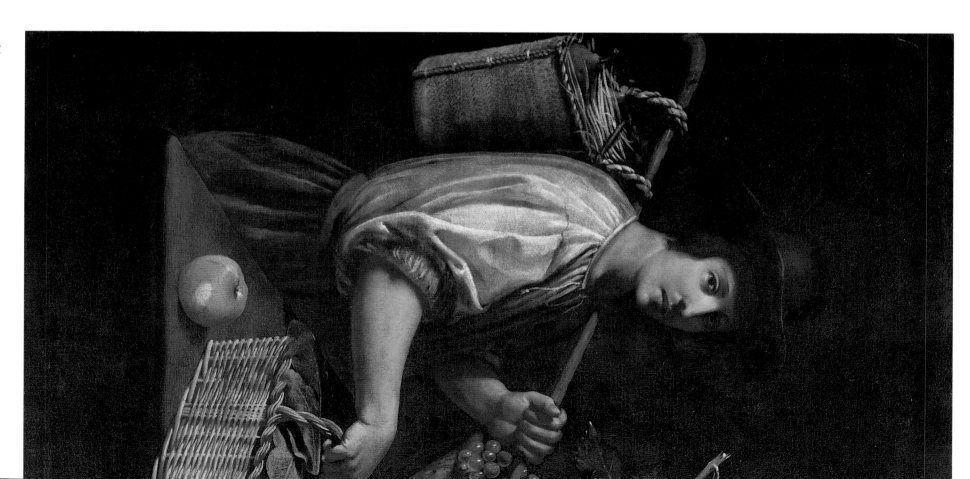

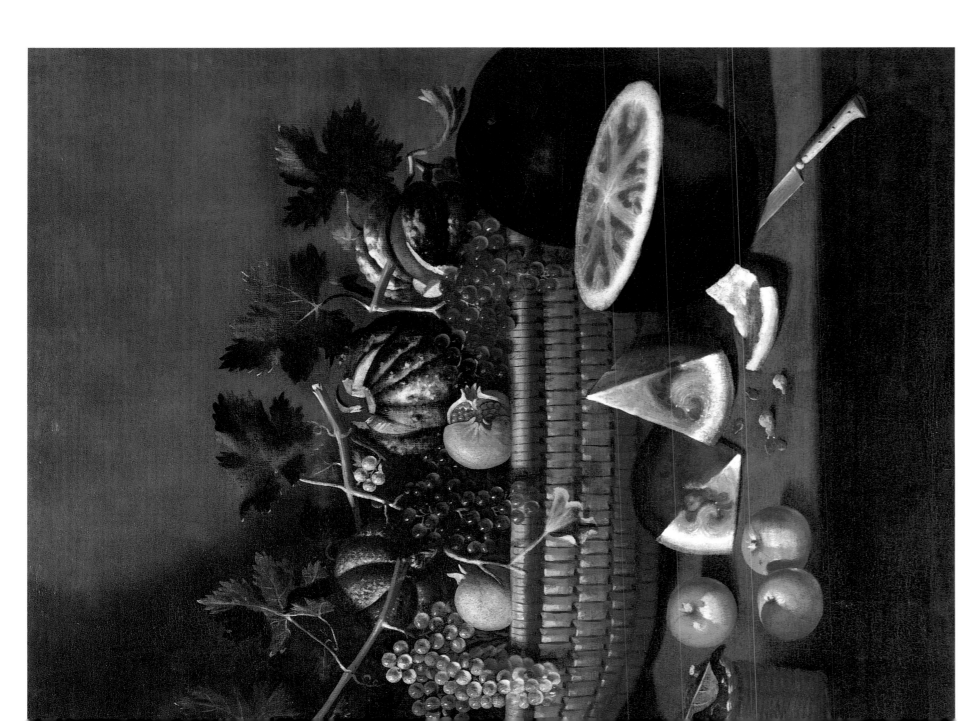

A Pair of Terracotta Vases with Bouquets of Flowers
A Pair of White Vases with Bouquets of Flowers

Jacopo Ligozzi
(Verona 1547 – Florence 1627)
Oil on canvas, 50 × 62 cm; 49 × 62.5 cm
Bibliography: Sestieri 1991 (cover illustration)

*T*he Florentine school of still life traces its origins to the natural science illustrations made by Jacopo Ligozzi for the Medici dukes. The Veronese artist was recommended by Ulisse Aldrovandi to Francesco I de' Medici, who called Ligozzi to Florence around 1577 in order to document the flowers, herbs and fruits cultivated in the granducal gardens. The Gabinetto Disegni e Stampe degli Uffizi still preserves a great many of Ligozzi's luminous illustrations in tempera on white paper. By 1589, a miniature representing flowers in a blue vase in the Tribuna gallery in the Uffizi was ascribed to him.

The delicate brushwork and the calculated symmetry of these two pairs of vases and flowers suggest a very early date, seemingly not later than 1600. The classical ornament of the vases, which do not represent actual types, are typical of the antiquarian taste of the sixteenth century. The subtle chiaroscuro combined with a pronounced linearity evoke the paintings of Ligozzi, a Veronese artist transplanted to Florence. The simplicity of the floral arrangement, which allows each of the blooms to be studied individually, is also analogous to Ligozzi's specialty of botanical illustration. In 1991, this *Pair of Terracotta Vases with Bouquets of Flowers* and the *Pair of White Vases with Bouquets of Flowers* were attributed to Jacopo Ligozzi by Giancarlo Sestieri.

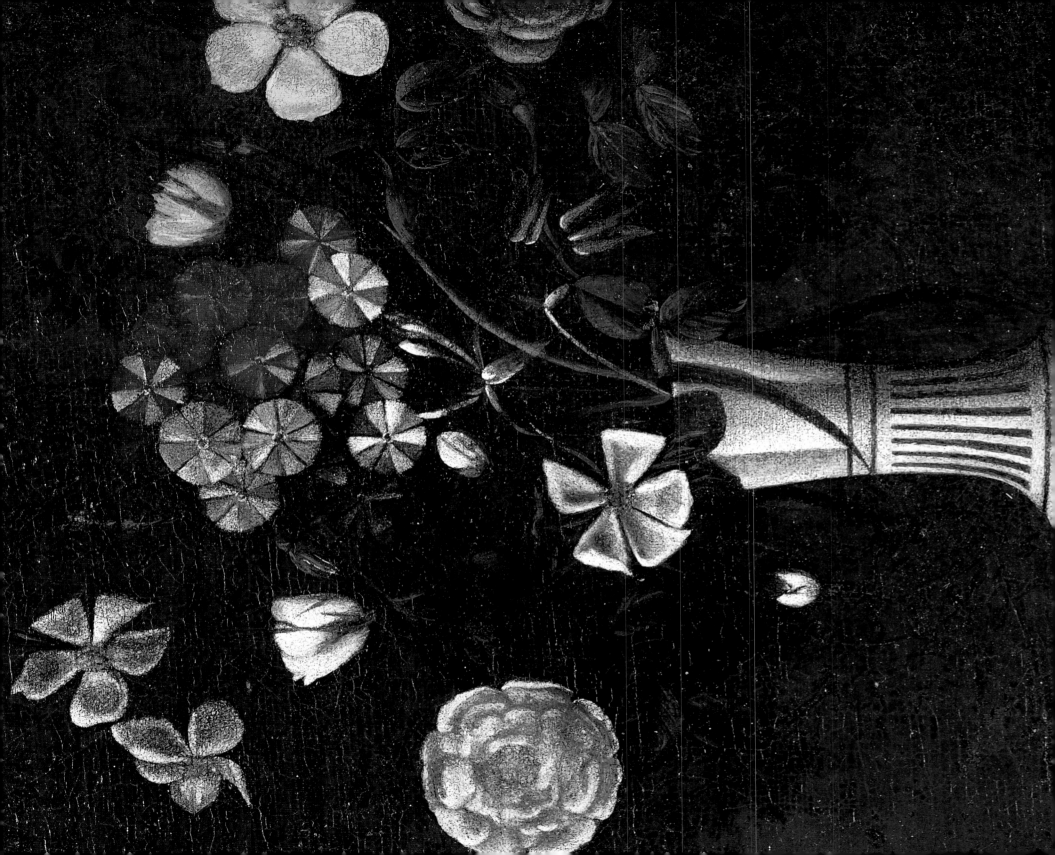

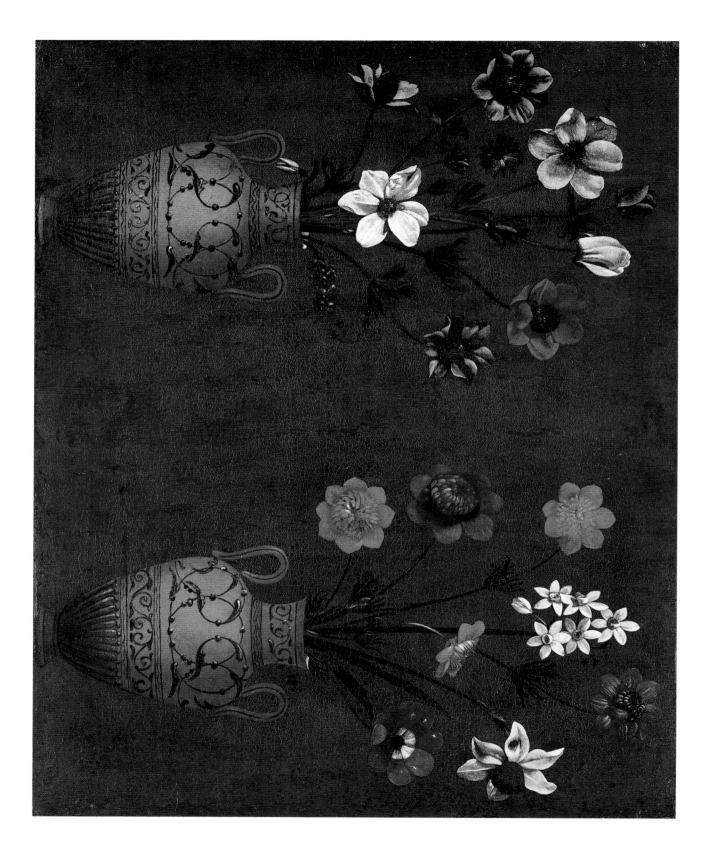

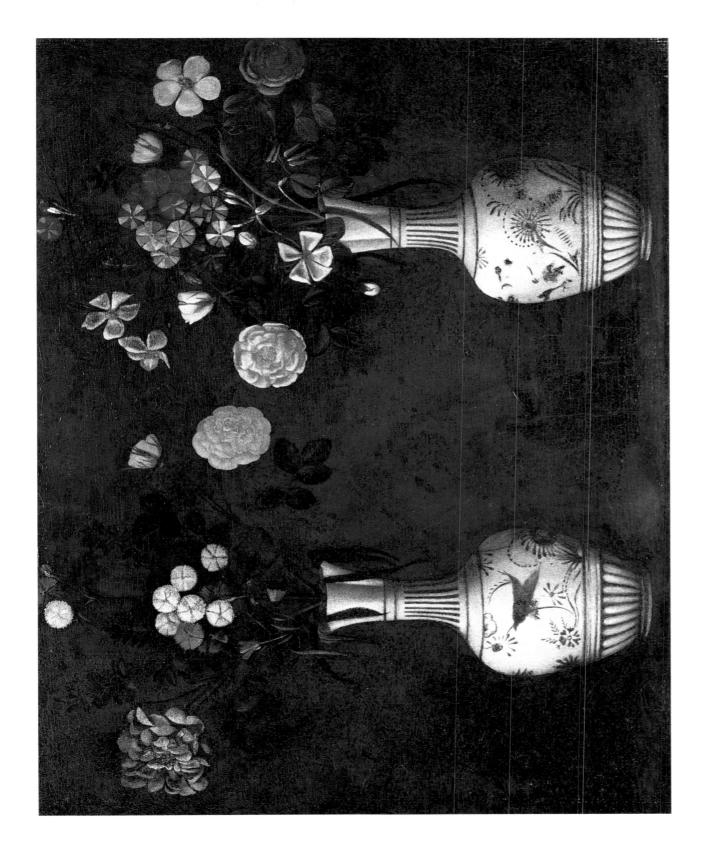

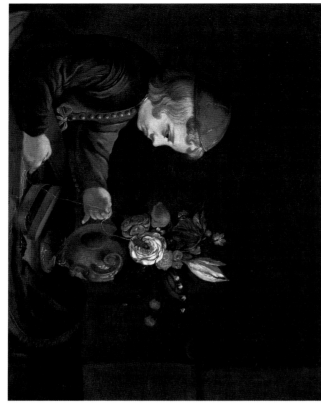

A Child Playing with a Beetle and a Vase of Flowers

Emilian or Lombard Painter
(first half of the seventeenth century)
Oil on canvas, 56.5 × 72 cm

A young boy has tied a string onto a beetle and is watching intently as the insect explores a rose in a vase. On the table is an oval box from which other beetles are taking advantage of the boy's distraction to make their escape. Nothing is seen of the dark room except for a column of stone blocks, at right, which suggests a palace interior. The ornate vase and the fringed drape on the table are other indications of wealth, as are the boy's buttoned and ribboned jacket and silk-trimmed cap.

This fascinating glimpse into a child's curious pastime is an almost unique subject for a seventeenth-century painting. The picture has been attributed to Paolo Antonio Barbieri, no doubt because Barbieri often collaborated with his brother, Il Guercino, on genre compositions *cum* still life. However, the style of this *Child Playing with a Beetle and a Vase of Flowers* is Emilian, but not particularly Guercinesque. Nor is it attributable to Pier Francesco Cittadini, who specialised in a different kind of still life painting with figures, of which a good example is offered in this same exhibition.

It is the sympathetic contemplation of a child's private reverie that sets apart this *Child Playing with a Beetle* — as if the viewer were a member of the family, quietly looking on from the door. The few precedents that can be found for this kind of intimacy are all confined to Emilian artists like Parmigianino and Annibale Carracci and mainly to their drawings. Sofonisba Anguissola of Cremona painted her sisters and made drawings of boys and girls in a similar spirit, which were certainly known as well to the painter of this remarkable *Child Playing*.

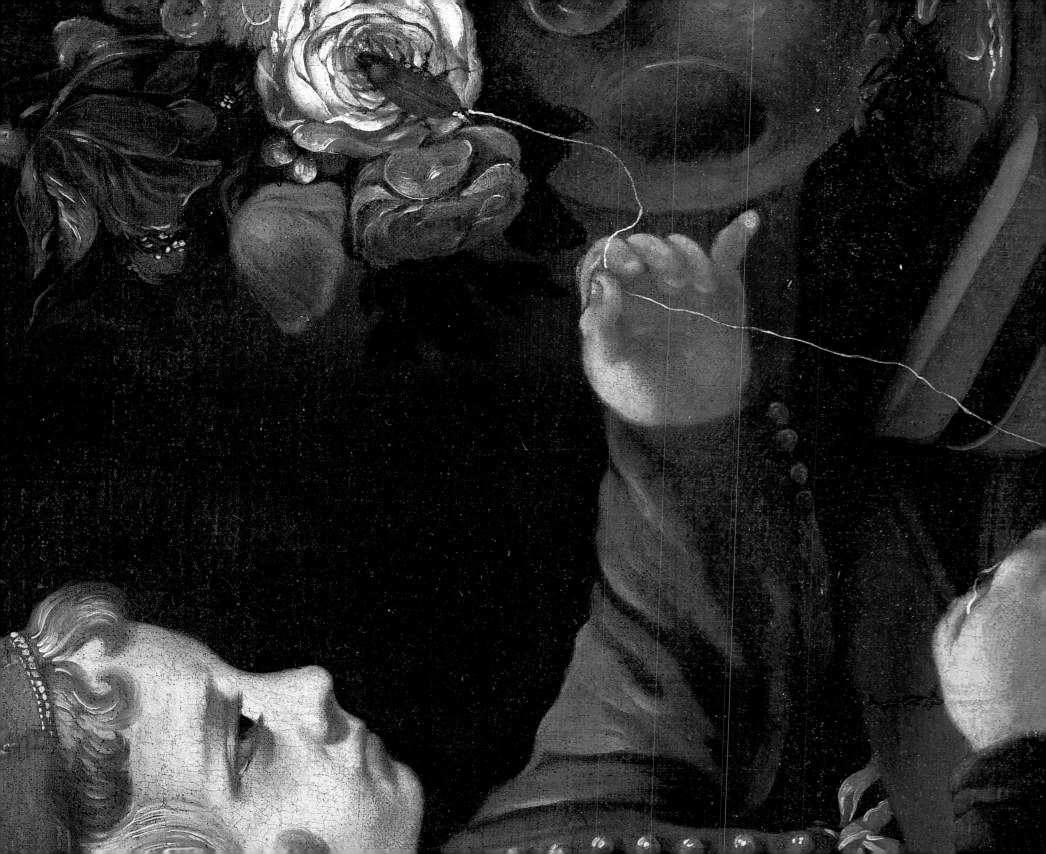

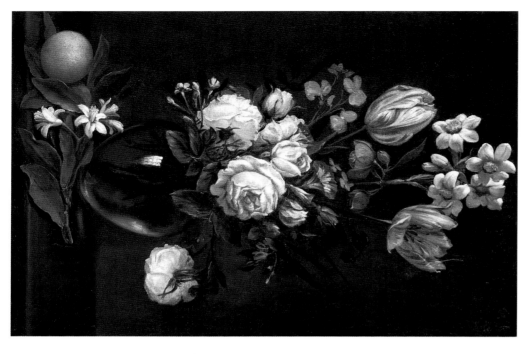

8

A Vase of Flowers

Anonymous Painter of the circle of Daniel Seghers
(first half of the seventeenth century)
Oil on canvas, 53.5 × 36.5 cm

An arrangement of tulips, roses, morning bindweed (*convolvulus tricolor*), and other delicately tinted flowers are placed in a glass vase on a table. To the left, we see a single orange and a sprig of white orange blossoms.

This small canvas adheres faithfully to one of the classic compositions of Netherlandish flower paintings, which was made famous by such masters as Jan Bruegel, Ambrosius Bosschaert, Baldassar van der Ast, and many other specialists. Even the bright reflection in the crystal vase of a paned glass window is a characteristic touch.

Dutch and Flemish flowerpieces were abundantly imported into Italy, and the Netherlandish approach was already known in Rome and Milan before 1600 through the works left there by Jan Bruegel. The present *Vase of Flowers* is more spontaneous in its arrangement and seems to reflect the flowerpieces of the next generation to work in Italy – artists like Daniel Seghers, who were less influenced by botanical miniatures. The picture displays a breadth of handling combined with a decorative delicacy that suggests a French artist closely emulating a Netherlandish model.

The representation of orange blossoms naturally raises the question of an artist with Italian experience of some kind. Seghers, who was in Rome 1625–27, often included orange blossoms in his garlands. On the other hand, orange blossoms were also painted in flower-pieces by the prolific Jan van Kessel (1626–79), who never left his native Antwerp.

9

Studies of Aquatic Birds

Carl Borromäus Andreas Ruthart
(Danzig ca. 1630 – L'Aquila 1703)
Oil on canvas, 32 × 57 cm

Bibliography: Bocchi, Bocchi 1998, p. 610, fig. 47

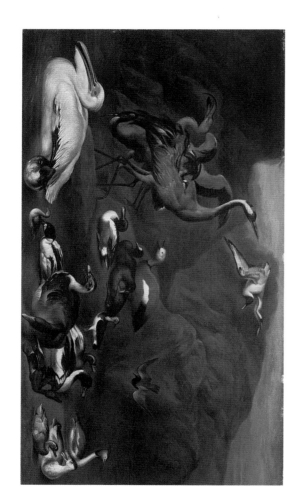

D uring the first part of his career, Ruthart travelled widely without settling for long in any one country. Born in Danzig (now Gdansk, Poland), he was in Rome by 1659, a member of the Guild of St. Luke in Antwerp by 1664, in which year he had already moved on to Regensburg before entering the service of Prince Karl Eusebius von Liechtenstein in Vienna from 1665–67. Ruthart was in Venice in 1672; later that same year that he took holy orders in Rome.

His profession as a Celestine monk was the turning point in his life; soon afterwards he moved to his order's principal monastery in Collemaggio near L'Aquila in the Abruzzi. He seems to have spent the last three decades of his life in the service of the Celestines, painting an altarpiece for Sant'Eusebio in Rome and fourteen frescos of the life of Saint Peter Celestino for the basilica of Santa Maria di Collemaggiore; these scenes are notable for their woodsy settings and depiction of every kind of fauna and fowl.

Ruthart was one of the premier animal painters of the seventeenth century, specializing in the depiction of wild animals fighting each other or being hunted by hounds. He also painted pastoral scenes, still lifes, a few landscapes, and portraits of Celestine saints. His animal subjects were eagerly acquired by the great European collectors, including Bruhl, Czernin, Esterhazy, Harrach, Archduke Leopold Wilhelm, Leuchtenberg,

Liechtenstein, and Schulenburg. The largest selection of his works are on permanent exhibit in the Sala Carlo Ruther of the Museo Nazionale d'Abruzzo. Further bibliography on this rare artist can be found in the catalogue of the exhibition, Liechtenstein. The Princely Collections, at the Metropolitan Museum of Art, New York, 1985–86, and in Meijer 1990, pp. 331–35.

This meticulous Study of Aquatic Birds belongs to an important series by Ruthart that was formerly in the collection of the Marchesi Strozzi in Florence. The ten studies in oil on canvas were rediscovered when they appeared at auction at Christie's, London, on May 20, 1993. The studies display a marvelous assortment of animals and birds, depicted with an extraordinary acuteness, as though seen through a lens. Presumably Ruthart was working from preliminary drawings.

The mountainous landscape behind the ducks, cranes, and pelican lends a compositional unity to this Studies of Aquatic Birds that is lacking in most of the other works in the Strozzi series. It is evident, though, that this canvas was made like the others to serve as a repertory of motifs for use in other paintings. The pelican floating tranquilly on the water, left, and the four birds (shoveler, coot, moorhen, ruddy shelduck), at center, reappear in other studies in the series. The pelican alone was used for the large painting of A Pelican and its Young in L'Aquila (Moretti 1968, p. 17, repr.).

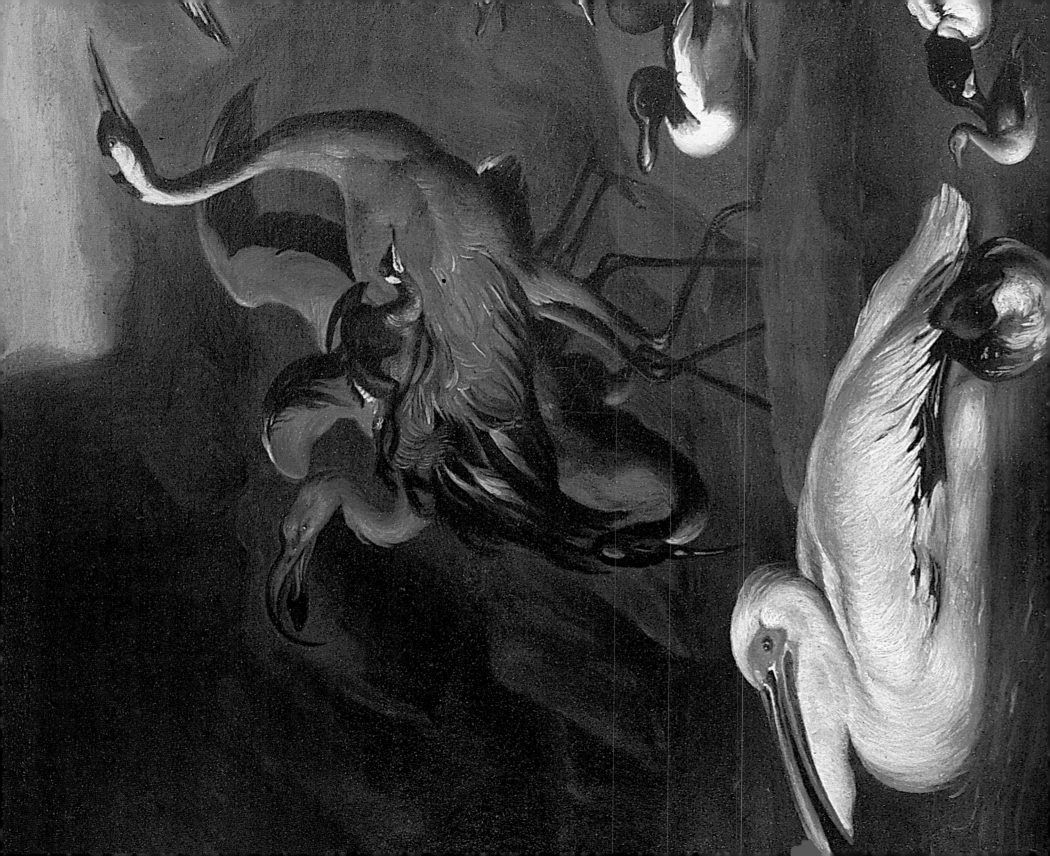

THE FLAVORS OF *Nature*

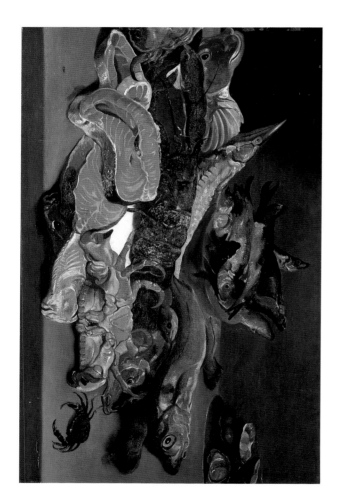

10
Still Life with Fish
Alexander Adriaensen
(Antwerp 1587–1661)
Oil on panel, 67.5 × 106 cm

*A*s a capital and thriving seaport, Antwerp supported a prolific school of specialists in painting fish and other bounty from the sea. Alexander Adriaensen stands out among these painters for his remarkably unpretentious compositions, generally somewhat small in format, but filled to overflowing with every variety of fish. He was a pupil of a minor painter, Arthur van der Laeck, and his good reputation among his contemporaries was based as much on his paintings of fruits and game. Pieter Paul Rubens owned two paintings by him, neither of which represented fish. Although Adriaensen never travelled, his pictures did, and were emulated in Italy by painters such as Giacomo Ceruti and Giovanni Crivelli.

This fine and characteristic work by Adriaensen is particularly interesting because its main elements are skillfully transposed from the central part of *The Monkey and the Swan*, a famous pantry piece by Frans Snyders now in the San Francisco Art Museums. Snyders' much larger canvas (163.4 × 221.4 cm) includes two life-sized figures; Adriansen ignored them and the profusion of other details in order to select only the elements that interested him: the mouth-watering assortment of salmon steaks, sea trout, ray, crabs, oysters, sturgeon, and lobster. Set out on a plain counter, with a neutral backdrop, these appetizing foods become the protagonists of one of Adriaensen's typical compositions. It should be pointed out that his authorship of this panel is established by his distinctively fluid and semi-transparent application of paint. Snyders used a more Rubensian palette with thick highlights.

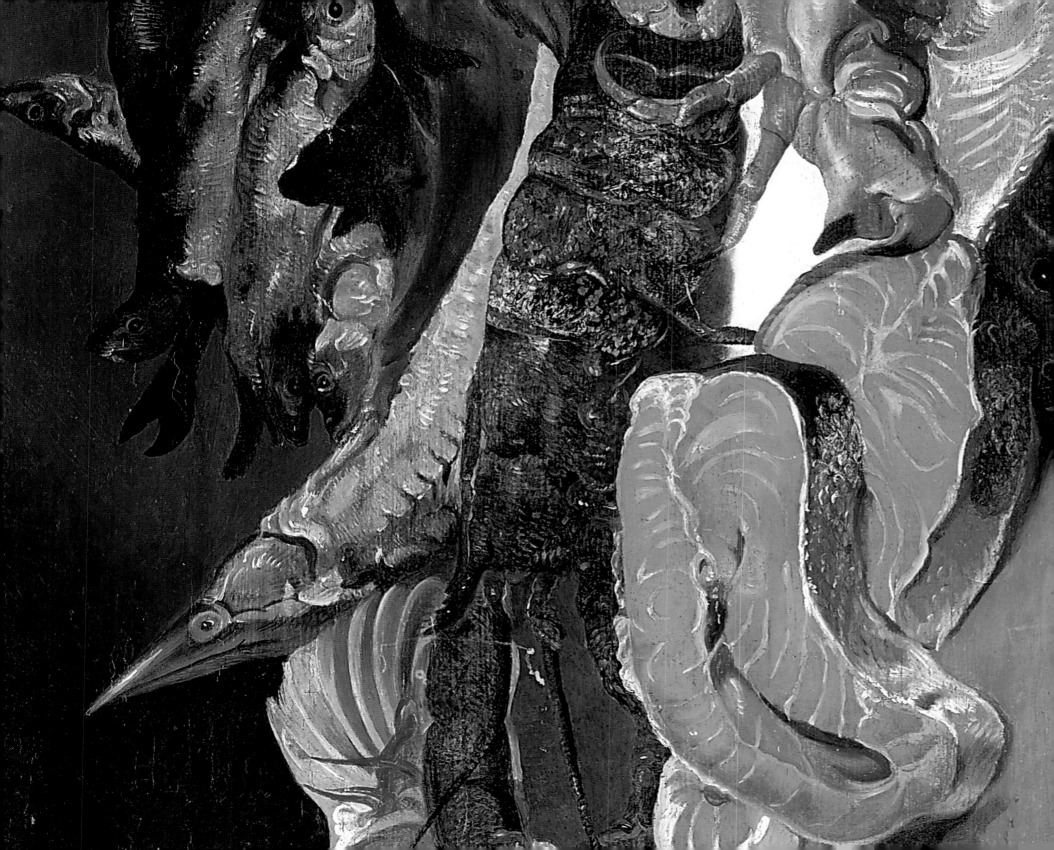

11

Kitchen Scene with Christ
in the House of Martha and Mary

Adriaen van Utrecht
(Antwerp 1599–1652)
Oil on canvas, 171 × 210 cm

Although his name suggests otherwise, Adriaen von Utrecht was active throughout his life in Antwerp, apart from his study travels to France, Italy and Germany from whence he returned in 1625. A pupil of Herman de Ryt, van Utrecht was most deeply influenced by the game, fruit and vegetable still lifes of Frans Snyders (1579–1657), the unrivalled Flemish specialist in this genre. Jan de Heem and Jan Fyt were also influential on his later works. Van Utrecht often collaborated with other artists; among the prominent Antwerp painters who contributed figures to his market scenes, garlands, and still lifes of fruit and vegetables were Jacob Jordaens, Erasmus Quellinus and David Teniers. His paintings were exported in large numbers and especially to Spain, where his works are well represented in the the Prado Museum in Madrid.

This spectacular *Kitchen Scene with Christ in the House of Martha and Mary* combines a kitchen scene with the episode from the Gospel of Luke (10:38–42) when Jesus was welcomed into the house of Martha and Mary. In the background at left Mary listens eagerly to the teachings of Jesus. Her sister, Martha, is shown in the foreground, looking somewhat overwhelmed by a wondrous bounty of the birds of the air and the fruits of the earth. No wonder she chided Mary for not helping her in the kitchen. But despite these sumptuous attractions for the palate, Jesus replied to her, 'Martha, thou art anxious and troubled about many things, and yet only one thing is needful: Mary has chosen the better part, and it will not be taken away from her.'

Broad, horizontal compositions in which the foreground still life takes visual precedence over a small-scale religious subject were introduced into Netherlandish painting in the mid-sixteenth-century by Pieter Aertsen (1508–75) and Joachim Beuckelaer (ca. 1530–73). Masters such as Frans Snyders and even the young Velázquez in Seville (1618) continued the trend into the first years of the seventeenth century.

Artists of Van Utrecht's generation had largely ceased to need the expedient of a Biblical story as an excuse to paint a pantry still life; this *Christ in the House of Martha and Mary* recalls the pictures of the previous generation because, in fact, Van Utrecht derived it from a famous composition by Frans Snyders, as Hella Robels confirmed in a letter written some years ago. Van Utrecht's preference for smoother brushwork and warm tones of grey-green and brown make it possible to distinguish his hand from Snyders' broader and more agitated execution.

As a final observation, we can point out the triptych that graces the hearth in the room where Jesus and Mary are seated. The center panel of this painting — which looks, anachronistically, rather more Netherlandish than antique — represents Moses with the Tablets of the Ten Commandments. Had the ancient Hebrews decorated their houses with paintings, this Old Testament subject would have been an appropriate choice for two pious sisters; in the present context, it serves to contrast the Law brought by Moses to the New Law brought by Jesus.

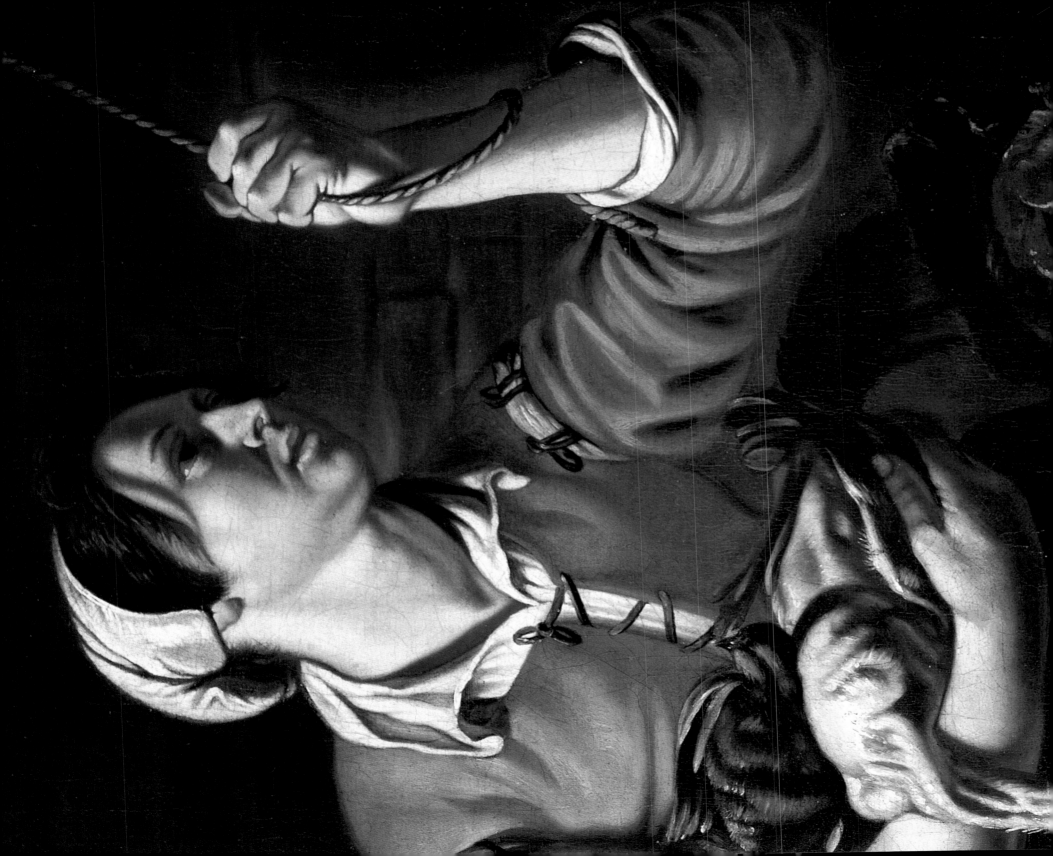

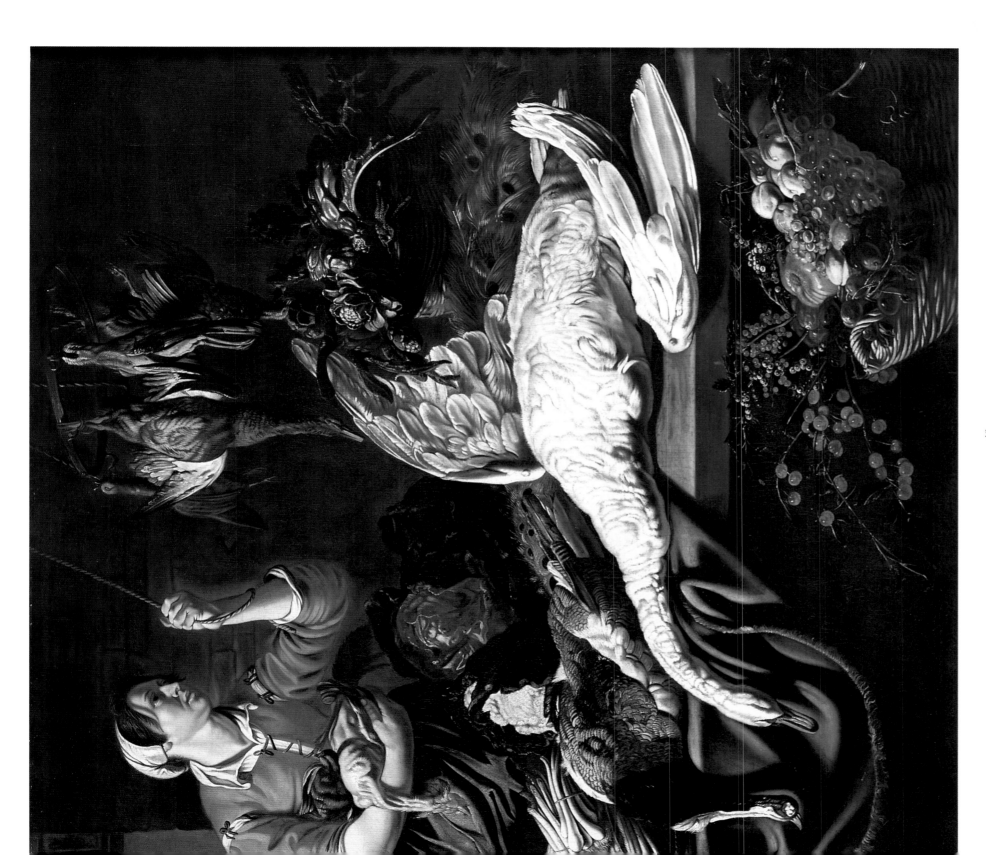

43

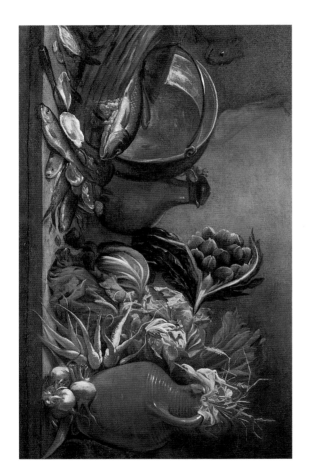

12

Kitchen Still Life

Painter close to Francisco de Herrera,
called lo Spagnolo dei pesci
(Seville 1627 – Madrid 1685)
Oil on canvas, 62.5 × 102 cm

A fresh catch of fish and oysters has been set down on a larder shelf, attracting the gluttonous gaze of the household cat hidden in the shadows. The rumpled harvest of an autumn garden is seen at right: radicchio, greens, turnips and carrots. A pitcher and a jug promise good drink for a satisfying supper even in this late time of the year.

The delectable commestibles in this painting are not nearly so remarkable, however, as its impressionistic handling. The artist experiments throughout with a bold interplay of over- and underpaint, leaving exposed broad areas of the dark brown *imprimatura* (in the pitcher and the cat) and using scattered brush strokes for the highlights. The transparent shadows create a contemplative mood by casting an atmospheric veil over everything.

While the subject matter (oysters on a kitchen shelf) and the tonal unity are derived from Netherlandish painters of the 1630s and 1640s, Dutch or Flemish still life painters were rarely so free in their techniques. Compared to those painters, moreover, the atmosphere seems comparatively dry and the modelling of volumes seems less emphatic: such qualities would point instead to a Spanish painter. As Rome at mid-century was the most promising venue for an international artist of this sophistication, the possibility of a connection with 'lo Spagnolo dei pesci', Francisco de Herrera, comes first to mind, but cannot be demonstrated. Often cited in old Roman inventories, lo Spagnolo dei pesci remains a mystery as regards his development. The sole signed picture by him is indeed based on Netherlandish still lifes but is not executed in this tonal style (Bocchi, Bocchi 1992, pp. 340–41). For this reason, we must be content with styling our present painter his 'compatriot'.

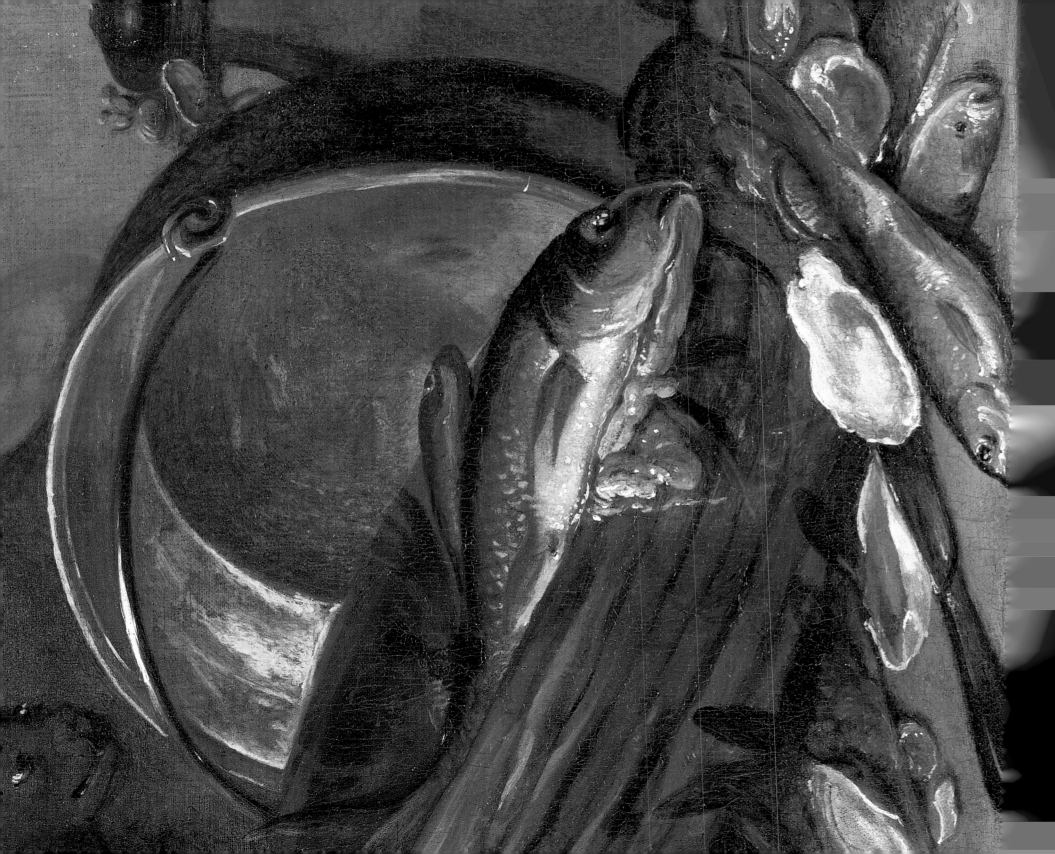

13

A Bunch of Grapes with Various Fruits on a Ledge

Michelangelo Cerquozzi
(Rome 1602–60)
Oil on canvas, 47 × 35 cm

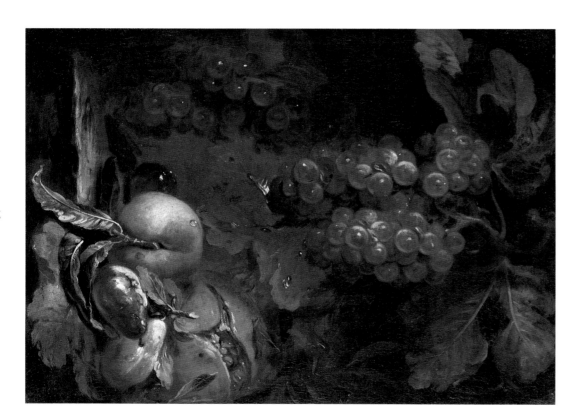

46

Cerquozzi was also known as Michelangelo delle Battaglie or delle Bambocciate (scenes of the daily life of common people) from the success of his paintings of those subjects. Passeri wrote in the seventeenth century of Cerquozzi's connection with Pietro Paolo Bonzi, one of the pioneers of Roman still lifes, but his importance in this field was not sufficiently appreciated until Briganti's groundbreaking article of 1954. In 1983, Spike published a *Cincinnatus called from the Farm* (private collection) with an abundant basket of fruit and large figures, which remains one of Cerquozzi's rare signed pictures. In the light of recent research Cerquozzi has emerged as a pivotal personality, whose early still lifes were heavily

influenced by the ex-Barberini *Basket of Fruit on a Stone Ledge* by Caravaggio (Spike 2001", cat. no. 35). Cerquozzi carried forth the Caravaggesque style of still life painting, especially as practiced by Agostino Verocchio, until the development of the baroque style of Michelangelo Pace, called Campidoglio.

This diminutive, but vivid, still life of grapes and fruits is broadly and rapidly brushed, almost to make it seem an anticipation of the manner of Campidoglio. The deep colors of the peaches and the scintillating drop of water on the pair emerge from the suggestive penumbra of a shaded corner of the orchard. This simple composition was one of the artist's preferred, and most widely imitated.

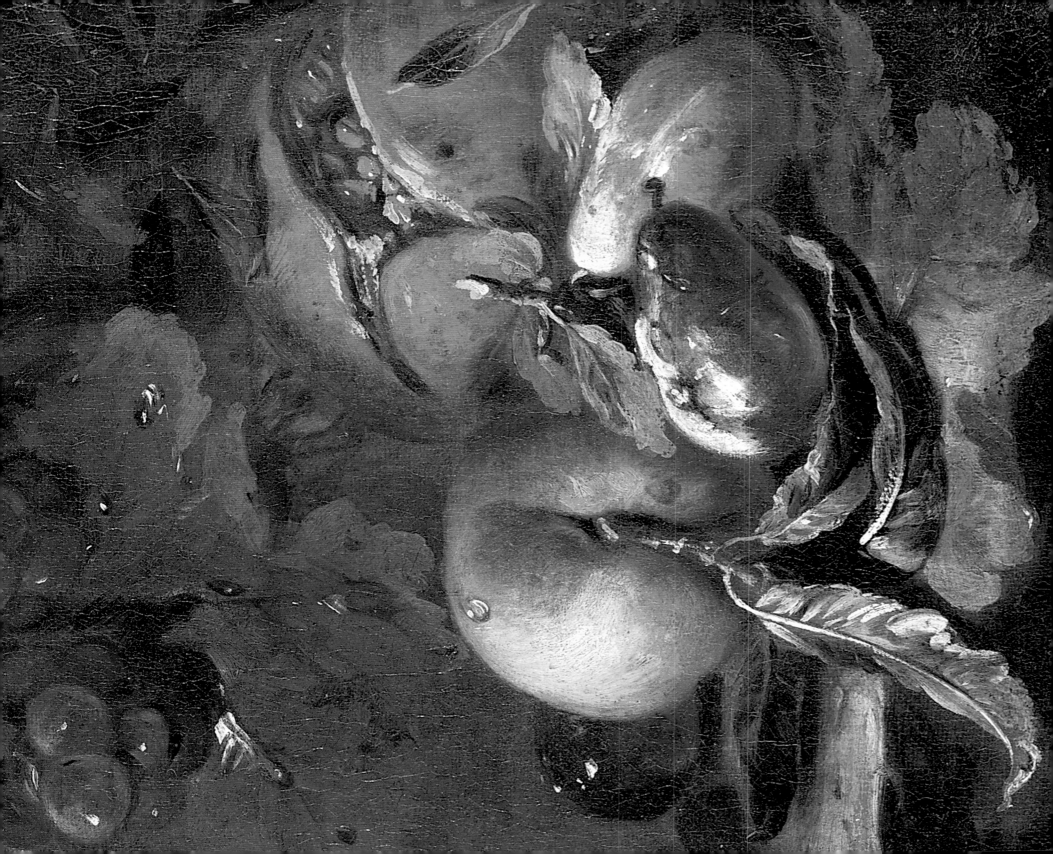

Wooden Tub with Onions, Basket with Cherries, Peaches and Pears
Turnips, Radishes, Savoy Cabbage, Artichokes and Mushrooms

Emilian Painter
(second half of the seventeenth century)
Oil on canvas, 79.5 × 117.5 cm each

Bibliography: Arisi 1973, figs. 34 and 35, pl. I

This pair of still lifes are remarkable examples of the taste for rustic, even humble, simplicity, that is a distinctive tradition in Bolognese and Emilian painting. Both of the canvases display common varieties of fruits and vegetables spilled out unceremoniously on the bare earth. A semblance of landscape can be glimpsed in one of the pictures, while, in its companion, the bowl of green pea pods appears to sit on a ledge in a crude larder, although the painter has devoted scant attention to describing the rural settings, in fact. By not making any claims of exceptional quality for either the food or the household, the artist appears to be saying that nature's bounty need not be lavish to be nourishing, good, and sufficient for everyone, farmer and nobleman alike. The dates of Emilian still lifes, not to mention their attribution, are often disputed, although considerable progress has been made. For many years, scholars considered the Pittore di Rodolfo Lodi, author of an anonymous still life in the Bologna picture gallery, to be the vigorous, if slightly naïve, protagonist of an initial phase of Bolognese still life painting in the first decades of the seventeenth century (cf. Arcangeli 1961, pp. 336–338). In the light of recent research, scholars are now inclined to assign precedence to Paolo Antonio Barbieri (1603–49), whose career did not begin until the 1620s. This new reconstruction thus involves a kind of paradox: although the roots of Emilian naturalism can be traced back to the Middle Ages, and notwithstanding the precocious activity by Antonio da Crevalcore (documented 1478–1513), it now appears that Bolognese painters followed by at least a decade their counterparts in Rome, Milan, and even Naples, in the production of independent still life compositions. By the same token, even the direct pupils of Bartolomeo Passerotti and Annibale Carracci declined to imitate their innovative genre paintings of fruitvendors, butchers, bean eaters, fishmongers, perhaps because they had been dubbed

pitture ridicole by Cardinal Paleotti (cf. Wind 1974, pp. 29–30; Ghirardi 1986, p. 548).

This pair of still lifes displays some notable affinities to three paintings in private collections and the Ravenna Pinacoteca now generally assigned to Paolo Antonio Barbieri, which are discussed and illustrated by Daniele Benati in a valuable recent publication (Benati, Peruzzi, 2000, pp. 76–84, figs. 32, 33, 35). Subdued hues of orange, red and yellow are immersed in an earth-toned penumbra in these still lifes, which share a fascination for chains of onions and other simple round shapes. On the other hand, our present painter was altogether less exacting than Barbieri, the pupil of his elder brother Guercino, in the modelling of volumes and depiction of spatial perspective. It was surely the haphazard arrangements of the present canvases, which reflect the disorder but not the comic spirit of Bartolomeo Arbotori, that convinced Ferdinando Arisi to describe them as early works of Felice Boselli in his landmark monograph of long ago 1973. Indeed, I believe that Arisi's dating to the 1670s retains its validity, making this anonymous artist, according to our new understanding, an Emilian painter roughly contemporary to, and working in a popular vein akin to the Pittore di Rodolfo Lodi (cf. Benati, Peruzzi, 2000, pp. 110–113).

Some final reflections on the three still lifes cited above; if indeed by Barbieri, they could only have been painted at the end of his career as they show notable progress beyond the archaic symmetry and smooth surface textures influenced by Guercino that characterize the famous *Spezieria* (Spoleto), dated 1637 in the *Libro dei conti*, and the other still lifes heretofore given to him. Dating from the 1640s, these still lifes trace the transition in Bologna from Barbieri's archaisms to the baroque style that Cittadini introduced at the end of the same decade.

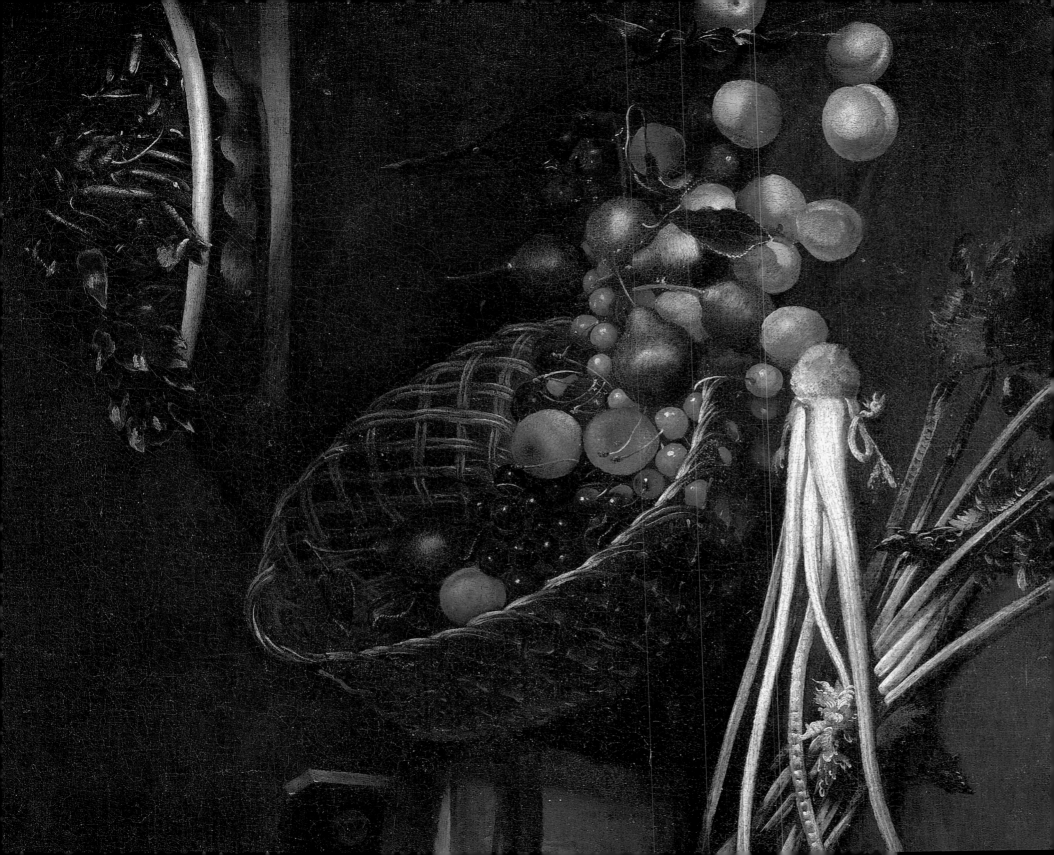

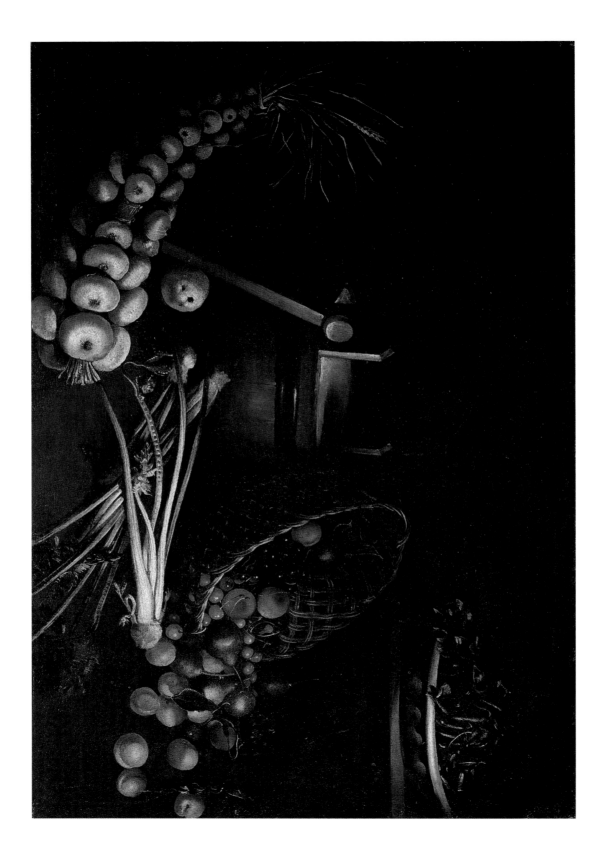

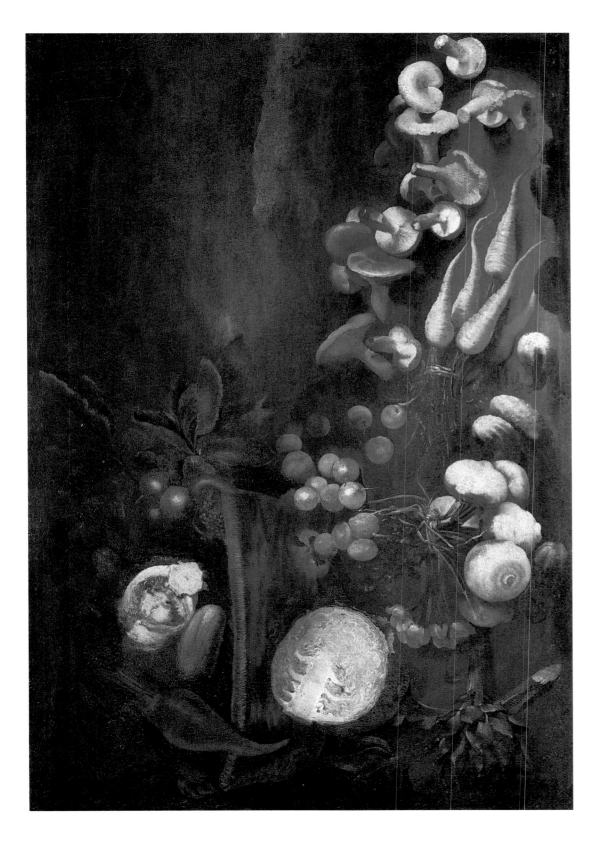

16
Melons, Lemon Slices, Apples, Figs, Pears and Pomegranates

Paolo Paoletti
(Padua ca. 1671 – Udine 1735)
Oil on canvas, 76 × 98.5 cm

The fruit still lifes by Paolo Paoletti combine the earthiness of the Po river plain, where the artist was born, with the colorful decorativeness of Venetian painting, to which he was exposed during his lifelong activity in the regions of Friuli and Treviso. Although Paoletti was mentioned in passing by a few early writers on art, he would probably be unknown outside of Friuli were it not for the research of an Udinese scholar, Tito Miotti, the author of a small monograph and several articles. Paoletti appears to have passed a prosperous career with little or no competition from other still life specialists. According to de Renaldis (1738), he lived in Udine for many years as a guest of Count Caiselli, whose palace held a room entirely decorated with his still lifes. His local fame remained high through the end of the eighteenth century; the artist Leopoldo Zuccolo (ms. 1790) wrote, 'Paoletti nel suo genere di frutami, e cose commestibili è ammirabile, e valentissimo; i molti quadri sparsi per tutti refetori, e tinelli di Udine eccitano un acuto appetito in chi li osserva; e potriano rinovare i miracoli del uve d'Apelle, o pure le pene di Tantalo' (Bergamini, Bergamini 1983, p. 277).

This boisterous still life displays in abundance the cheery confusion that is typical of Paoletti. An avalanche of melons and lemon slices spill forward as if out of a cornucopia. The lemons as thick as wheels, and the apples, each one perfectly round and fat, are the artist's typical celebration of deliciousness. Similar lemon slices like miniature wagon wheels and exaggeratedly symmetrical apples can be found in most of Paoletti's paintings, including one in the Castello Valentinis in Tricesimo (Friuli), published by Miotti in 1954, and a pair of unpublished still lifes (85 × 115 cm; Romigioli Antichità, Milan) first identified by Ugo Ruggeri. Paoletti's compositions are invariably crowded with an amusing humble-jumble of natural and fanciful elements; his playfulness is remarkably reminiscent of the work of two Emilian still life specialists, Bartolomeo Arbotori (1594–1676) and Felice Boselli (1650–1732), as Renato Roli (La natura morta italiana 1964, p. 114) first pointed out many years ago.

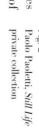

Fig. 2
Paolo Paoletti, Still Life
private collection

Lemon Slices, Apples, and Apricots in a Landscape

Paolo Paoletti
(Padua ca. 1671 – Udine 1735)
Oil on canvas, 96 × 73 cm

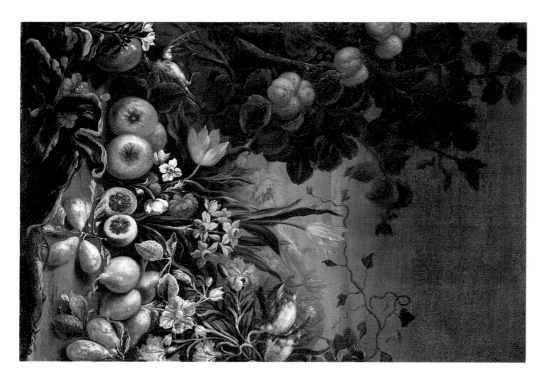

*T*his *Lemon Slices, Apples, Apricots in a Landscape* has so many fruits in common with the precedent still life that the two paintings would be considered pendants if their compositions had the same orientation. Fruit still lifes of vertical format are in fact somewhat unusual. The pale tones of yellow, red and green are typical of Paoletti's palette, as is his willingness to leave the red clay imprimatura uncovered throughout the composition and especially in the background.

Like the Emilian painters Bartolomeo Arbotori and Felice Boselli, Paoletti paints fruits and foodstuffs that are exaggeratedly desirable: preternaturally full of sap, rounded to the point of bursting, and glowing. The velocity and airiness of his execution are typically Venetian, however. Paoletti was a direct antecedent for the playful still lifes produced by Francesco Guardi and his atelier later in the *Settecento*.

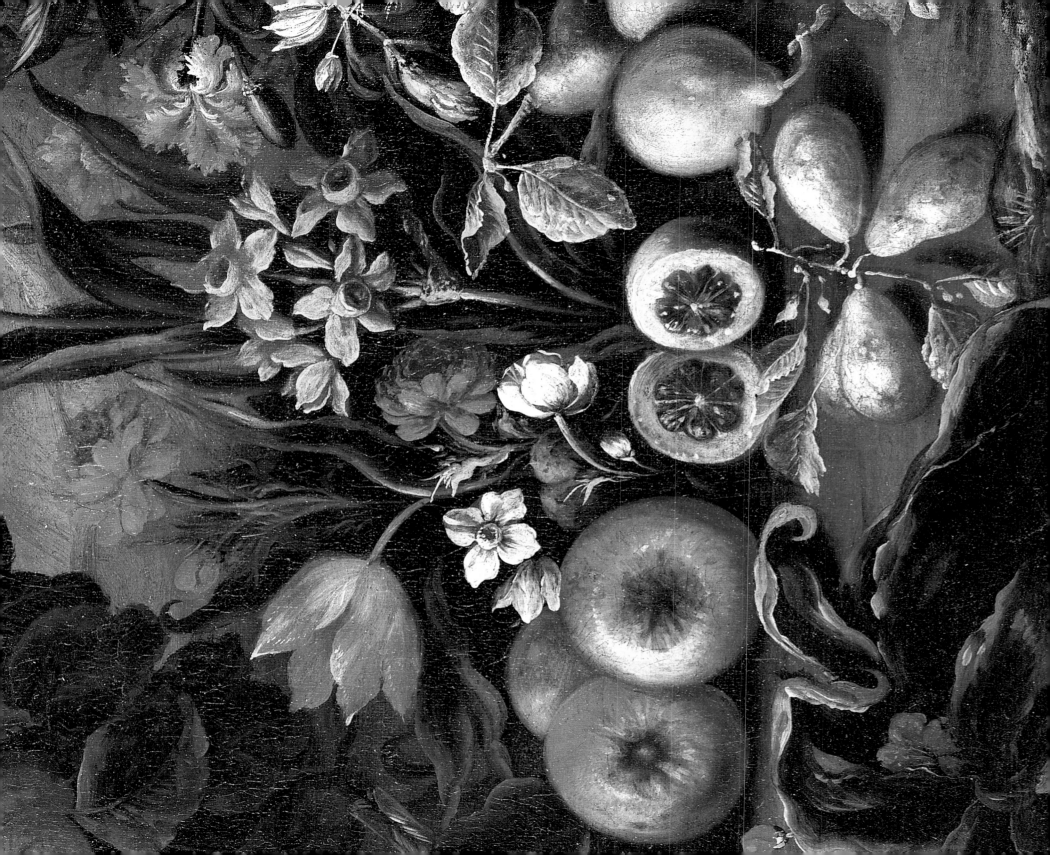

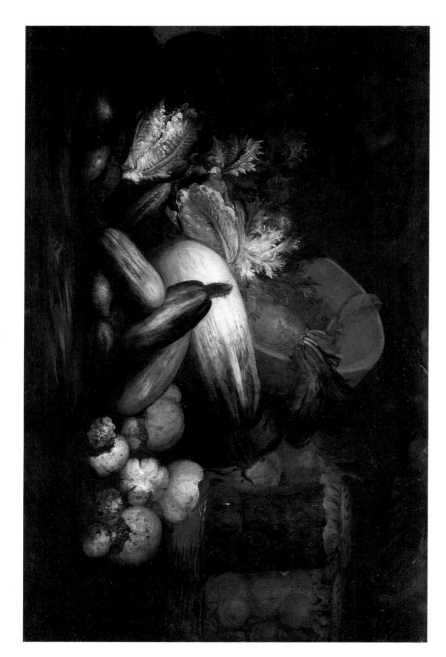

18

Squashes, Mushrooms, Lettuce, and Fruit Jars

Emilian Painter
(second half of the seventeenth century)
Oil on canvas, 65.5 × 102 cm

*T*he pale tonalities of pale red, orange and green are typically Emilian in this still life as is its enthusiastic appreciation of the garden's humblest offerings: never in the history of Italian art have squashes and a carrot received such regal treatment. The mushrooms add an autumnal air to the selection, as do the glass jars of preserved fruits. This still life of cool vegetables reminds us good-naturedly that the summer heat has passed. There is an inherent good humor, besides, in the lively, pastose brushwork which places the painter in the generation between Arbotori and Felice Boselli, with certain affinities to the anonymous Pittore di Rodolfo Lodi. The mushroom caps are barely recognizable as such, the artist takes such delight in laying the colors on thickly. That Arbotori must have been his point of departure is clear from his fanciful treatment of the swirling, serrated leaves of lettuce leaves. This was a 'signature' motif of the Piacentine master that Boselli also found irresistible.

Melons and other Fruits under a Grape Arbor

North Italian Painter
(mid-seventeenth century)
Oil on canvas, 100 × 75.5 cm

*T*he artist of this exuberant and delicious still life is mainly motivated by the desire to show as many good things to eat as possible, without attempting to unify them particularly. Thus the melons are split open and heaped up, and the figs, asparagus, and peaches are simply inserted in the open spaces around them. If this painter appears to make fewer errors in draftsmanship, it is perhaps because of the greater experience acquired by all artists of his time in treating fruits and grapes as the subjects of art.

By the mid-seventeenth century, still lifes and landscape paintings were beginning to overtake religious pictures as the preferred decorations for city houses and country villas. Hundreds of specialists provide canvases to satisfy the demand; the names of these artists may never be known because they were not written about by their contemporary critics, and they rarely signed their works. The sensuous execution and broad chiaroscuro of this *Still Life* are typical of the style of the Po River Plain, north of the Appennines.

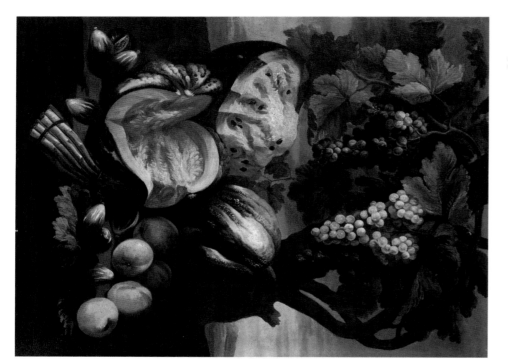

Still Life with Poultry, Game, Squash, Lemons and Garlic

Jacob van de Kerckhoven, called Giacomo da Castello [?]
(Antwerp 1637 – Venice 1712)
Oil on canvas, 88 × 122 cm

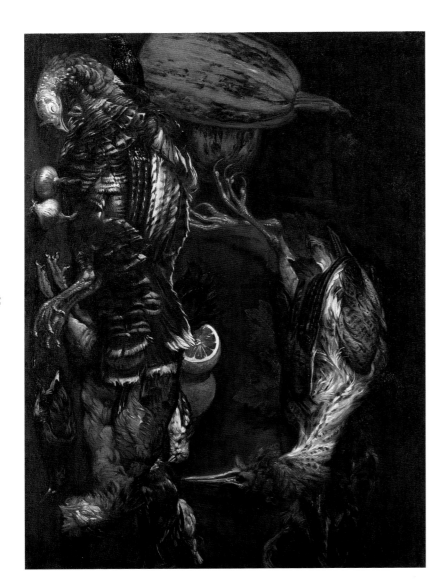

Van de Kerckhoven was trained in the Antwerp workshop of Jan Fyt (Antwerp 1611–61), a celebrated painter of game and hunting still lifes, who evidently encouraged his pupils to take the road to Italy, as he had as a young man, and as Fyt's own master, Frans Snyders, had done before him. Fellow pupils, David de Koninck (1636?–1701) and Pieter Boel (1622–74), established their workshops in Rome and Genoa, respectively, while Van de Kerckhoven had transferred to Venice by 1685. The Italians simplified his name to Giacomo da Castello, in reference probably to the area of Venice where he lived for the rest of his long and productive life. He specialized in still lifes for private collectors representing game, fish, and fruits. Probably more than a hundred of his pictures have been identified thus far although their chronology has yet to be understood. It seems clear that he proceeded from the Flemish naturalism in which he was trained to a brilliantly decorative style that imbues the forms with an almost metallic sheen.

An expert in the culinary arts would recognize this still life as containing the ingredients for a memorable repast of various domestic and wild fowl. There is a hidden artfulness in the painter's arrangement of these elements mainly in pairs and adroitly leading the eye to every corner of the composition. The plumage is described with an ornithologist's accuracy. It is surprising to note how freely and quickly the painter has brushed in the feathers over the red bolus ground of the canvas. The aura of respectful silence that descends upon these magnificent creatures is a quality often found in the paintings of Jan Fyt, who painted more thickly, however, in the Flemish manner. The liberal application of whitish highlights, often applied in short parallel strokes, is reminiscent of Van de Kerckhoven's characteristic technique. For this reason, this remarkable game piece has been attributed to Van de Kerckhoven with the hypothesis that it is an early work executed under the influence of his master, Fyt.

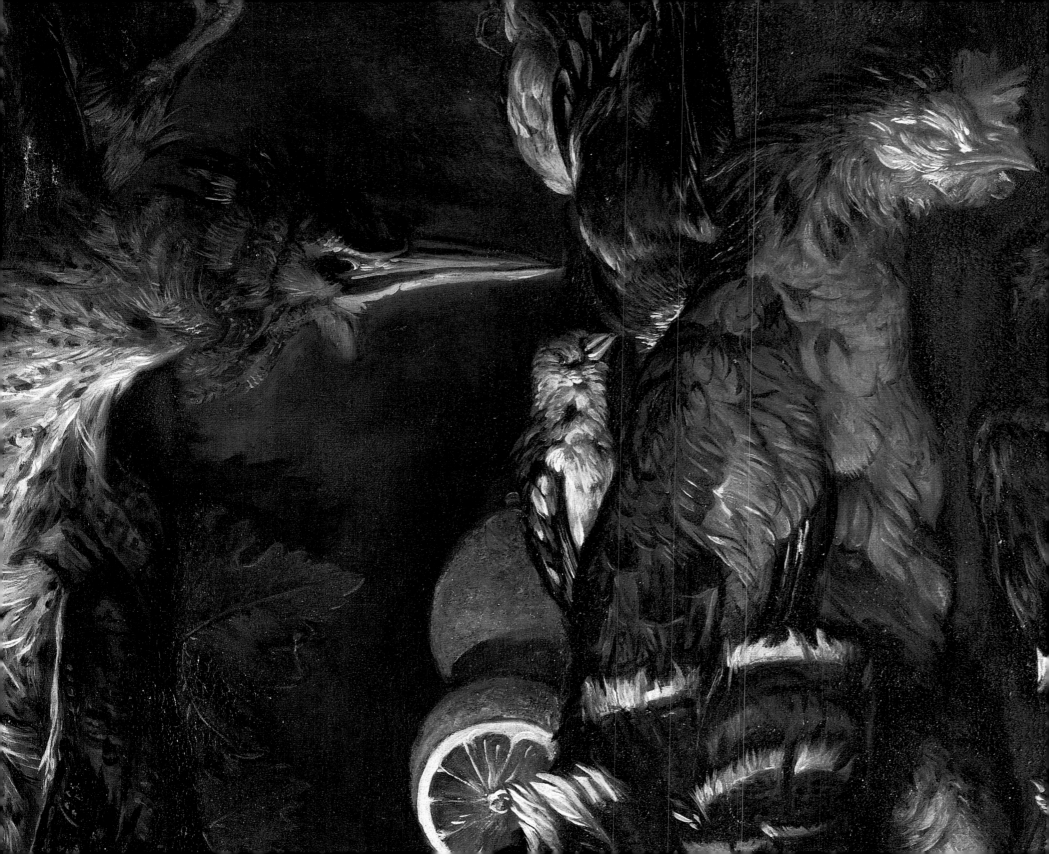

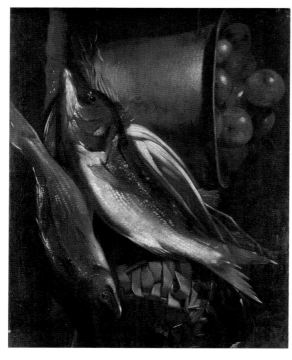

Still Life with Fish and Fruit

Simone del Tintore
(Lucca 1630–1708)
Oil on canvas, 76.5 × 97 cm

S imone del Tintore painted still lifes of fruits and game, not infrequently in collaboration with other painters, which carried his name far beyond the borders of his native Lucca. He was trained in the academy that Pietro Paolini (1603–81), a leading follower of Caravaggio, established in Lucca after his return from Rome. The craggy-faced old men and women that del Tintore often included in his still lifes are based on models by Paolini.

Del Tintore's development appears to have embraced several distinct phases whose precise chronology remains to be determined. Early in his career he may have absorbed influences from as far away as Venice. Two still lifes, initialled 'S.T.', in the Castello Sforzesco in Milan repeat, almost exactly, the characteristic motifs of the Venetian still life specialist widely assumed to be Bernardo Strozzi. Indeed, the same, or similar, harvest baskets, tubular squashes and lemons were depicted by del Tintore throughout his long career.

Del Tintore characteristically limited his palette to the tonalities of brown, green and copper that we find in this fine composition of two fish, celery, apples, kettle and the artist's signature motif of a coarsely woven basket. The elements are illuminated in the darkness by a ray of light that descends from the left. The vigorous handling and solid modelling of this picture place it in del Tintore's mature phase and certainly prior to 1671 when his Game and Fruit in a Milanese private collection reveals his transition into a dryer, less tonally unified technique.

There are many elements in this still life, especially the distinctive green and brown apples, that suggest that del Tintore was in contact with the Lombard artist known as the Pseudo Fardella or Pittore di Carlo Torre, who was formerly believed to be from Tuscany, but is now known to have been active in Milan (see cat. no. 44). He was del Tintore's contemporary and was either influenced by him or attracted by the same precedents that remain to be identified.

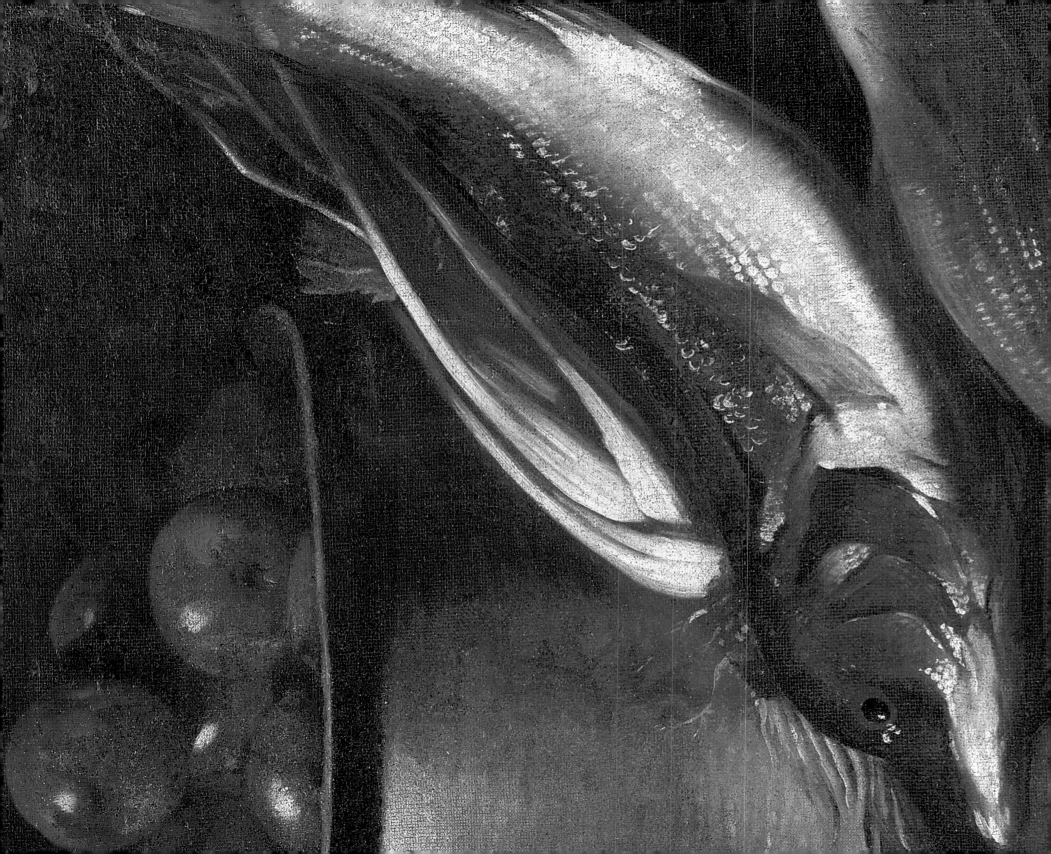

Nature IN FLOWER

Sculptured Vase with a Bouquet of Flowers

Bartolomeo Ligozzi
(Florence ca. 1630–95)
Oil on canvas, 56 × 45 cm

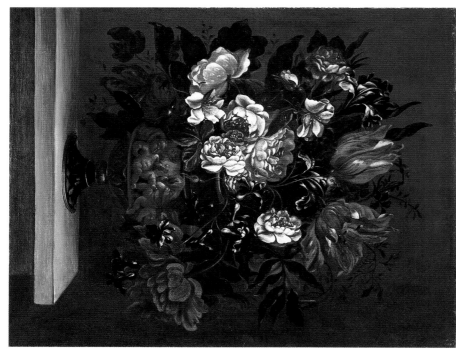

*B*artolomeo Ligozzi, the grandson of the famous Jacopo Ligozzi, enjoyed a long and productive career as a flower painter in the service of the Medici court. His works are amply cited in the Florentine archives from 1660 onwards; Grand Prince Ferdinando de' Medici, the greatest collector in Florence, commissioned no fewer than ten still lifes from Ligozzi between 1682 and 1686.

Celebrated in his own day and for a century afterwards, Ligozzi was forgotten in the nineteenth century and most of his works dispersed. As late as 1984, Luigi Salerno would write in his chapter on 'Tuscany after 1650': 'nulla sappiamo di Bartolomeo Ligozzi, fiorista'. Documented works by him finally appeared in the 'Floralia' exhibition of still lifes from the collection of the Palazzo Pitti.

Compared to the flowerpieces by his predecessors such as Mario de' Fiori in Rome and Pierfrancesco Cittadini in Bologna, Ligozzi's still lifes are noticeably archaic, deliberately deferring to the precedent of his illustrious grandfather. The silky surfaces of the striped tulips in this fine bouquet are intended to appeal to a taste for miniatures, for example. By the same token, the scalloped edges of the roses appear more ornamental than natural.

Ligozzi's preference for vases with classical decorations like these playing putti shows his awareness of the flowerpieces by Tommaso Salini and Mario de' Fiori in Rome. His simple compositions like this one, in which a sculptured vase is isolated on a ledge against a shaded background, were important for his Florentine successors and especially Andrea Scacciati.

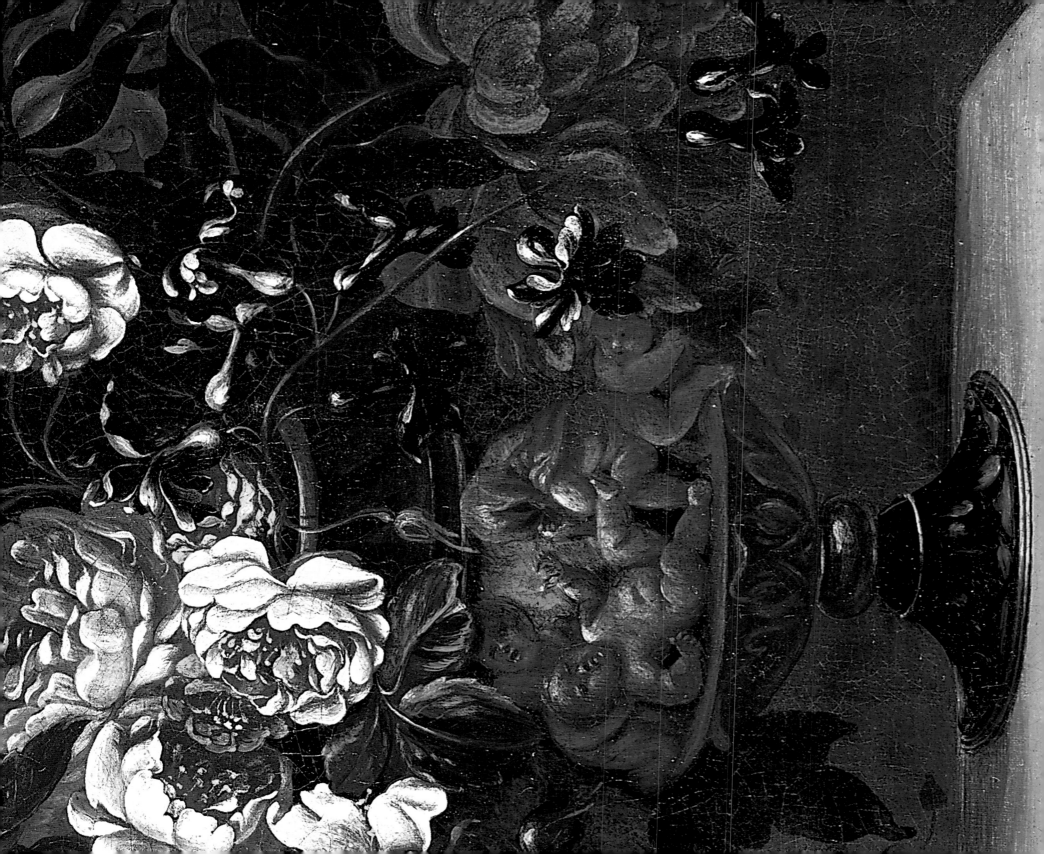

Three Amorini Arranging Flowers in a Basket

Astolfo Petrazzi [?]
(Siena 1580–1653)
Oil on canvas, 70 × 115 cm

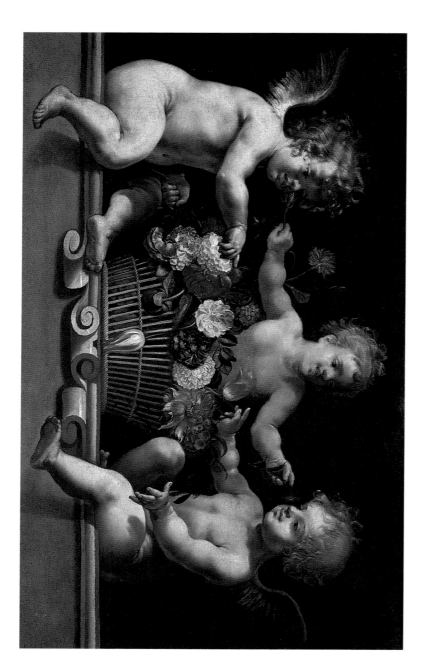

*T*his *Amorini* is a remarkable rediscovery from the early seventeenth century in which the painter attempts to reconcile passages of preciosity, as seen in the superb flowers and the cupids' golden curls, with his naturalistic description of robust bodies strongly modelled by deep shadows. Three winged amorini are seated on a stone ledge sculpted with a strapwork motif as they contentedly arrange exquisite flowers, including some that are exotic, in a basket. The amorino in the center has playfully taken two flowers and thrust them under the nostrils of his companions. The scent of the rosebud causes the amorino at left to smile, while the other amorino is visibly startled by the purplish flower. The message encoded in this innocent mischief among cupids seems to be that the consequences of love can be both pleasurable and disconcerting.

Such emblematic intentions, together with the stylized features of the cupids' faces, which are still vaguely Mannerist, are qualities that point to the hybrid Caravaggism that emerged in Siena shortly after 1610. Even before they travelled to Rome, Rutilio Manetti,

Astolfo Petrazzi and Francesco Rustici must have been influenced by the paintings by Caravaggio, both originals and commissioned copies, that Giulio Mancini began to send to his brother in Siena as early as 1606. The fact that none of Mancini's paintings by or after Caravaggio were flowerpieces perhaps explains why the amorini in this picture are noticeably more natural than the flowers, which recall the ornamental bouquets in late sixteenth-century engravings.

Astolfo Petrazzi was the still life specialist among the Sienese Caravaggists, and indeed one of the most important still life painters in Tuscany, according to a letter sent by principe Mattias de' Medici to his brother Gian Carlo in 1630 (Avanzati, in *La natura morta in Italia* 1989, II, p. 541). As Petrazzi's works from the second decade of the seventeeth century, which is the period when this *Amorini* was probably painted, are as yet unknown, his authorship cannot be either confirmed or excluded. Petrazzi was trained in the circle of one of the leading Sienese mannerists, Ventura Salimbeni, whose influence he never entirely outgrew.

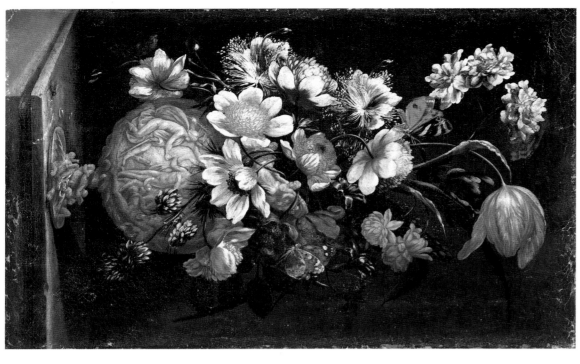

*Flowers in a Golden Vase sculpted
with the Judgement of Paris*

Francesco Mantovano [?]
(documented in Venice 1636–63)
Oil on canvas, 45.5 × 29 cm

*T*he delicacy of the brushwork, the relatively large scale of the flowers to the vase, and the preciosity of the ornamentation on the golden vase, are 'archaic' qualities that suggest a dating not later than the 1630s for this splendid bouquet. The painter seems to have been aware of North European artists such as Georg Hoefnagel (who worked in Italy), Georg Flegel and Jacques de Gheyn II, who were active at the beginning of the seventeenth century. On the other hand, the asymmetrical and dynamic arrangement of the flowers, their difficult foreshortenings, locate this artist within the context of the incipient Baroque style.

It is here suggested that this flowerpiece represents an early work by Francesco Mantovano, an important but only recently rediscovered specialist, who painted the same repertory of red and white anemones and tulips, delicate white roses (see the following entry, cat. no. 25). The hypothesis of a Mantuan origin is supported by the Raphaelesque classicism of the golden ewer, and in particular by the fantastical dragon at the base that seems to evoke Giulio Romano's capricious designs for gold and silverware. The execution of this picture is altogether finer and more miniaturist than that of the pictures currently assigned to Mantovano (see Bocchi, Bocchi 1998, figs. 488–99), a discrepancy that could be the result of the artist broadening his technique in Venice after leaving his native Mantua prior to 1636.

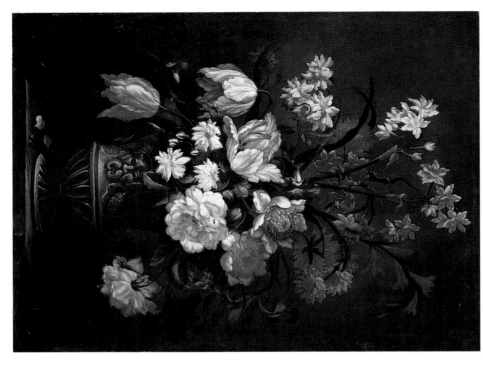

25

Flowers in a Vase decorated with a Grotesque Mask

Francesco Mantovano
(documented in Venice 1636–63)
Oil on canvas, 65 × 50 cm
*Bibliography: Veca 1982, p. 252, fig. 257
(as Giacomo Recco); Bocchi, Bocchi 1998, p. 403, fig. 502*

Francesco Mantovano was an active and admired still life specialist in mid-seventeenth-century Venice. Two references to 'Francesco Pittore Mantovano' in letters sent by the Mantuan ambassador in Venice seem to confirm that he was born in Mantua. By 1636, Mantovano was already inscribed in the *fraglia* [association] of Venetian painters, which means that he was born by 1618 at the latest. Although his still lifes are not cited in any Venetian collections apart from Schulenberg, his contemporary fame is attested by Boschini (1660) and Martinioni (1663). Boschini praised Mantovano's paintings of flowers, fruits, fish and animals, and included a woodcut of a composition of flowers and fruits that does not correspond very closely to the artist's known works. Šafarik and Bottari (*La natura morta in Italia* 1989, I, p. 326) first compiled the available documentation on Mantovano, but the artist did not

emerge from obscurity until his flowerpieces were rediscovered by Ulisse Bocchi (1998, pp. 392–410) on the basis of a series of small canvases in the Accademia dei Concordi in Rovigo.

This fine bouquet displays all of Mantovano's characteristics, as Bocchi was the first to recognize. The same vase decorated with a *mascherone all'antica* appears in a still life that passed through Finarte, Milan (Bocchi, Bocchi 1998, fig. 501). Apart from the wandering blue columbines and the yellow jonquils, the floral selection is dominated by tints of red, pink and white. Clusters of three small white roses recur in most of Mantovano's flowerpieces. The overturned pink rose, lower right, is likewise a favorite motif of Mantovano's compositions. The previous attribution to Giacomo Recco, while untenable, was notable at least as a recognition of Mantovano's residual archaisms such as the depiction of insects on the flowers.

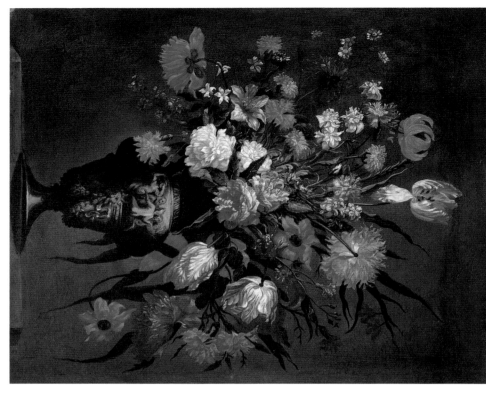

A Blue Vase with a Bouquet of Flowers

Mario Nuzzi, called Mario de' Fiori [?]
(Rome 1603–73)
Oil on canvas, 77.5 × 63.5 cm

Mario de' Fiori was the painter *par excellence* of the baroque bouquet of flowers, achieving such fame that the street where he lived in central Rome still bears his name. Mario's reputation was confirmed as well by the great number of imitators he inspired and by the multitude of paintings that are incorrectly assigned to him. The rediscovery of the inventory of the house of Tommaso Salini at his death in 1625 has confirmed the tradition that Mario was the nephew and pupil of Salini (Pegazzano 1997, pp. 131–146; see also Gregori 1997, pp. 58–63). To his lasting credit, Mario de' Fiori was able to reconcile the Caravaggesque naturalism of his master, Tommaso Salini, with the stylistic innovations of baroque painting. His brushwork combines, almost imitably, a pastose richness with a punctilious touch. Mario's flowers have a scintillating quality that in his best works seems comparable to fireworks seen against a nocturnal sky. This *Blue Vase with a Bouquet of Flowers* comes close to the style of Mario de' Fiori without evincing however the master's brilliant technique. The flowers are experdy described but their overall effect is more static than is expected from the Master. Given our limited knowledge it is not possible at present to determine whether this bouquet of Roman execution around 1630 should be assigned to Mario de' Fiori or to an independent painter under his influence. The blue vase decorated with figures is typical of floral still lifes of the first half of the seventeenth century in Rome and Naples. The motif is cited in several paintings left unfinished by Salini at his death (Gregori 1997, pp. 58–63).

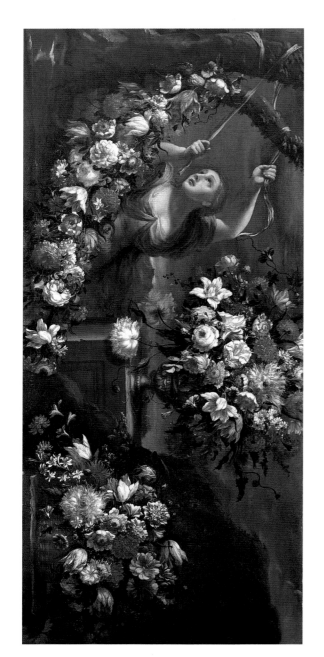

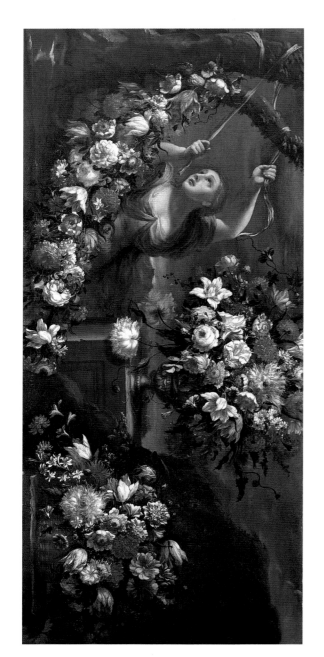

27

A Girl Tying a Festoon of Flowers to a Tree

Giovanni Stanchi
(Rome 1608 – ca. 1673)
Oil on canvas, 97.5 × 220 cm

See the following entry for a biography of Giovanni Stanchi, founder of one of the most important *ateliers* of Roman still lifes (cat. no. 28).

The inventories and documents of seventeenth-century Roman art collections make frequent reference to flowerpieces attributed to Giovanni Stanchi or, simply, 'lo Stanchi'. It is not clear whether Stanchi or Mario de' Fiori, his rival, first specialized in floral garlands and festoons; in any event, these classically-inspired compositions were quickly established as characteristic of Roman Baroque still lifes. Both Stanchi and Mario de' Fiori were able to avail themselves of the collaboration of first-rate painters for the insertion of figures.

This remarkable painting of a *Girl Tying a Festoon of Flowers to a Tree* appears to be an early work by Giovanni Stanchi as it comprises elements that became archaic after around 1640. The desire to display three varieties of floral arrangement takes precedence over the description of a recognizable time and place. The festoon, vase, and basket are equally magnificent, but the elevated position of the vase of flowers makes it seem that Stanchi has judged this most traditional arrangement to be the winner of the competition. The young woman at left, although quite pretty, plays a decidedly minor rôle in the scene.

Fig. 3
Giovanni Stanchi, *Festoon of Flowers*
Rome, Pinacoteca Capitolina

Fig. 4
Giovanni Stanchi, *Festoon of Flowers*
Rome, Pinacoteca Capitolina

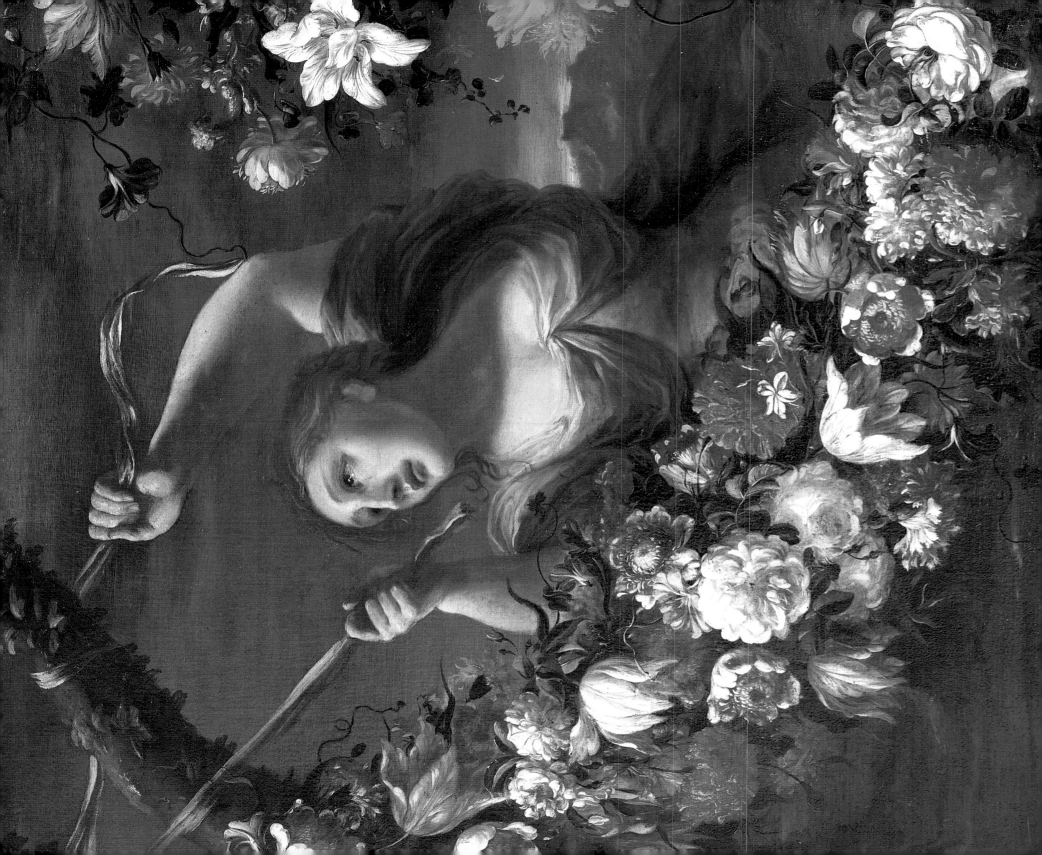

A Sculptured Vase with a Bouquet of Flowers

Giovanni Stanchi
(Rome 1608 – ca. 1673)
Oil on canvas, 96 × 73 cm

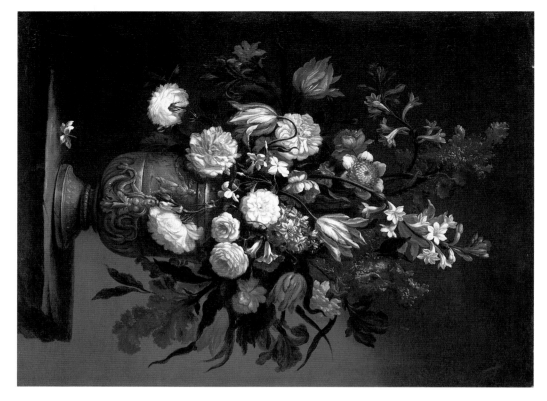

*T*he personality of Giovanni Stanchi, one of the most prominent flower painters of the Roman *Seicento*, remains to be defined. Born in 1608, Stanchi belonged to the same generation of the famous Mario de' Fiori, whose influence on him is readily visible from the similarity between the mirrors painted in the Palazzo Colonna by Nuzzi around 1660 and by Stanchi ten years later (Šafařík 1981, pp. 80–87). Although Stanchi remained, inevitably, in the shadow of his great contemporary, he achieved notable success in his career. He was admitted into the Accademia di San Luca and receiving Barberini commissions by 1638. In the following year he collaborated with Andrea Camassei, one of the Barberini painters, on a large canvas of putti and flowers (cf. *Antologia delle Belle Arti*, 9–12, 1979, p. 194).

His still lifes of fruit and flowers are cited in the Colonna and Orsini collections by the mid-1650s. The last decade of his career saw considerable activity for the family of Pope Alexander VII Chigi. The documentary evidence has been collected by Laura Laureati in an exemplary entry in *La natura morta in Italia* 1989, II, pp. 770–73.

Despite the numerous still lifes that have been attributed in recent years to the Stanchi family, no attempt has yet been made to distinguish between the hands of Giovanni Stanchi and his brother Niccolò (Rome 1623–90 ca.). This situation dates back to their own day to judge from the numbers of paintings listed, simply, as 'dello Stanchi' in the old Roman inventories. Still less is known of their brother Angelo (1623–73 ca.), the youngest member of the Stanchi workshop. As none of their pictures are signed, the only certain attributions are the mirrors painted with flowers by Giovanni Stanchi, with figures by Carlo Maratti, in the Galleria Grande of the Palazzo Colonna, and the mirrors painted by Niccolò, with figures by Ciro Ferri, in the Palazzo Borghese at Campo Marzio.

This monumental *Vase of Flowers* displays sufficient correlations to Stanchi's style as evinced in the two Colonna mirrors to justify its attribution as a fine and characteristic work. Precisely the same repertory of slightly ponderous flowers — pink roses especially — can be found in several paintings attributed since the seventeenth century to 'Stanchi', e.g. the *Garland of Flowers* in the Palazzo Pitti (inv. no. 1691; Mosco, Rizzuto 1988, cat. no. 32); and the *Festoon of Flowers* in the Capitoline Gallery (Sacchetti inv. no. 1726; *La natura morta in Italia* 1989, II, fig. 908). These 'Stanchi' florals have in common their relatively dark and insignificant leaves.

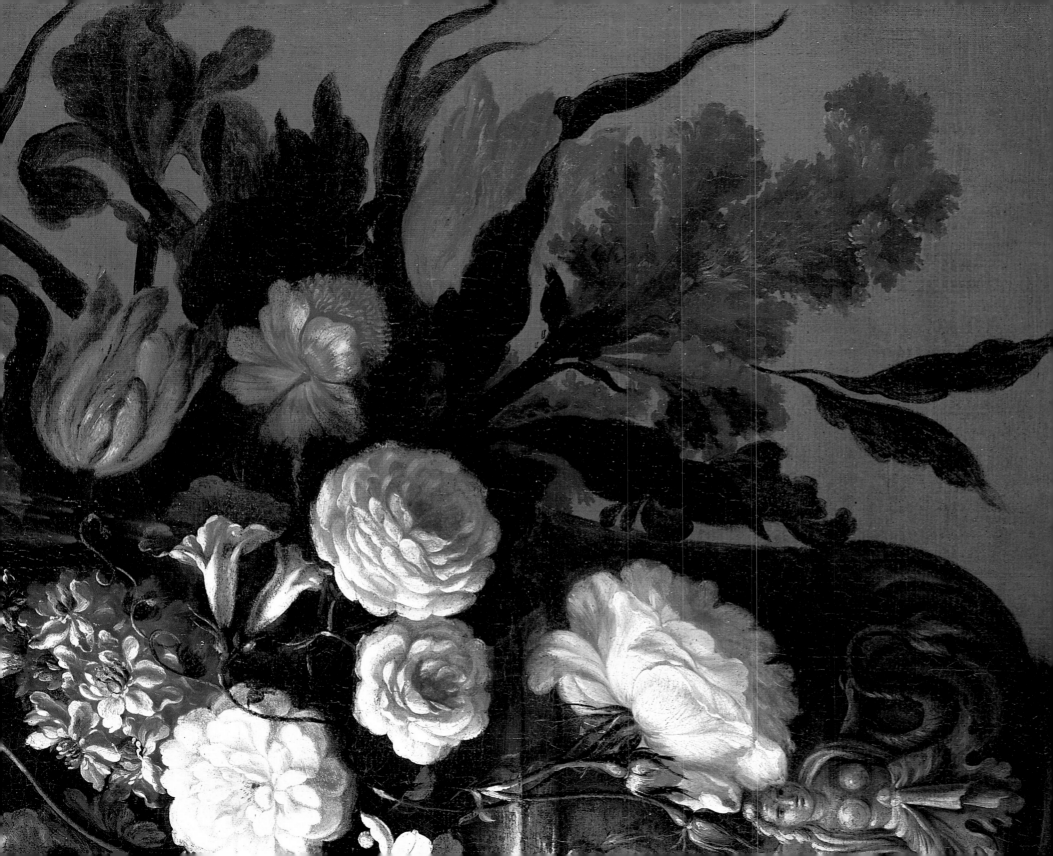

A Vase of Flowers toppled over

Florentine Painter
(mid-seventeenth century)
Oil on canvas, 46.2 × 54.4 cm

A crystal vase, filled to overflowing with brightly tinted flowers, has toppled over. Its pink and white roses, red carnations, white tuberoses, and blue columbines spill out onto the earth. It is the ancient motif of the *cornucopia* translated from fruits to flowers. But good things to eat are not lacking. At the top of the picture, a fresh pomegranate, still glistening with dew, and attended by a pair of purple figs, presides over the scene. The contrasts of deep green and orange/red suggest a Florentine origin this extraordinary still life. Of the numerous painters employed by the Medici during the second half of the seventeenth century, Andrea Scacciati (1642–1710) is the *naturamortista* who most often employed this palette of colors. Yet this picture displays an originality and wit that are the antithesis of Scacciati's grandiose compositions. Bimbi was capable of such charm, perhaps, but his delineated and polished flowers are noticeably different from the sensuous *impasto* of this artist's technique. Finally, one is led to suspect that the inventive and chromatic qualities of this flowerpiece are the attributes of a 'universal' painter who was not a specialist in this subject.

A Sculpted Vase with a Bouquet of Flowers

Andrea Scacciati
(Florence 1642–1710)
Oil on canvas, 95 × 72 cm

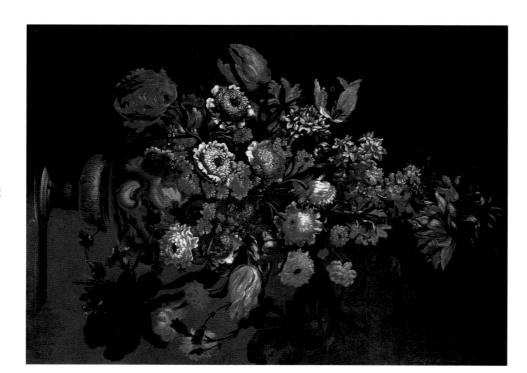

Andrea Scacciati and Bartolomeo Bimbi were the principal flower painters in the service of Cosimo III and *gran principe* Ferdinando de' Medici at the end of the seventeenth century. Giovan Camillo Sagrestani (1660–1731) wrote a useful biography of Scacciati: 'Before a flower painter dedicates himself to the practice of his art, he should learn first to paint the human figure in order to be able to give the sense of volume that flowerpieces require. This is in fact what Scacciati did, going first to learn from Mario Balassi and then from Lorenzo Lippi, who exhorted him to study from nature every type and quality of flower. This Scacciati did, and when he began to paint pictures, he was very soon the best flower painter in Florence, engaged by many nobles and gentlemen. Scacciati moved his activity to Leghorn for many years, but tiring of that place he returned to Florence where he was employed by the grand duchess Vittoria della Rovere.' (C. C. Sagrestani, *Vite dei pittori*, Ms. Pal. 451, Firenze, Biblioteca Nazionale; transcribed by Piero Bigongiari 1982, p. 163)

Scacciati adapted for Florentine tastes the exuberant bouquets in sculpted vases characteristic of Roman Baroque flowerpieces by Mario de' Fiori and Giovanni Stanchi. Although the chronology of Scacciati's pictures has yet to be examined, this fine example presumably dates from relatively early in his career as it retains a Roman monumentality, especially evident in the sculpted relief of sea tritons on the vase. As the years passed, Scacciati tended to embellish his flowerpieces, moistening the leaves and stems with drops of water and depicting golden vases.

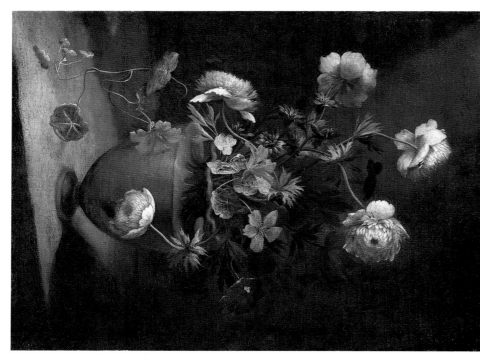

Vase of Anemones and Other Flowers

Nicola van Houbraken
(Messina 1660 – Leghorn 1723)
Oil on canvas, 63.5 × 48 cm

*B*orn in Messina, Nicola van Houbraken was the nephew of Jan van Houbraken, a pupil of Rubens, who moved to Sicily in 1635. After the family's transfer to Leghorn in 1674, Nicola van Houbraken matured into one of Tuscany's leading still life painters. Several of his paintings of fruit and flowers were included in the 1706 and 1729 exhibitions on the feast day of San Luca in the cloister of the Santissima Annunziata, Florence. His name can also be found in Medici inventories rendered variously as Niccolino Vanhoubraken, Niccolò Vanderbrach, Van Bubrachen, Wanoubraken, Valdubrochen and Nicola Messinese.

Van Houbraken shows his Netherlandish origins in his preference for wildflowers and the sharp edges of his foliage. Many of his known works have affinities to the *sottobosco* paintings of Otto Marseus and Matthius Withoos who were also active in Italy. Unlike those Dutch artists, Van Houbraken never painted animals and insects.

This charmingly informal *Vase of Anemones and Other Flowers* is the first bouquet by Van Houbraken to come to light and thus constitutes a notable addition to his *œuvre*. The artist's characteristic tonalities of red, green and brown emerge from a suggestive *penumbra*. The flowers and vines spill out of the terracotta vase in every direction, as if they are alive and in movement. Even the foreground is invaded as a bluish vine and a red and white anemone seem to reach out to the viewer. Similar anemones can be seen in some of the still lifes by Van Houbraken recently published by Gianluca and Ulisse Bocchi (1998).

Still Life with Flowers and Cherries

Milanese Painter of the circle of Vicenzino

(active ca. 1690–1700)

Oil on canvas, 73 × 91.5 cm

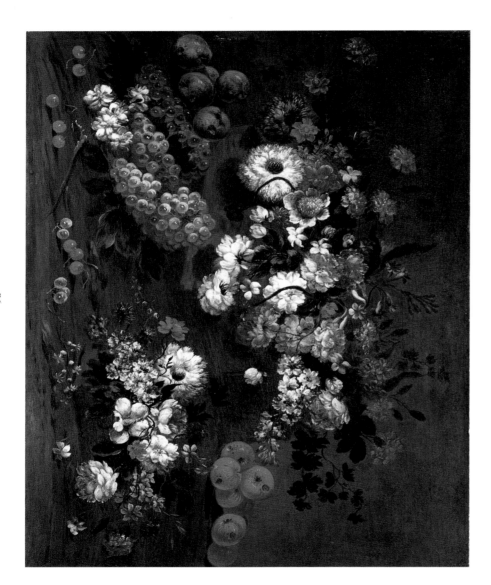

T his triumphant display of brightly tinted anemones, roses, carnations, cherries, and other fruits and blossoms scattered haphazardly on the bare earth is representative of the high quality of Milanese still lifes during the heyday of the 'Vicenzino' dynasty of painters. Perhaps the grapes are too evenly painted — every one on the bunch identical to its neighbor — and the green leaves not sufficiently scintillating to reach the heights of a Giuseppe Vicenzino, but this artist was well aware of the *capsicuola*, and possibly even trained by him. The diaphanous, fragile petals of the roses and the massing of the plucked flowers in simple wooden gardening boxes show his awareness of Vicenzino's early style such as the signed work illustrated by Ulisse and Gianluca Bocchi (1998, fig. 111) in a private collection in Cremona.

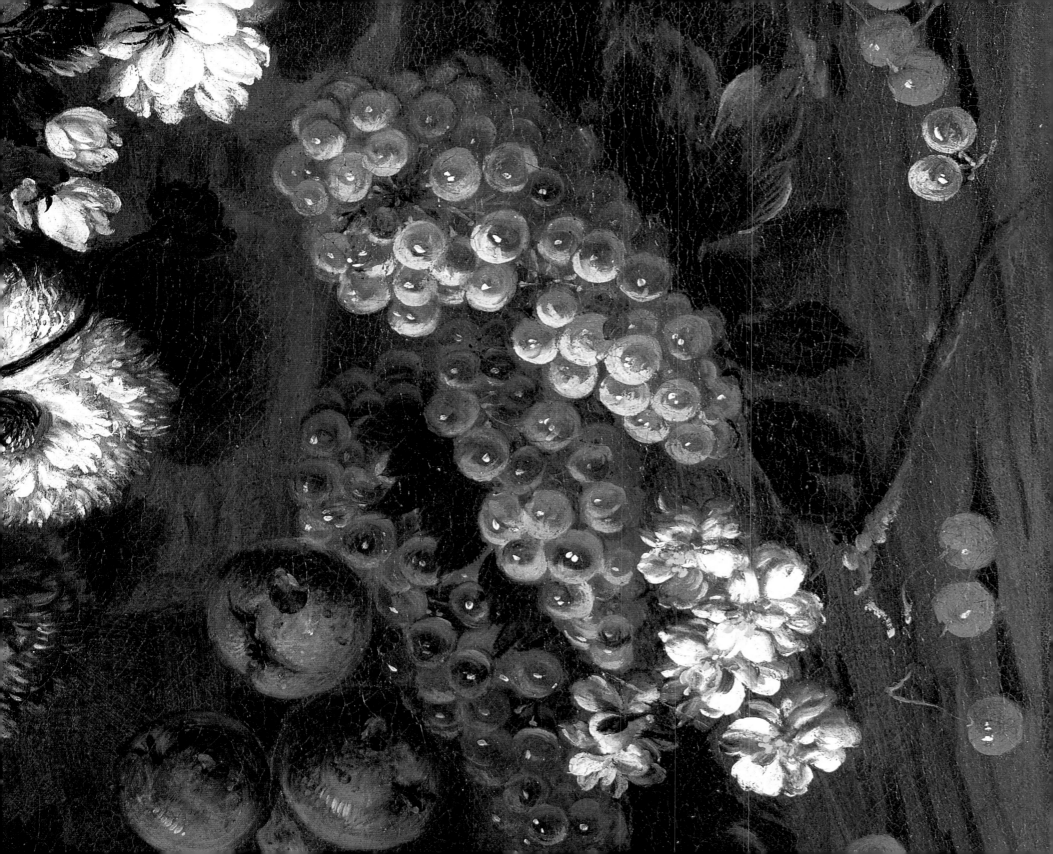

Two Vases, a Platter and a Basket of Flowers
Two Vases, a Platter and a Basket of Flowers

Elisabetta Marchioni
(Rovigo † 1700 ca.)
Oil on canvas, 144 × 190 cm each

Elisabetta Marchioni was an accomplished and prolific painter of flowerpieces that are admirable for their proto-Rococo exuberance. The scarse information regarding her life and career has been helpfully summarized by Eduard Safarik (*La natura morta in Italia* 1989, p. 329). She seems to have lived quietly in Rovigo, contentedly providing decorative still lifes for the leading houses of the city. A single exception was a floral *paliotto* (altar frontal) that she donated to the Capuchin church, preserved today in the Pinacoteca della Accademia dei Concordi in Rovigo (Bartoli 1793, pp. 318-19). This *paliotto* enabled scholars to distinguish between the still lifes by Marchioni and by her contemporary Margarita Caffi (Milan 1647 [?]-1710), which had long been confused. As Caffi was a prominent member of a celebrated family of still life specialists – she was the sister of Giuseppe Vicenzino – it seems likely that she was the originator of the style that Marchioni practiced faithfully throughout her career. The still lifes of these remarkable *pittrici* were important influences on Francesco Guardi's flowerpieces of the later eighteenth century.

These hitherto unpublished pair of still lifes are praiseworthy examples of Marchioni's spontaneous, almost improvisational, approach. As is most of her compositions, the painter has placed the vases, platters, and baskets on two levels in order to fill the entire painted surface with flowers. The bouquets are composed of a fanciful mixture of roses, carnations, tuberoses, and variegated tulips rendered with the artist's customary freedom and vivaciousness. Marchioni's flowers always give the impression of having been invented at the very moment of their execution, as opposed to being copied from nature. She must have prided herself on her capacity to make endless variations on her favorite theme without ever repeating herself exactly. No two roses by Marchioni, however similar, are precisely the same. By the same token, she painted similar vases in nearly all of her pictures but always with slight variations in the *repoussé* ornamentation.

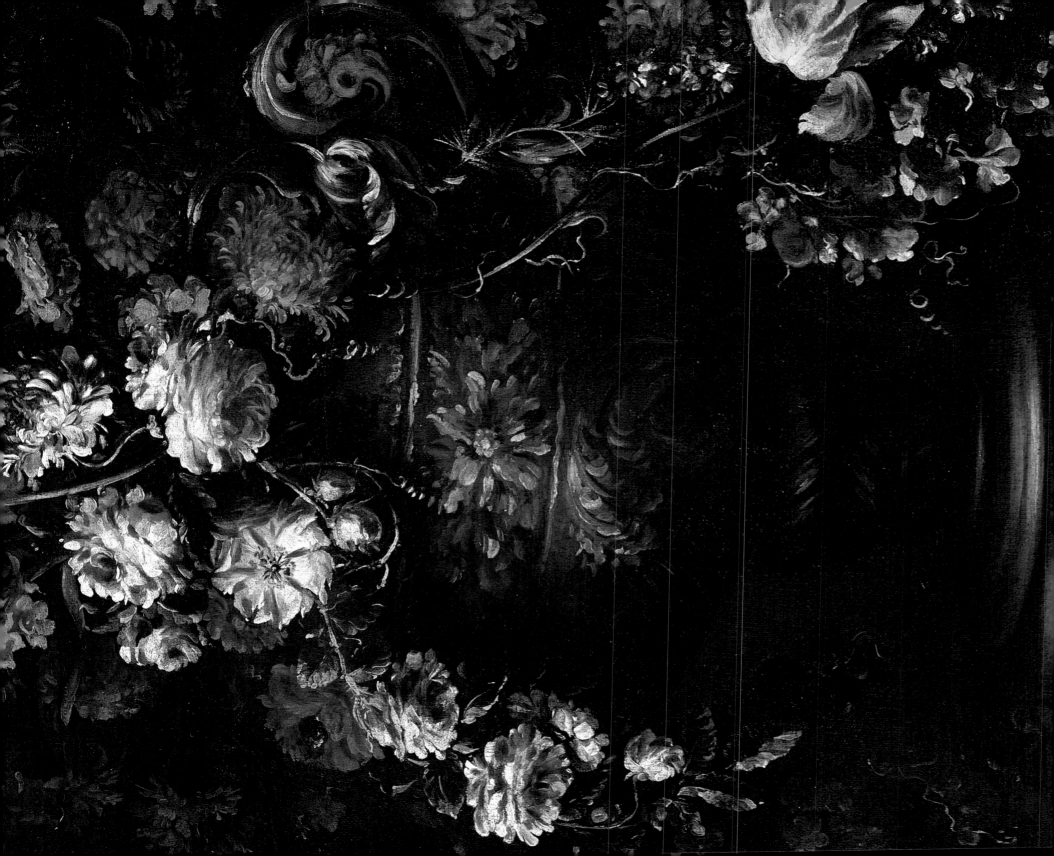

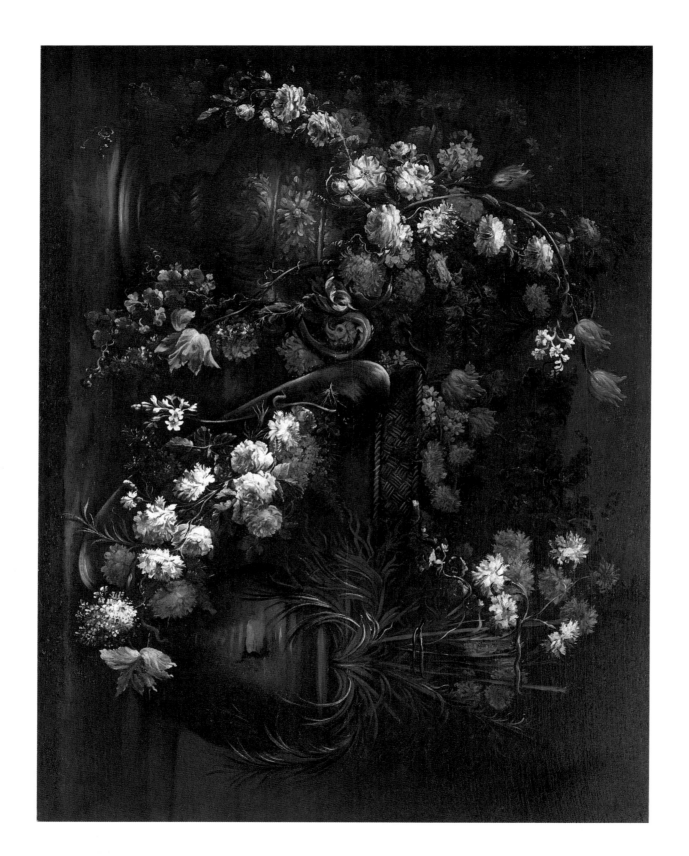

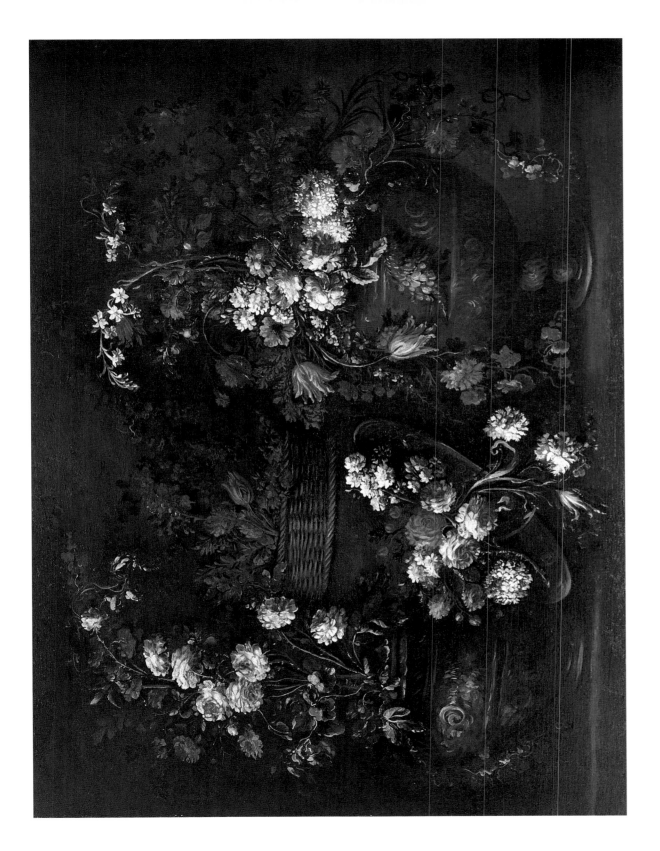

Nature's HARVEST

Young Woman with Harvest Fruits

Pittore della Vendemmiatrice
(active in Cremona, ca. 1600)
Oil on canvas, 94 × 73.5 cm

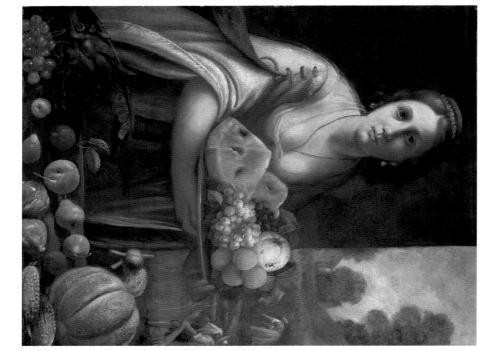

*T*his remarkable painting of a *Young Woman with Harvest Fruits* (*Vendemmiatrice*) brings together a cross-section of the artistic currents in North Italian painting around 1600. It is not certain, in fact, that this picture was executed by a single artist, whom we have called the Pittore della Vendemmiatrice. For example, it is difficult to reconcile the strongly contrasted realism of the melons, cucumbers, peaches and pears in the foreground with the more conventional, and decorative, treatment of the fruits held on the platter. By the same token, the beautiful girl is portrayed with the blandness typical of late sixteenth-century 'reformed Mannerism', while the wheat harvesters glimpsed in the background are broadly and freshly rendered in the Venetian way (Pozzoserrato, for one), which Annibale Carracci introduced into Bologna.

The *Young Woman with Harvest Fruits* displays tonalities of yellow and green, contrasted with deep brown shadows, that suggest that the Pittore della Vendemmiatrice was active in Cremona or in some other crossroads on the Po river plain. The fruits and cucumbits in front of the girl comprise a Caravaggesque still life of a precociously early date. A Caravaggesque still life containing remarkably similar cucumbers and melon was long attributed to Bartolomeo Manfredi, who was born in Ostiano, between Cremona and Casalmaggiore (*La natura morta italiana* 1964, cat. no. 33; private collection). The Manfredi attribution was abandoned upon the discovery of another version including a figure of a girl eating grapes (Cottino 1995, fig. 10); the girl appears to have been painted by a Bolognese artist, which confirms that these still lifes were painted north of the Appennines.

There is evidence that the *Vendemmiatrice* was in prominent Florentine collection in the early seventeenth century. Mina Gregori (1986, fig. 20) published a large *Rinfresco* (private collection) by an anonymous Florentine painter, close to Jacopo Vignali, in which the figure of the girl holding a tray of fruit is carefully copied.

Fig. 5
Bartolomeo Manfredi,
attributed to, *Still Life of Fruits*
Milan, private collection

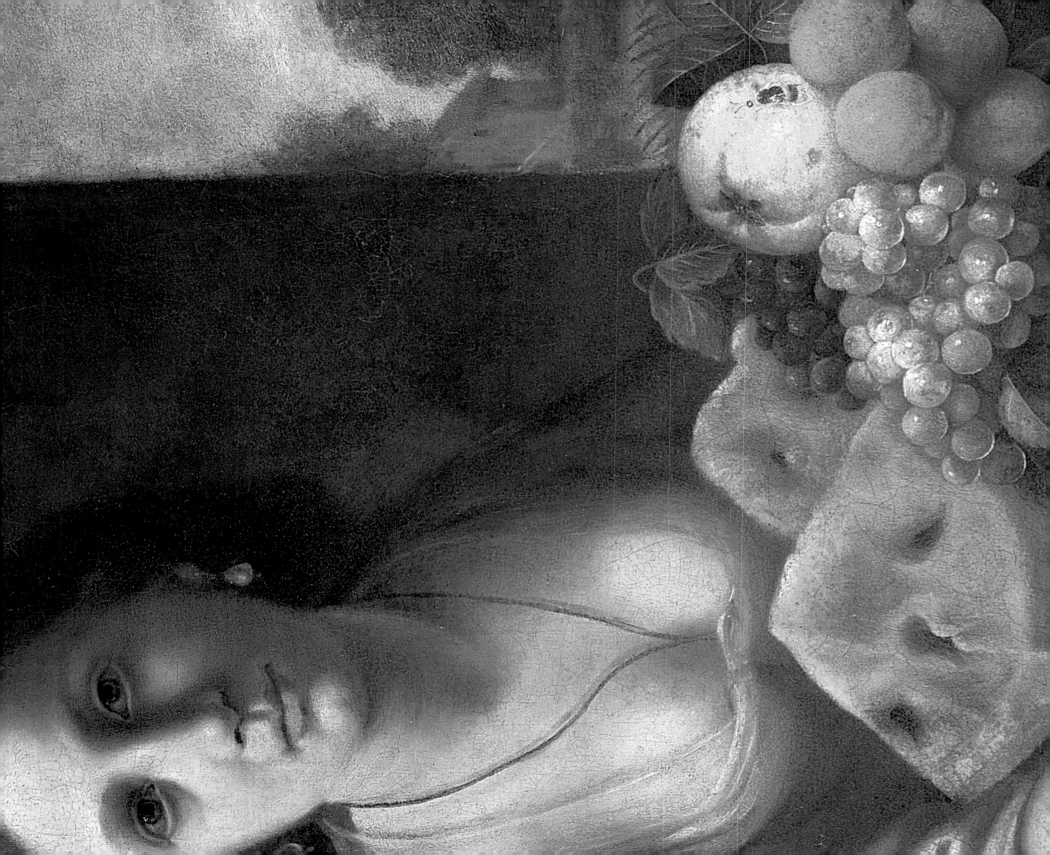

Fruits, a Partridge and a Boar's Head

Jacob van de Kerckhoven,
called Giacomo da Castello
(Antwerp 1637 – Venice 1712)
Oil on canvas, 73 × 99.5 cm

V an de Kerckhoven was trained in the Antwerp workshop of Jan Fyt (Antwerp 1611–61), a celebrated painter of game and hunting still lifes, who evidently encouraged his pupils to take the road to Italy, as he had as a young man, and as Fyt's own master, Frans Snyders, had done before him. Fellow pupils, David de Koninck (1636 [?]-1701) and Pieter Boel (1622-74), established their workshops in Rome and Genoa, respectively, while Van de Kerckhoven had transferred to Venice by 1685. The Italians simplified his name to Giacomo da Castello, in reference probably to the area of Venice where he lived for the rest of his long and productive life. Van de Kerckhoven was one of the painters patronized by John Cecil, the fifth Earl of Exeter, during his Grand Tour of Italy in 1684. He commissioned two large compositions of exotic birds (Safarik and Bottari in *La natura morta in Italia* 1989, figs 423, 424), which though executed in the artist's mature technique reveal the influence of Carl Ruthart (see cat. no. 9). Probably more than a hundred of his still lifes of game, fish, and fruits have been identified although their chronology has yet to be understood. It seems clear that he proceeded from the Flemish naturalism in which he was trained to a brilliantly decorative style that imbues the forms with an almost metallic sheen.

This unpublished *Fruits, a Partridge and a Boar's Head* is composed in the carefully deliberated style of Caravaggio, which makes it an especially interesting rediscovery. Van de Kerckhoven usually followed Jan Fyt's manner and depicted dead game and birds in casual heaps on the ground as if in the aftermath of a hunt. In this remarkable picture, by contrast, the game and fruits are displayed on a monumental stone ledge and then illuminated with a focussed ray of light that descends from the upper left. The reference to such antecedents as the *Fruit on a Stone Ledge* by Caravaggio (Spike, 2001ª, cat. no. 35) is so precise as to suggest that Van de Kerckhoven had occasion to see the original in the palazzo Barberini during an unrecorded visit to Rome. As Barone Paolo Sprovieri, a noted *gourmand*, has kindly pointed out, the provisions in this still life would be just enough for a dinner for two persons. The freshness of the meat is demonstrated by the glistening traces of blood beneath the beast's neck. The head was prized especially by hunters for the brains which were roasted on a grill. It appears that Van de Kerckhoven wished to call attention to this delicacy by the subtle and amusing device of placing two pomegranates, with their lobes emphasized, directly on top of the boar's cranium. The boar's head is a leitmotif that Van de Kerckhoven depicted at every stage of his career, including his earliest known still life, dated 1661 (Safarik and Bottari in *La natura morta in Italia* 1989, fig. 422). The fur of the beast is rendered in thick brushstrokes almost indistinguishable from Fyt's. Almost identical representations of a boar's head appear in still lifes in private collections published by Proni (in Bocchi, Bocchi 1998, figs. 576 and 585) and by Pallaga (Godi 2000, cat. no. 98).

Flowers, Fruit, Mushrooms, a Parrot and a Monkey

Abraham Bruegel
(Antwerp 1631 – Naples 1697)
Oil on canvas, 89 × 98.5 cm (oval)

Born in Antwerp, the son of Jan Bruegel II, Abraham Bruegel was the last distinguished representative of the artistic dynasty founded a century before by Pieter Bruegel the Elder. Abraham was inscribed in the painters' guild in Antwerp in 1655, but no works from his pre-Italian career have ever been identified. By 1659 he was already resident on the via del Babuino in Rome. Don Antonio Ruffo in Messina became an important patron almost immediately after his arrival; Bruegel is believed to have visited Sicily twice, in 1663–64 and 1667–68. Bruegel's letters to Ruffo contain vivid descriptions of the Roman art world, 1665–71, as he relates that he has painted still lifes with figures by Giacinto Brandi and Giovanni Battista Gaulli, called Baciccio. He also collaborated with Carlo Maratti, the leading painter in Rome. Bruegel was admitted into the Accademia di San Luca in 1670, and the Congregazione dei Virtuosi al Pantheon a year later. His presence in the Eternal City is last recorded on September 17, 1673; in 1675 a son was born to him in Naples. Bruegel's arrival in Naples signalled the irresistible advent in the local school of the unabashedly decorative mode of still life painting that had evolved by that date in Rome,

largely through his own efforts. A complete catalogue of his paintings has not yet been attempted, but is very much to be desired.

The parrot and monkey in this still life are characteristic motifs that Bruegel would repeat and develop throughout his long and prolific career. Their presence in this very early painting helps to undersore both the artist's Netherlandish roots and the fact that it was Bruegel who revived these motifs in Roman painting. This casual composition of *Flowers, Fruit, Mushrooms, a Parrot and a Monkey* represents an important addition to his *oeuvre* as it belongs to the artist's first activity in Rome, before he had fully assimilated the freer and more sensuous technique of Michelangelo Campidoglio. These paintings, of which the present is one of the first to be published, must date prior to 1670, when Bruegel signed and dated a still life (Rijksmuseum, Amsterdam) executed in his mature style. The roses and grapes in the present picture are closely comparable to their counterparts in the pair of *Garlands* (Palazzo Corsini, Rome), which are also considered early works. The oval format of the canvas is demonstrably original; it is very likely that the still life was made to be inset in the decoration of a wall.

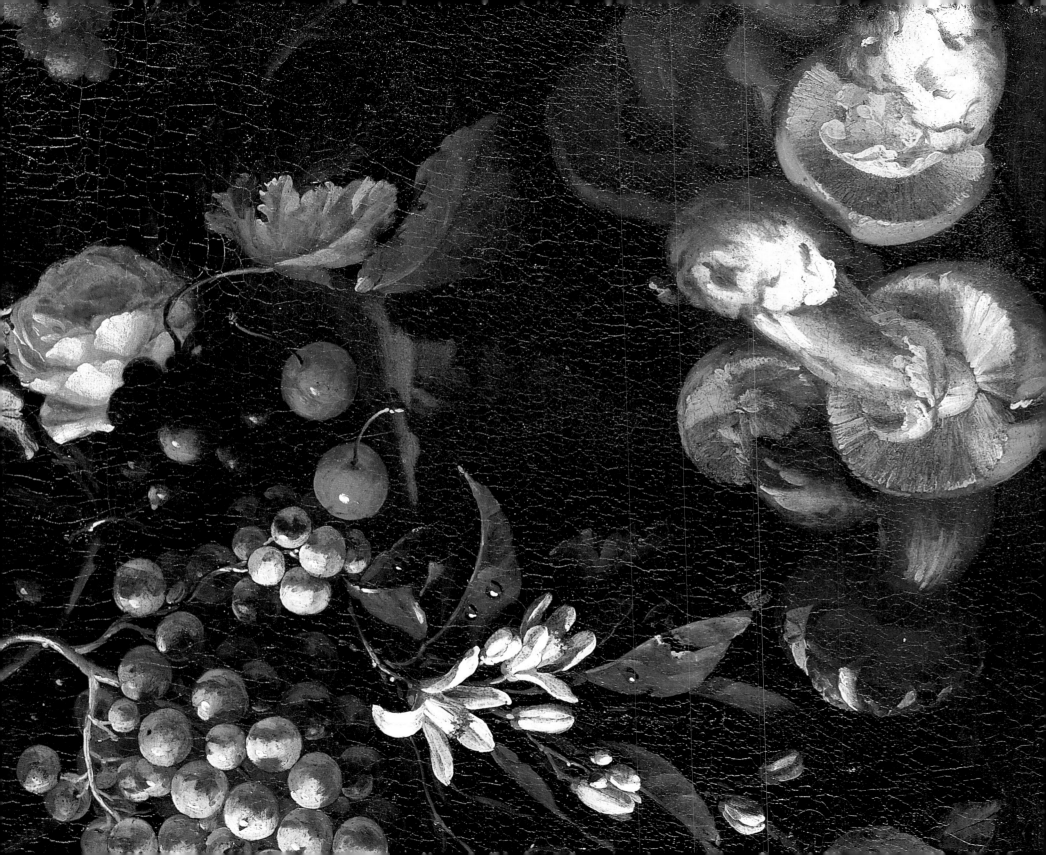

38

Fruits and Flowers in a Glass Vase in a Landscape

South Italian Painter
(second half of the seventeenth century)
Oil on canvas, 73.5 × 100 cm

*T*his exuberant depiction of sweet fruits (melons, peaches, grapes, and plums) and pretty flowers is not easy to place in a specific school, although its rapid, somewhat sketchy seems typical of the later seventeenth century.

The romantic view of mountains and cliffs in the distance is a motif that first appears in Neapolitan still lifes around 1640; the incongruousness of placing a fancy bouquet in a crystal vase directly on the rough earth is reminiscent of Neapolitan compositions after the arrival of Abraham Bruegel in 1675; indeed, there are certain affinities to the style of the Metropolitan Master, a Bruegel follower; meanwhile, the green grapes, elbow-shaped, are a variety rarely found north of Rome.

On the other hand, our anonymous painter does not exhibit the technique of a native Neapolitan, nor can he be identified among the well-known masters of that school: his touch is more pastose and less luminous than that of the Neapolitans, who were permanently impressed by Luca Forte and the other early Caravaggists. The slice of watermelon, for example, is invitingly tactile, and playful to the eye, without glistening with drops of water in accord with Parthenopean tastes.

Compared to the Metropolitan Master, moreover, our painter does not demonstrate the sophisticated self-awareness of an artist working in either Rome or Naples. For the time being, then, in view of our limited knowledge of still life painting south of Rome, including Sicily, but not Naples, the attribution of this charming example must remain to a *pittore meridionale* still to be discovered.

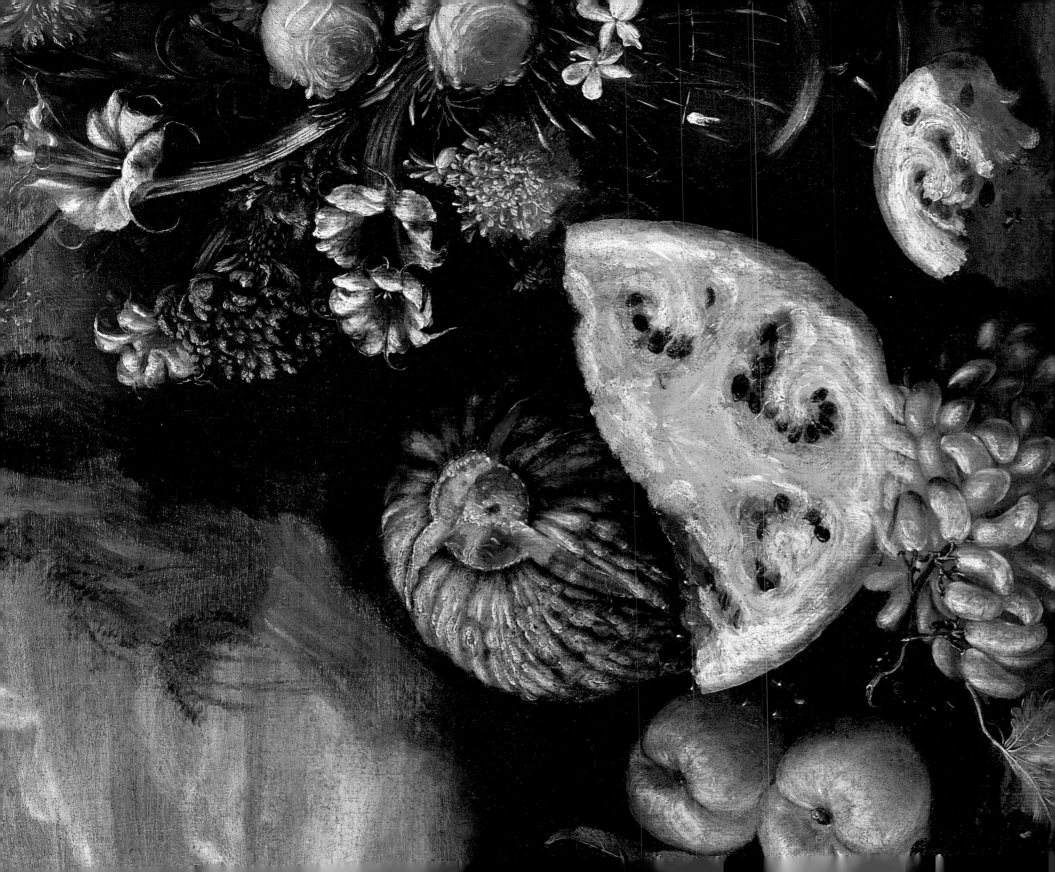

Watermelon, Lemons, Plums and a Peach

The 'Metropolitan Master'

(1700 ca.)

Oil on canvas, 28.5 × 46.5 cm

The reverse of the canvas bears a collector's mark
in red wax seal: 'FSS'

*T*his vigorous canvas invites comparison to the two following pictures (cat. nos. 40, 41) as it also has the characteristic dimensions and horizontal format of a *sovrapporta*, that is, a painting placed above a door. The stylistic differences between the two still lifes tend to confirm the Roman character of *Grapes, Pomegranates and Pears* and suggest a Neapolitan origin for this vivacious *Watermelon, Lemons, Plums and a Peach*. The Parthenopean still lifes are distinguished for their playfulness: the fanciful swirls of the pink-and-white watermelon are a case in point. Neapolitan painting is characterized, moreover, by a more pronounced chiaroscuro. The highlights on the leaves and plums have a decorative liveliness that does not contribute to the modelling of the forms.

The attribution to the 'Metropolitan Master' serves to identify this painter as a follower of Abraham Bruegel, but the assignation must remain hypothetical until the activity of the 'Metropolitan Master' receives a clearer definition. Raffaello Causa gave this name to the painter on the basis of a painting in the reserves of the New York museum (as the picture was subsequently de-accessioned, its current whereabouts are unknown). For Causa (1972, pp. 1019 and 1048) and Trezzani (1989, p. 784) the Master was Neapolitan, a follower of either Ruoppolo or Bruegel. The problem is exacerbated, of course, by the fact that Bruegel transferred his activity from Rome to Naples in 1675. Other scholars have pointed out that certain paintings attributed to the 'Metropolitan Master' are unmistakably Roman, showing affinities both to Bruegel and to his predecessor, Michelangelo Campidoglio (see Bocchi, Bocchi 1992, pp. 222–25, and for additional bibliography). This arcane discussion among the specialists is a separate matter from the simple and unpretentious delightfulness of this small canvas.

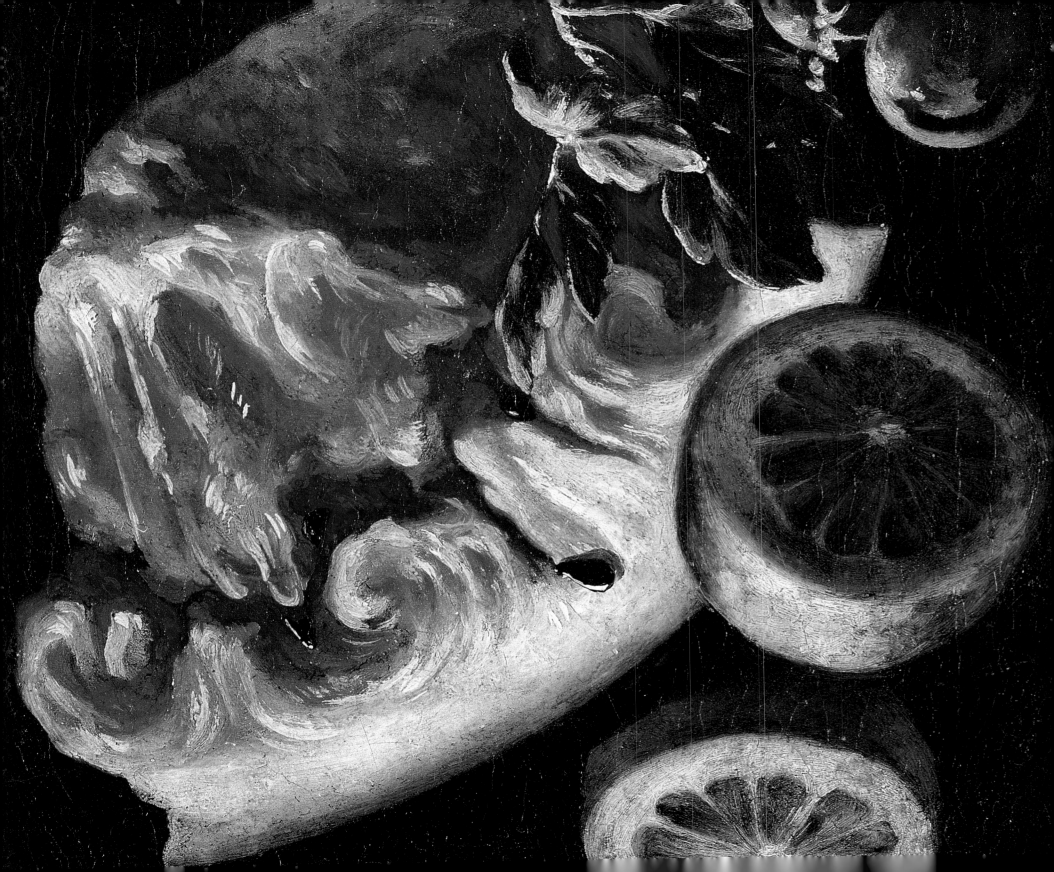

Pomegranates, Grapes and Figs

Franz Werner von Tamm,
called Monsú Daprait
(Hamburg 1658 – Vienna 1724)
Oil on canvas, 41 × 65.5 cm

Von Tamm was the most important still life specialist of his epoch, and one of the few to gain an international reputation. He arrived in Rome during the 1680s and quickly achieved a preeminent position in that city. His paintings were admired by Carlo Maratti, the Roman *caposcuola*, who was content to collaborate with Von Tamm in numerous compositions of figures and still lifes. In 1736 Pascoli dedicated a long biography to him, which begins by noting (p. 368): 'His works have travelled throughout Europe, and there is not a distinguished or tasteful house that does not have and esteem them.' To judge from the abundant references to still lifes by 'Monsú Daprait' (meaning *bravo*) in Italian inventories, Pascoli's remark was not an exaggeration. Von Tamm contributed to his wider fame by leaving Rome to go to Vienna where he was in the service of Emperor Leopoldo by 1701. He also worked extensively for Prince Joann Adam Andreas von Liechtenstein, who was well informed on the most important trends in Italian painting.

This compact, yet monumental still life is a fine and characteristic work by Von Tamm. The chronology of Von Tamm's pictures has yet to be studied, but it seems probable that the present work was executed soon after his arrival in Rome, to judge from its close relationship to the still lifes by Roman artists of the previous generation. Von Tamm has adopted from Abraham Bruegel, for example, the motif of a massive pomegranate in the foreground, dramatically split open, which Bruegel had previously learned from Michele Pace, called Campidoglio. On the other hand, the other pomegranates and the green grapes are executed in a technique influenced from Cerquozzi. Von Tamm's own personality emerges most clearly in the overall blue and green tonality of the composition and in the treatment of the figs in the foreground shadow. Von Tamm is content to display the figs' deep tones of purple and green without emphasis on their three-dimensionality.

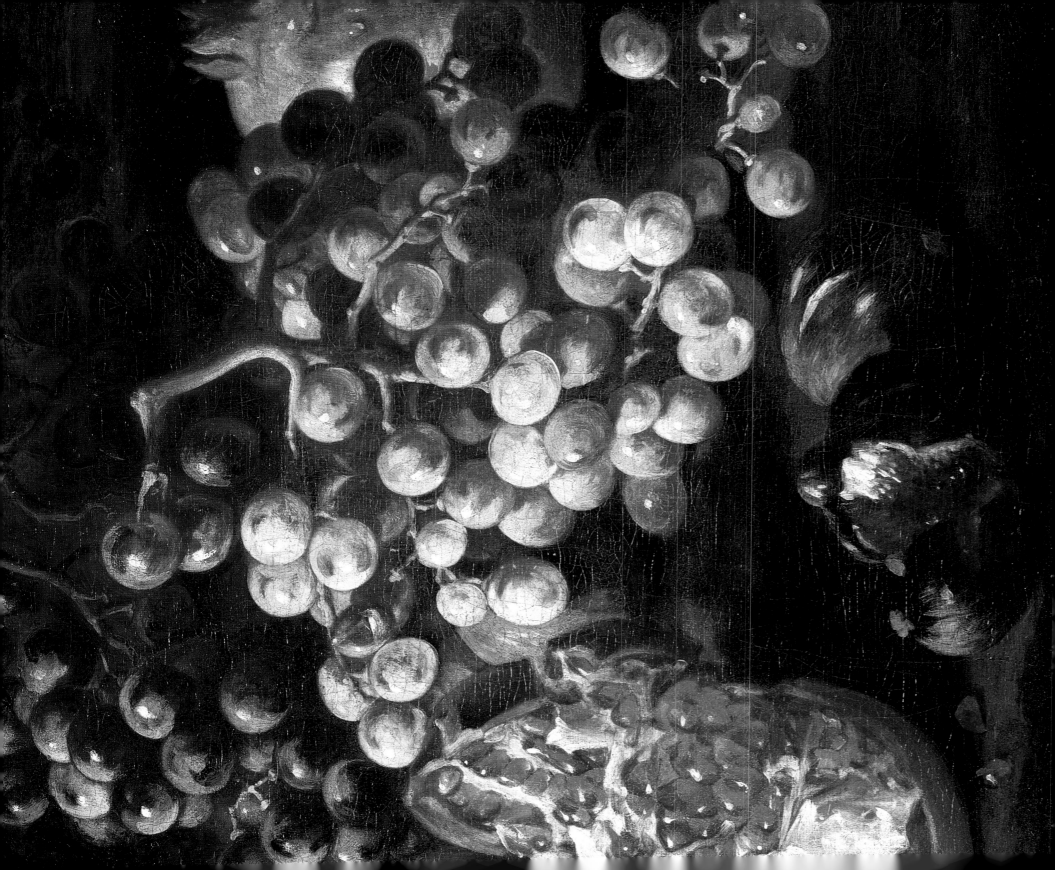

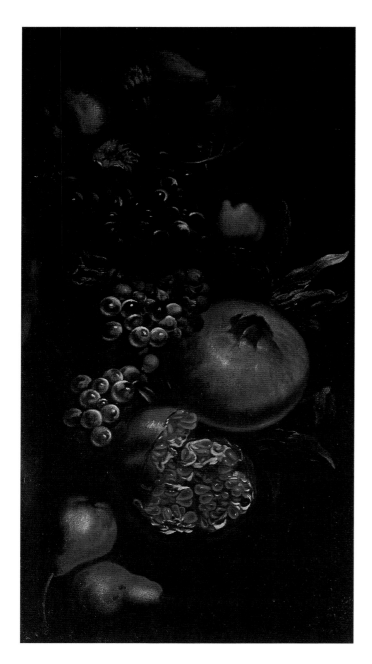

41

Grapes, Pomegranates and Pears

Roman Painter
(1675 ca.)
Oil on canvas, 39,2 × 69 cm

S till lifes achieved the apex of their popularity at the end of
the seventeenth century and early in the eighteenth, when
they became the most favored decorations for the grandiose
palaces of Rome. The compact dimensions and horizontal orien-
tation of this *Grapes, Pomegranates and Pears* are characteristic
of compositions made to be placed above a door. Often these
were made in sets according to the number of chambers and
doors to be decorated. After 1675 ca, the inventories of the
Colonna, Pamphilj, and Pallavicini palaces and villas, to name a
few, abound with references to such still lifes. As few artists
signed their canvases, most of these paintings were already
anonymous in the earliest documents.

This *Grapes, Pomegranates and Pears* was painted by an able
specialist who was well versed in the Roman Baroque tradition
of cascading grapes and sliced open pomegranates. The earlier
generation of Cerquozzi and Campidoglio had been succeeded
by an extraordinary phalanx of still life specialists, among them,
Abraham Bruegel (who had since transferred to Naples), Franz
Werner von Tamm, Maximilian Pfeiler, Pietro Navarra, the
Spadino family, and many other ateliers which are as yet anony-
mous. This anonymous painter seems to mediate between influ-
ences from the Spadino family, e.g. the white highlights on the
black grapes, and from von Tamm, e.g. the tendency to place a
prominent motif (the pomegranate) in the center of the picture.

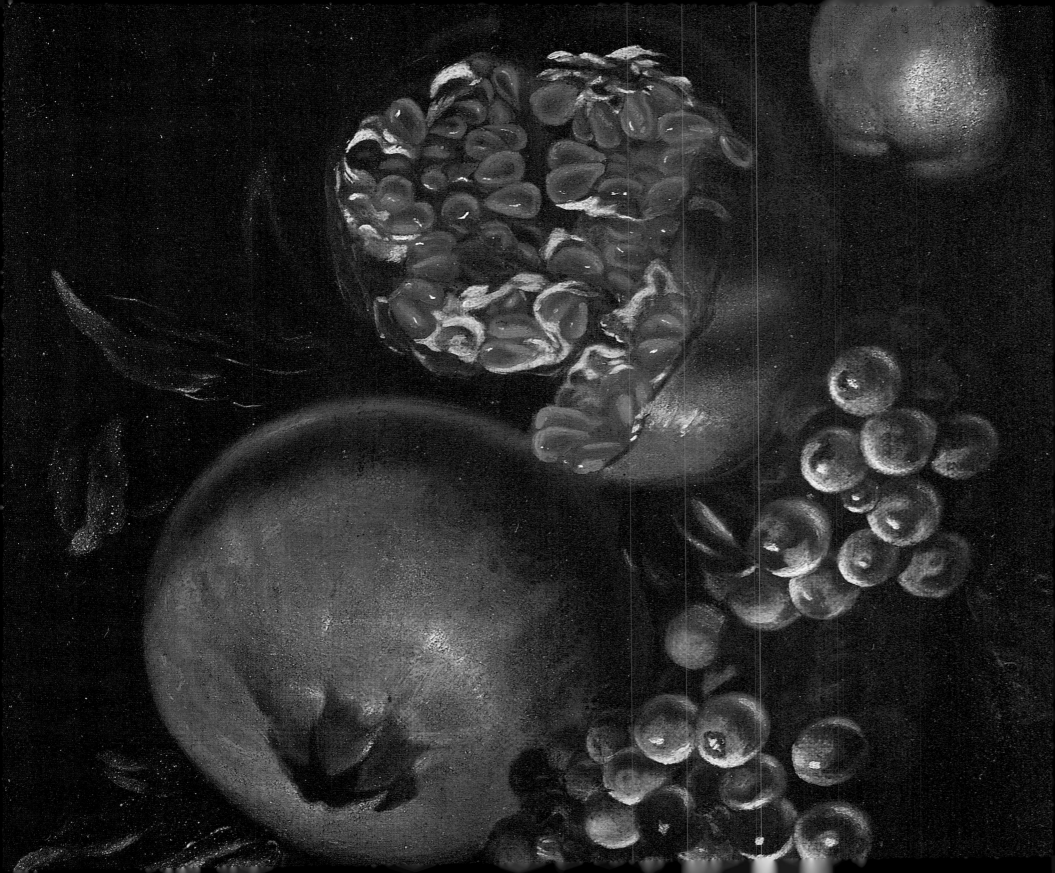

A Gilt Vase with Flowers and Fruits

Giovanni Saglier, attributed to
(active in Milan, in the late seventeenth century)

Oil on canvas, 37.5 × 48 cm

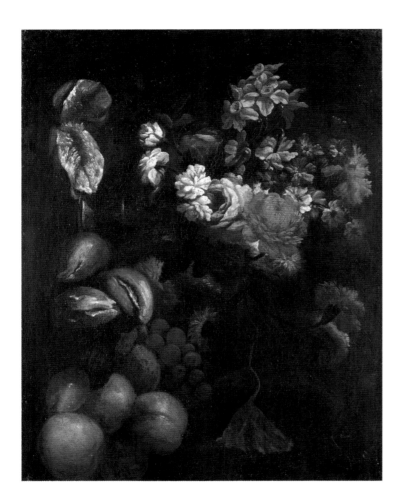

S tudies of the still life painter Giovanni Saglier only began in 1989 with an initial publication by Alessandro Morandotti. Saglier seems to have passed nearly all of his career in the service of Vitaliano VI Borromeo, who employed him in numerous capacities in the decorations of his palace on the Isola Bella in Lake Como from 1660 to 1690. Fifty still lifes of flowers and fruits by Saglier are listed in the inventory compiled after Borromeo's death in 1690. The floral decorations on the walls in the Throne Room and in the Sala della Regina were probably also painted by him. On the basis of his works at Isola Bella, and of those plausibly attributed to him by Ulisse Bocchi (1998), Saglier formed his style in emulation of Giuseppe Vicenzino and was also aware of the Roman flowerpieces of Mario Nuzzi.

This intimate still life is one of the first compositions containing both fruits and flowers to be attributed to Saglier although we know from the Borromeo inventory of 1689 (Morandotti in *La natura morta in Italia* 1989, p. 251) that he painted many of them. Comparative examples of fruits from his brush are therefore lacking, and it is on the basis of the bouquet that the attribution is proposed. We find here Saglier's favorite repertory of flowers – deep red carnations, pink roses, and yellow jonquils –rendered with his accustomed breadth and density of oil pigments. The tonalities and contrasts are unmistakably influenced by the Volo-Vicenzino family of painters.

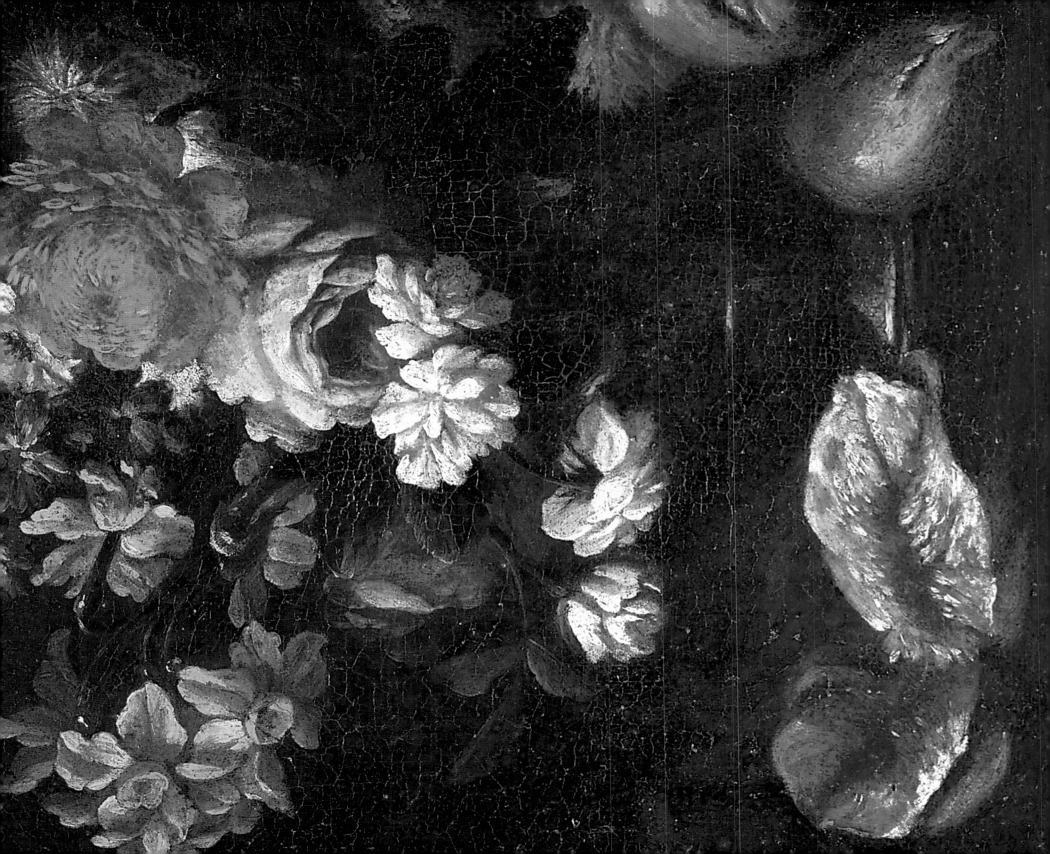

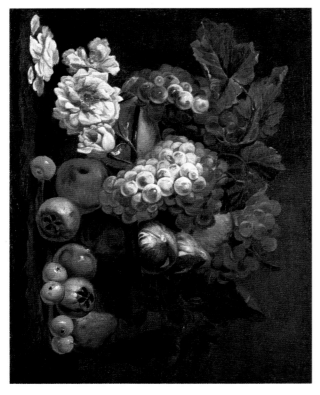

43

A Glass Bowl with Fruit and Roses

Giuseppe Vicenzino
(Milan 1662 – *post* 1700)
Oil on canvas, 34.5 × 43.5 cm

Giuseppe Vicenzino was the most talented still life specialist in Milan at the end of the seventeenth century; his sensuous, almost mysterious, vision of glistening leaves emerging from deep darkness was imitated by painters throughout Lombardy and North Italy. Recent researches by Vittorio Caprara and Giorgio Fiori have successfully lifted the veil of darkness that formerly covered the life and artistic formation of this important artist (see Bocchi, Bocchi 1998, pp. 63–132, for an excellent and copiously illustrated study of this new information). Vicenzino was the son and pupil of Vincenzo Volò (1606–71), a French painter who transferred to Milan towards the middle of the century. The Volò family came to comprise a dynasty of still life painters, Giuseppe Vicenzino (as he signed it; also known as Vincenzino) was the younger brother of Margherita Vicenzina (Volò) Caffi. The preciosity that characterizes the canvases by the Volò family can be ascribed no doubt to the French origins of the dynasty founder.

Typically Lombard in its pastel tints of violet, pink and green, this diminutive masterpiece is a remarkably intimate expression from the brush of Giuseppe Vicenzino. The rose and rose petals in the left foreground pay tribute to a great predecessor, Fede Galizia, whose still lifes endowed the motif with an unforgettable poignancy. Indeed, the composition as a whole conveys an affectionate reappraisal, from a Baroque perspective, of the small panels and canvases by Galizia and Panfilo Nuvolone, which invariably depict a bowl of fruit isolated on top of a table with one or two other fruits or flowers seen alongside. In this amusing updating of the austere still lifes of the early seventeenth century, the profusion of grapes, figs, leaves, pears, brown medlars, and red azaroles practically hide from view both the glass bowl and the stone ledge.

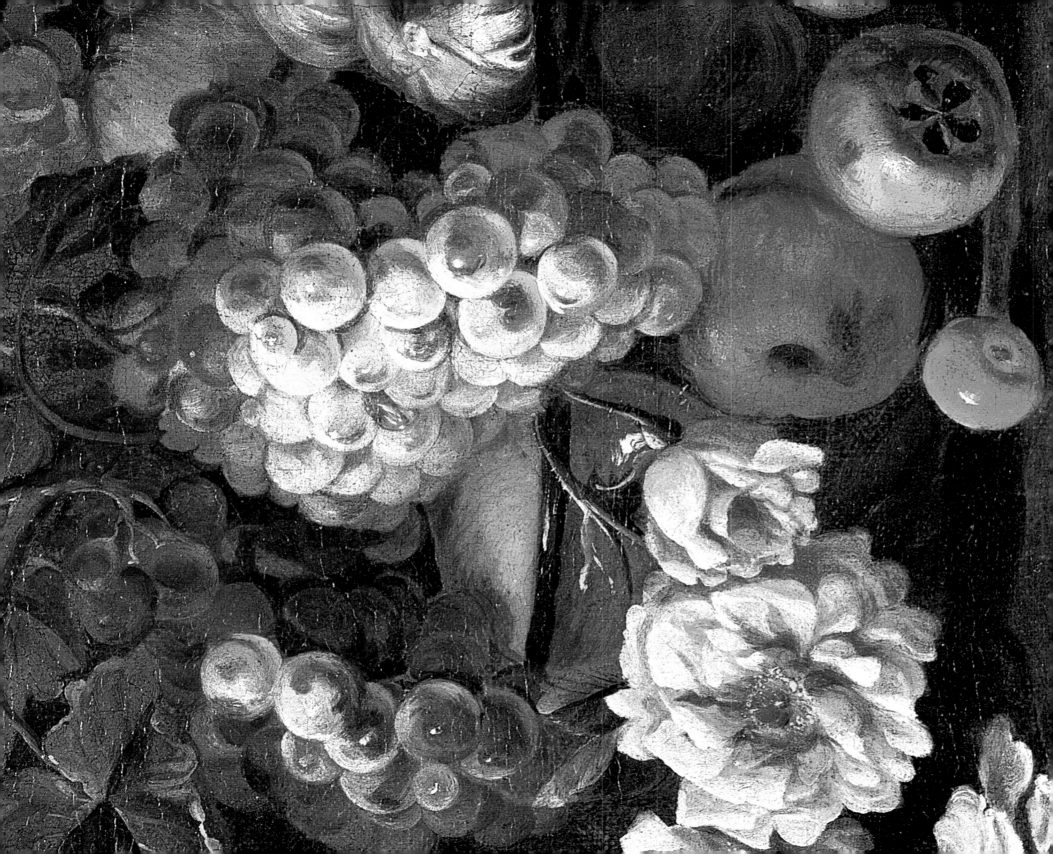

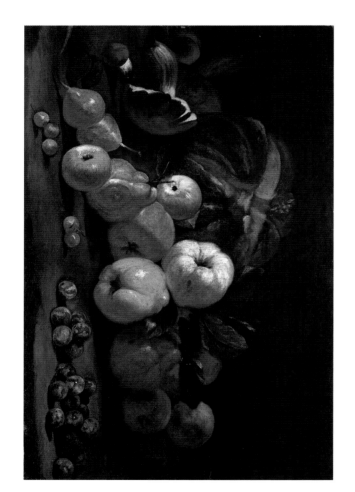

44

Melon, Quinces, Pears, and Prunes

Pittore di Carlo Torre
(active in Milan, late seventeenth
century / early eighteenth century)
Oil on canvas, 47 × 71 cm

*T*he Pittore di Carlo Torre was one of the most successful specialists in fruit and game still lifes of the late seventeenth century in Milan. This anonymous painter was formerly known as the Pseudo Fardella (Salerno 1989) after a series of his still lifes in the Florentine state collections were erroneously ascribed to Giacomo Fardella. The artist was renamed the Pittore di Carlo Torre by Giuseppe Cirillo and Giovanni Godi (1996), who pointed out two still lifes inscribed with the name of Canon Carlo Torre, Milanese author and poet (ca. 1615–79). Cirillo and Godi established that the Pittore di Carlo Torre was active in Milan between the years 1662 and 1675, the dates on two of his paintings. He seems to have presided over an active workshop, to judge from the varying quality of his works. The career of the Pittore di Carlo Torre must have extended at least until 1700 as his distinctive treatments of pears, asparagus, mushrooms and fish can be detected, in my opinion, in several paintings by Giacomo Francesco Cipper, called il Todeschini (see Godi 2000, cat. nos. 58 and 59).

This unpublished still life by the Pittore di Carlo Torre is smaller than most of his works, but nevertheless offers an anthology of his repertory of pears, mushrooms, plums and so forth. The pyramid of white peaches (mela cotogna) is a constant *leitmotif* in his compositions. Indeed, the same peach that is seen on top of its companions appears in one of the artist's best pictures, in a private collection in Milan, which is one of a pair (Cirillo, Godi 1996, fig. 23).

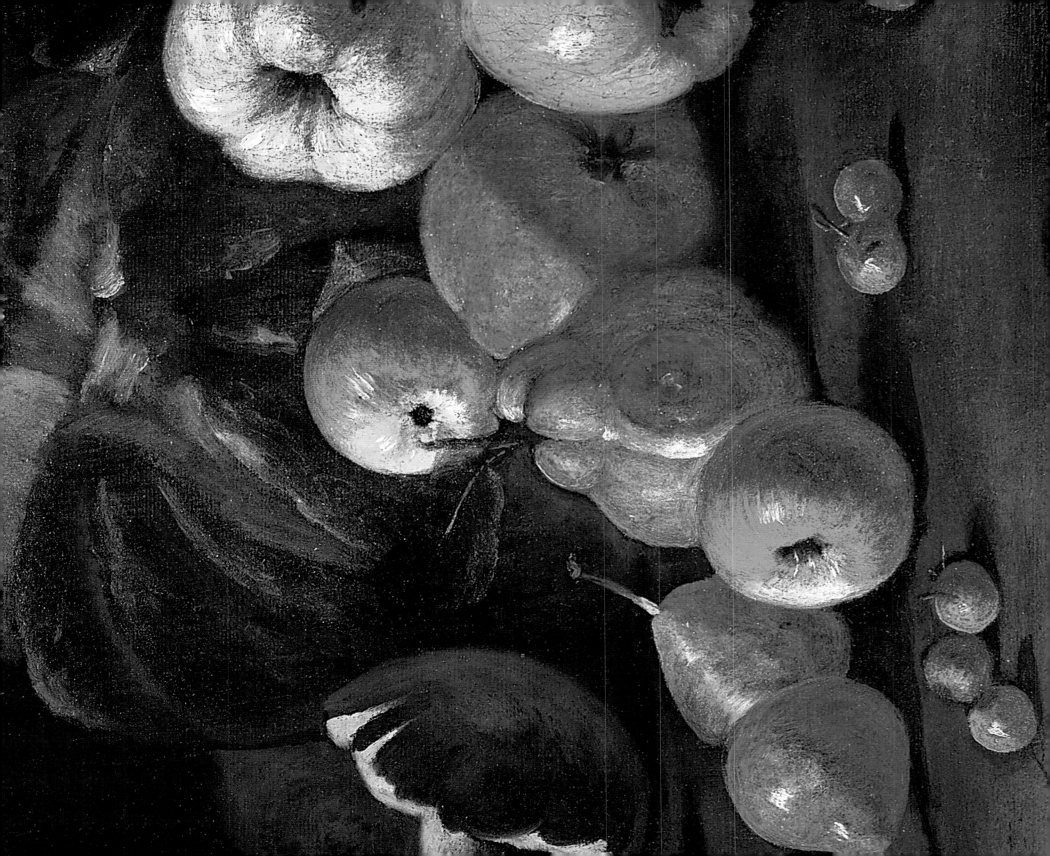

45-46
Melon, Plums, Pears, Quinces, Apples and Grapes
Plate of Strawberries, Citrons, Mandarin Oranges, Pears and Asparagus

Master of the Second Molinari Pradelli Pendant
(Lombardy, seventeenth century)
Oil on canvas, 80 × 100 cm each

This painter takes his curious name from two pictures in the Molinari Pradelli collection in Marano di Castenaso, which have been variously attributed to Giuseppe Ruoppolo, and to the circles of Simone del Tintore and the Pittore di Carlo Torre. The question received its first extended examination by Giuseppe Cirillo and Giovanni Godi (1996, pp. 39–43), who argued persuasively in favor of a Lombard origin for this painter. Cirillo (in Godi 2000, p. 162) has recently ascribed additional still lifes to this master and proposed, moreover, the possibility of identifying him with Marc'Antonio Rizzi.

The rediscovery of this pair of still lifes lends important support to Cirillo's hypothesis. The paintings are unmistakably by the same hand as the pendant still lifes in the Molinari Pradelli collection (fig. 6), and yet each of them illustrates some of the most characteristic motifs of Rizzi and the Pittore di Carlo Torre. If the asparagus and plate of wild strawberries could be considered 'signature' motifs of the latter artist, the same could be said of the pyramidal stack of pears and the split melon for Rizzi. The insertion of a flower or two, for purely decorative purposes, in the midst of the fruits can likewise be found in Rizzi's other pictures. Rizzi's refinements upon the repertory and compositional schemes of the Pittore di Carlo Torre have already been noted by Daniele Benati, Alberto Cottino, Cirillo and Godi. In these exceptionally fine still lifes, the Master of the Second Molinari Pradelli Pendant displays so many qualities in common with those two artists that the conclusion seems inescapable that they and the Molinari Pradelli pictures (fig. 6) represent the earliest phase of Rizzi's career.

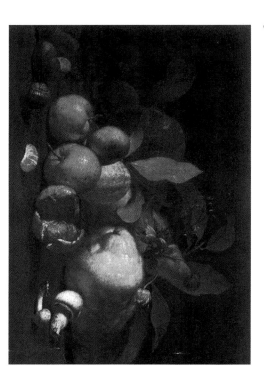

Fig. 6
Master of the Second Molinari
Pradelli Pendant,
Still Life
Marano di Castenaso,
Molinari Pradelli collection

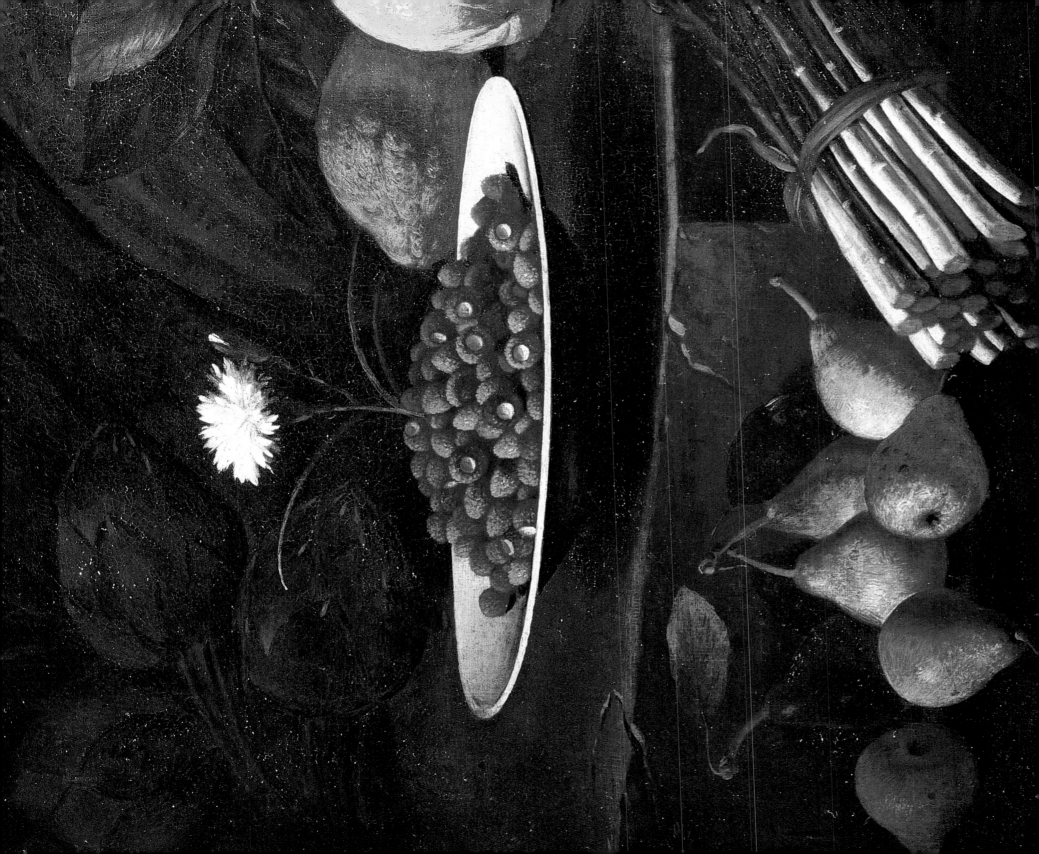

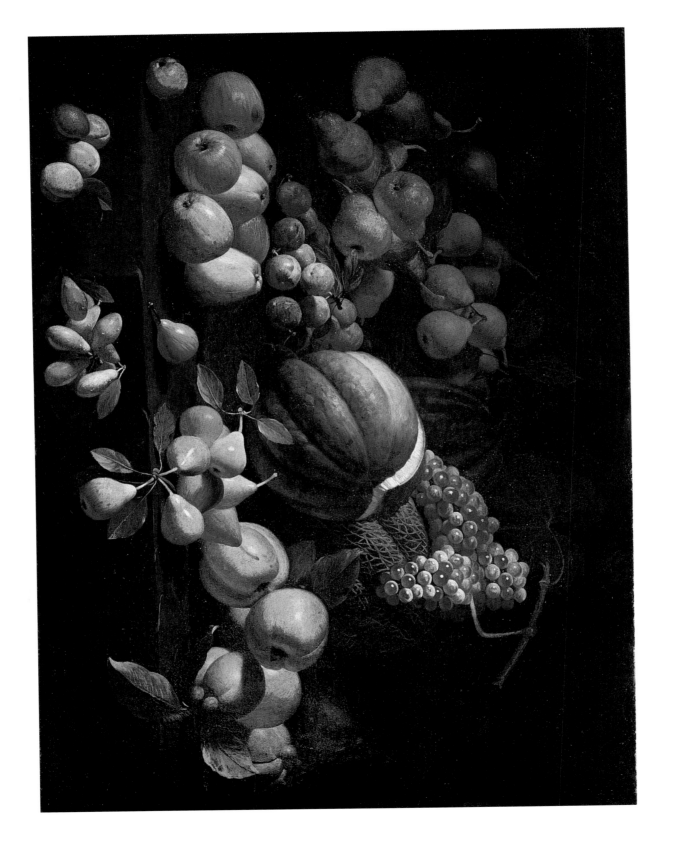

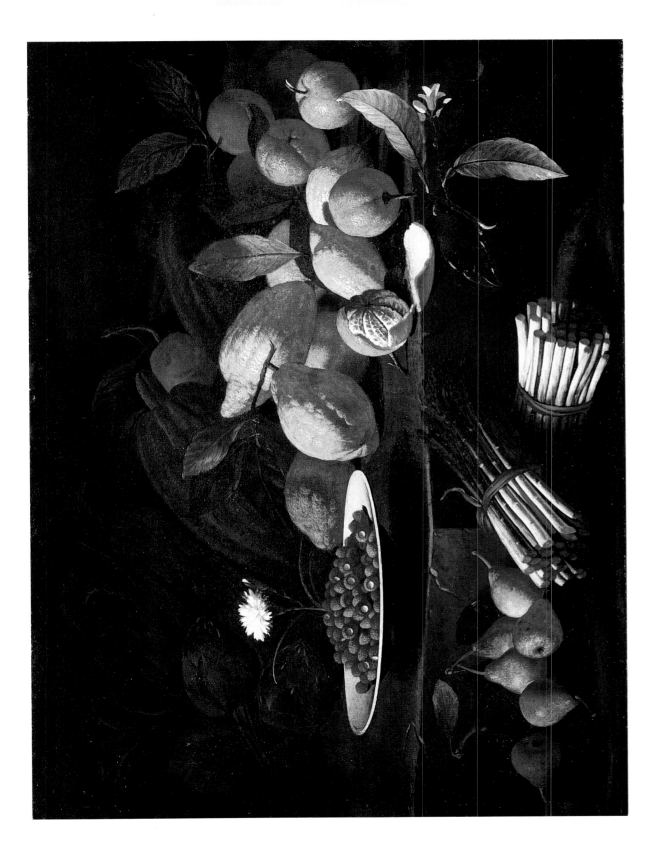

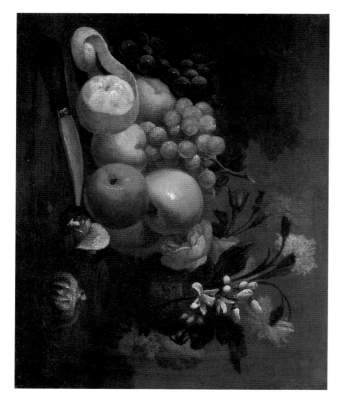

A Peeled Apple with Other Fruits and Flowers

Marcantonio Rizzi
(Pralboino 1648 – Montemartino 1723)
Oil on canvas, 38.5 × 48 cm

Marcantonio Rizzi has emerged from obscurity in recent years to gain recognition as one of the most representative still life painters active along the confines of Emilia and Lombardy at the turn of the eighteenth century. For a complete survey of the recent scholarship, see Alberto Crispo (in Benati, Peruzzi 2000, pp. 176–180). Raised in Casalmaggiore, Rizzi had transferred by 1666 to Piacenza, where he was employed in executing *suites* of fruit pictures for the decoration of noble residences. Commissions came to him from nearby Fidenza and Parma and very notably from the d'Este family in Modena; an inventory of the Palazzo Sassuolo cites no fewer than thirty-seven of his canvases. Like the Pittore di Carlo Torre, Rizzi almost always depicts a pleasing assortment of fruits scattered casually, and in heaps, on the bare ground; his principal follower was Gilardo da Lodi. The works of these three painters are very often confused.

This charming rendition of an informal repast is no larger than a detail of Rizzi's usual dimensions, but seems attributable to him on the basis of its affinities with one of the artist's few documented pictures, a *Grapes, Apples, Pears, Melons and Figs* that was part of a decorative frieze in the palazzo Ferrara in Piacenza (private collection; Arisi 1979, fig. 20). The motif of the peeled apple can be found in a still life by Rizzi in a Brescian private collection (*La natura morta in Italia* 1989, II, fig. 1050, con attribuzione erronea a Luca Forte). As the highlights on the green grapes are somewhat muted for Rizzi, and for Emilian-Lombard still lifes of the later *Seicento* in general, perhaps this is a late work executed as part of a series. The fruits and flowers are immersed in slightly mysterious depths of shadow evokes the manner of Vincenzo Volò, whose family's works were surely known to Rizzi.

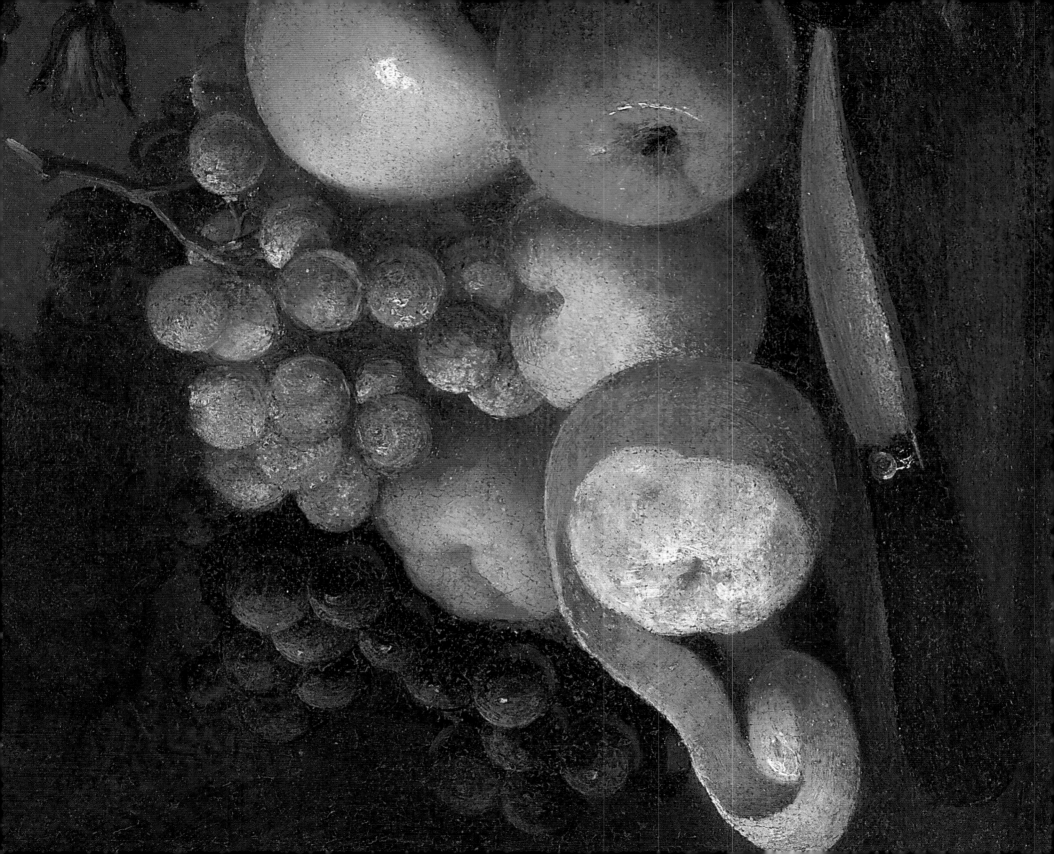

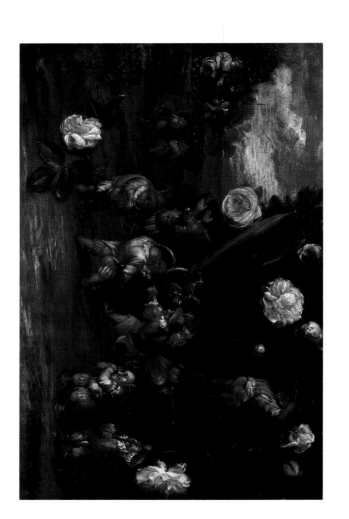

48–49

Dwarves Cutting Roses (Spring)

Dwarves Slicing a Melon (Summer)

Signed lower right: 'FAUST° BOCCHI'

Faustino Bocchi

(Brescia 1659–1741)

Oil on canvas, 47.5 × 73.5 cm each

Faustino Bocchi was raised in impoverished circumstances, from which he was gradually able to escape on the strength of his imaginary paintings of dwarves and their comical adventures. Although he appears to have arrived independently at this curious speciality, he based his landscape settings and village scenes on Netherlandish precedents which he could have known through the activity of his second master, Angelo Everardi, called il Fiammenghino, a painter of battles and *bambocciate*, i.e. rustic genre scenes. Bocchi's success inspired numerous imitators, most notably Enrico Albricci in Bergamo, but his works are easily distinguished from theirs not only for his superiority but also for the acuteness of his observations from nature.

The two paintings in this exhibition, *Dwarves Cutting Roses* and *Dwarves Slicing a Melon*, belong to an unpublished series of *The Four Seasons*. The Netherlandish roots of Bocchi's style are readily discernible in these broadly painted compositions, which can confidently be assigned to the artist's early activity some years before the end of the seventeenth century. The broad collars and loose-fitting costumes worn by the dwarves are also characteristic of Bocchi's early pictures.

The backgrounds of the four paintings have been artfully varied so as to convey the theme of the progress of the four seasons. The open sky is seen on the left side in the *Dwarves Cutting Roses*, in which the dwarves struggle to cut and collect the springtime flowers which for them are life-sized. The sky is directly overhead as though the feasting in the successive scene of *Dwarves Slicing a Melon* is taking place under a noonday sun. Autumn is the time of the harvesting of grapes, on which the gluttonous dwarves seem to feast while a dwarfish Silenus points ominously towards the waning light of sundown. The fourth season, *Winter*, is allegorized as a cold black night haunted by the stealthy approach of a murderous cat.

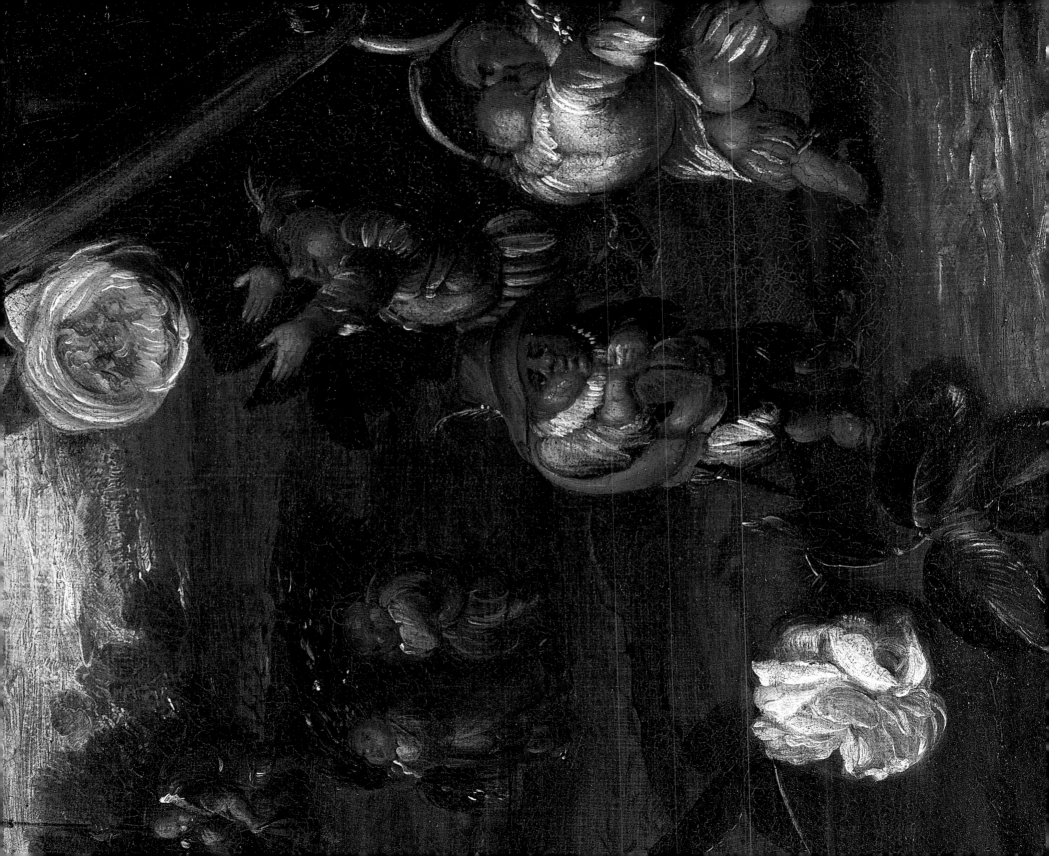

124

Fig. 7
Faustino Bocchi,
Dwarves Harvesting (Autumn)
private collection

Fig. 8
Faustino Bocchi,
*Dwarves Threatened by a Cat
(Winter)*
private collection

Lemons, Apples, Medlars and a Savona Plate

Bartolomeo Bimbi
(Settignano 1648 – Florence 1729)
Oil on canvas, 42 × 57 cm
Provenance: Giorgio Baratti, Milan

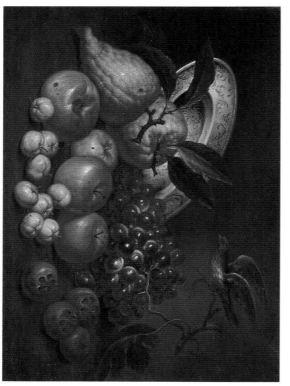

B artolomeo Bimbi, the unchallenged dean of Florentine still life painters, first took up his brush and palette without any intention – in the words of his biographer, Francesco Saverio Baldinucci – of 'copying flowers.' The young Bimbi received a conventional training as a figure painter first with Lorenzo Lippi and then with Onorio Marinari in Florence. He showed no interest in still lifes, notwithstanding his encounter with Mario de' Fiori in Rome in 1670, until one day the sight of a large painting of a garland of flowers by Agnolo Gori inspired him to try his own hand.

Bimbi's first garland of flowers was immediately acquired by Grand Prince Ferdinando de' Medici, who began the practice of sending him specimens of the rarest and most beautiful flowers for the artist to record on canvas. The large number of his canvases included in the periodic exhibitions in the cloister of the Santissima Annunziata, Florence, testify to his success with the Medici court and the other Florentine nobility. In 1692 Bimbi received the commission to decorate the mirrors in the Galleria of the Palazzo Medici-Riccardi, in collaboration with Anton Domenico Gabbiano for the figures and Pandolfo Reschi for the landscapes. Over the course of his long and productive career, Bimbi would direct his hand to every genre of still life. He remains best known for his employment by Cosimo III, grand duke of Tuscany, as a semi-official portraitist of botanical and zoological varieties and monstrosities. The Medici villas of Castello, Topaia and Ambrogiana were decorated throughout with Bimbi's paintings of flowers, fruit, and rare and exotic animals and birds.

This elegant *Lemons, Apples, Medlars and a Savona Plate* is a fine and characteristic example of Bimbi's mature style, datable to the beginning of the eighteenth century. The medlars and grapes impart an autumnal quality to the composition, which concludes other fruits that can be harvested in that season. The foods are casually displayed on the ground, with their leaves and branches as if freshly picked; the insertion of a precious plate of blue-and-white Savona is a subtle reminder, on the other hand, that this natural bounty is destined for a noble table.

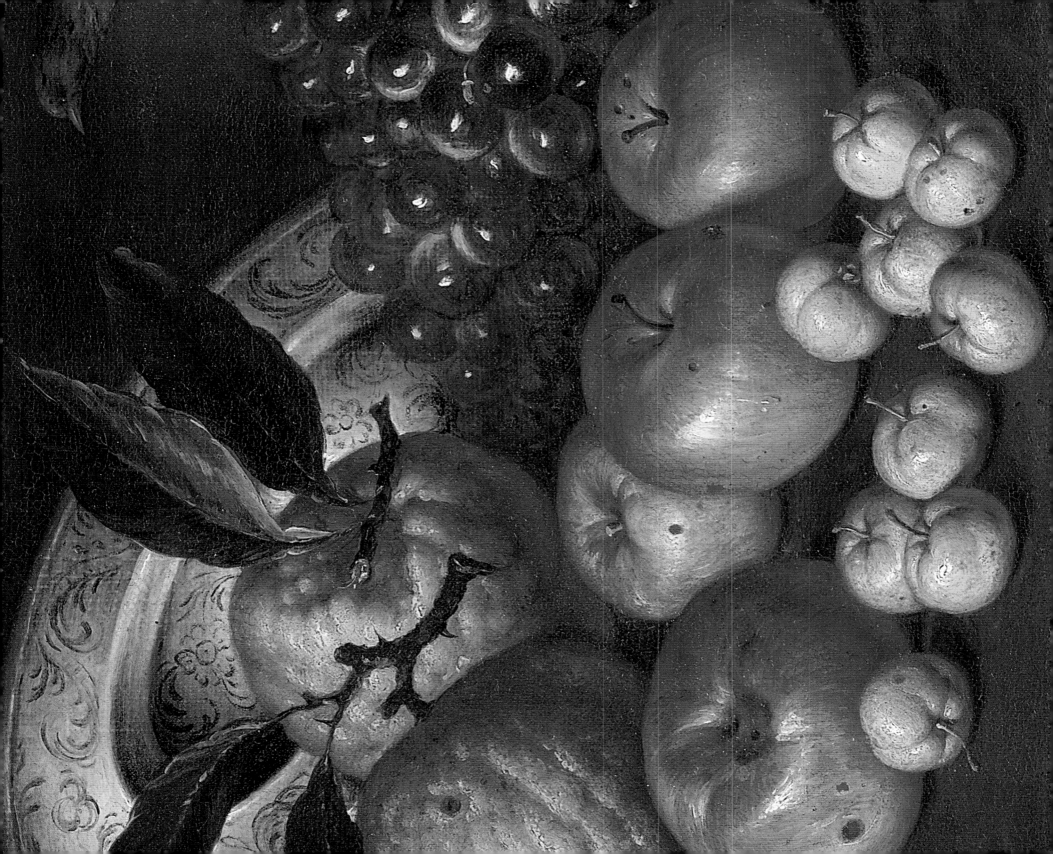

Terracotta Vases with White Grapes
and Other Fruits on a Terrace

Aniello Ascione
(Naples, documented 1680–1708)
Oil on canvas, 104.5 × 138 cm

*T*he most celebrated pupil of Giambattista Ruoppolo was Aniello Ascione, who carried the Baroque style over into the eighteenth century. Ascione's palette is somewhat lighter than his master's, and his compositions are more varied. Nevertheless his still lifes would have inevitably been confused with Ruoppolo's except that he had the foresight to place his signatures on many of them. Ascione's reputation was such that Ottavio Orsini, the leading Neapolitan collector of still lifes at the end of the seventeenth century, owned more than ten of his pictures, the same number as he had by Ruoppolo.

Previously attributed to the Neapolitan school, this amiable decoration was recognized by Federico Zeri as a fine and characteristic canvas by Ascione. In a letter (February 17, 1995) to the owner at that time, Zeri noted: 'The composition, choice of fruits and flowers, manner of describing each grape, and handling of colors and *impasto* correspond exactly to his approach.' Although little is known about the artist's chronology, Prof. Zeri was inclined to date this still life towards the beginning of Ascione's career, 1680 ca. To this analysis, we can add that Ascione adapted the arrangement of this painting, with some of the fruit cultivated in terracotta pots, and other fruit scattered at random in front of a low wall, from a composition made famous by Abraham Bruegel.

Fig. 9
Aniello Ascione, *Still Life*
private collection

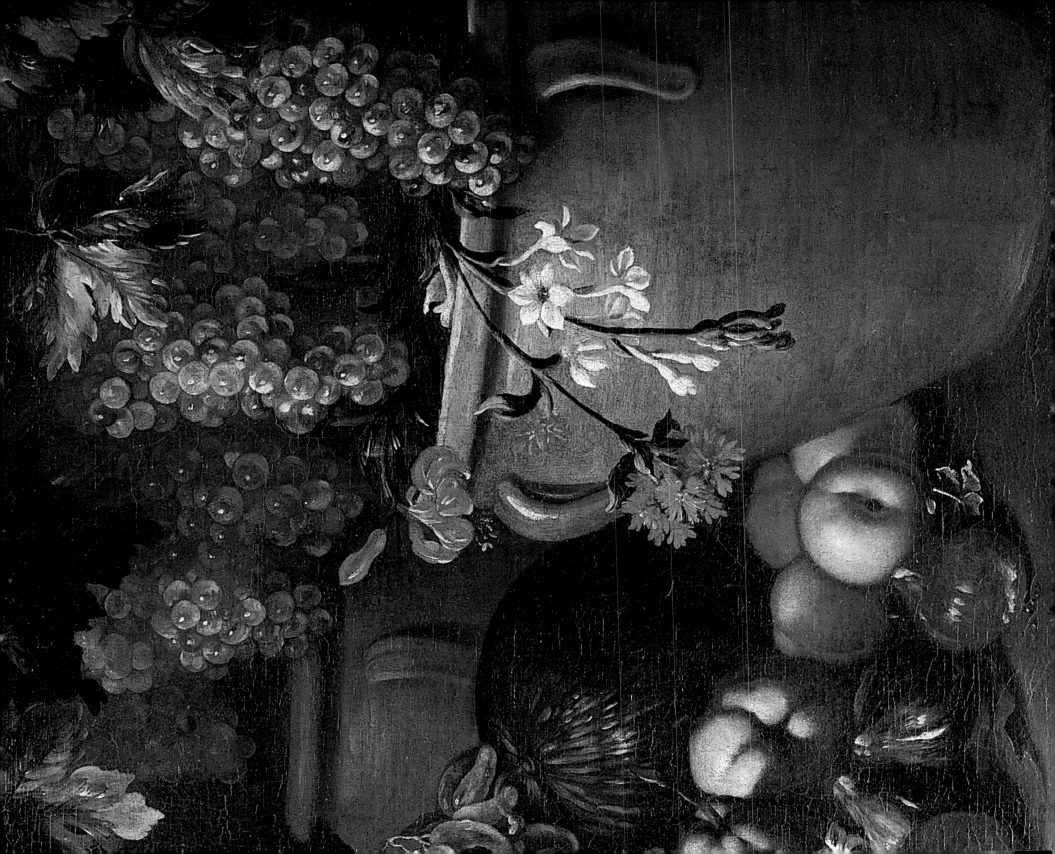

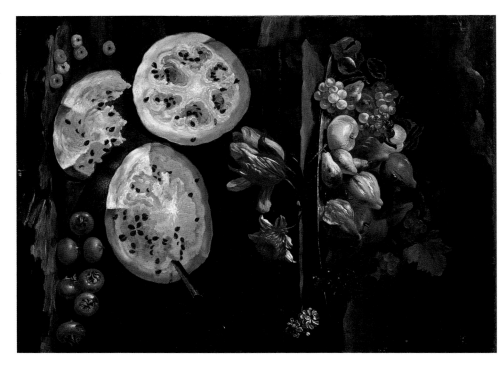

52

A Platter of Fruit on a Stone Wall, Flowers, and Watermelons

Aniello Ascione
(Naples, documented 1680–1708)
Oil on canvas, 97.5 × 87.5 cm
Signed with initials at upper center: '*A*[niello].*f*[ecit]'

*A*s few particulars concerning the life of Ascione have come down to us, it is worth transcribing in full the biography dedicated to him by Bernardo De' Dominici (1742, p. 300). 'Aniello Ascione was also a pupil of Ruoppolo and a talented artist in his own right. He painted appealingly with pleasant colors, especially favoring red lacquer. Ascione made many pictures of fruit and flowers, but especially of fruit, making a speciality of grapes. He practiced his profession with propriety, for which he was duly recognized; his works were chosen to adorn various noble galleries, and private apartments, and are held in esteem by everyone.'

The luscious fruits are depicted with a remarkable robustness even for the exuberant school of Naples. The upright format of the canvas raises the possibility that this still life was intended to be placed above a door; this impression is strengthened by the remarkable perspective of the anemone and two striped tulips, which appear to project forward towards the viewer. Perhaps only in the bouquets of Andrea Belvedere can a parallel be found in Naples for this *trompe l'œil* approach. Fortunately for our purposes, Ascione was proud enough of his conception to include his signature.

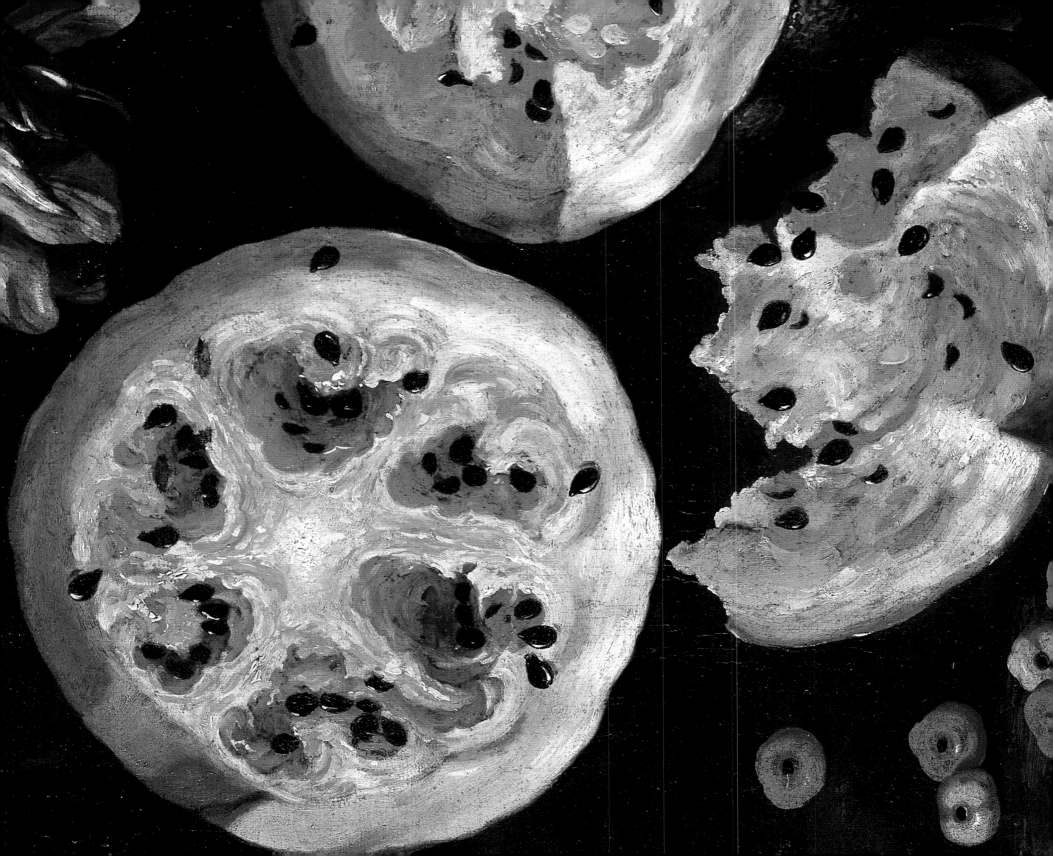

Bouquet of Flowers, Platter of Strawberries, Cherries and a Rabbit

Lorenzo Russo
(Naples, documented 1696)
Oil on canvas, 77 × 102 cm
Signed on wall: '*Rus.ô*'

*T*he sole documentation of the activity of Lorenzo Russo is a record of his payment in 1696 by the Principe di Leporano for 'pictures of flowers and fruit' (D'Addosio 1920, p. 105). This charmingly chaotic picture of flowers, strawberries, and a good-natured rabbit is attributed to Lorenzo Russo, an unknown Neapolitan still life specialist, on the basis of its signature on the wall. The style and execution of the painting are appropriate for an artist of the late *Seicento*, who, as is usually the case of minor masters, was open to a variety of influences.

As Russo derived the most elements from Gaetano Cusati, it may have been in this master's workshop that he trained. The spectacular platter of strawberries, rinned by roses, is found in a well known still life by Cusati, whose method of painting flowers was also influential here. On the other hand, the white *balles de neige* immersed in water are Russo's interpretation of a motif famous to Andrea Belvedere. Finally, a third stimulus that can be named is that of Nicola Cassissa, whose flowerpieces always included amiable animals, more to lend variety than as studies of nature.

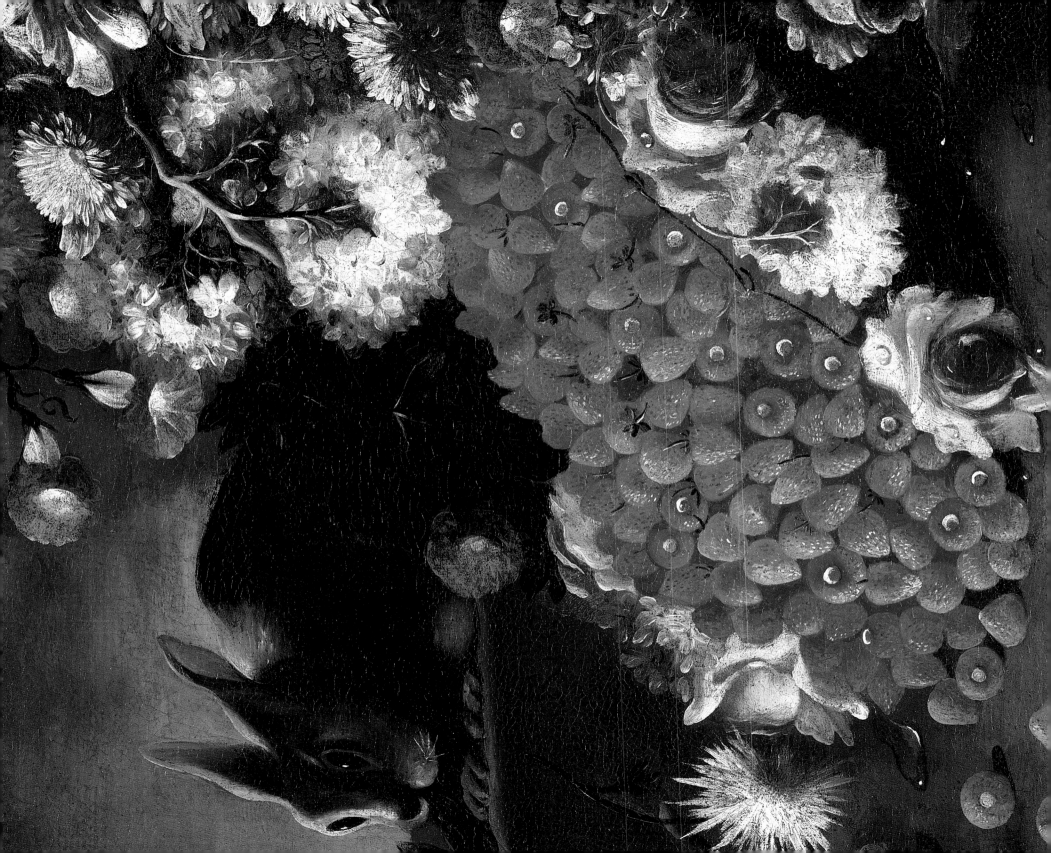

Nature ENNOBLED

Picnic Basket

Pier Francesco Cittadini
(Milan 1613/16 – Bologna 1681)
Oil on canvas, 108 × 75.5 cm
Bibliography: Benati, Peruzzi 2000, p. 95, fig. 49

After initial studies with Daniele Crespi in Milan, Pier Francesco Cittadini transferred to Bologna where, aged seventeen, he entered the studio of Guido Reni. By 1637, the precocious *Milanese* had already executed his first altarpiece. His *Conversion of St. Paul* for the church of San Paolo is generally dated around 1641.

The turning point of his career occurred during the 1640s when he lived and worked for some years in Rome. He was evidently struck by the proliferation of styles and genres being practiced by the international colony of artists, and especially Il Maltese, the specialist in carpet and elegant table still lifes. Cittadini's return to Bologna is documented by 1650–51 when he was engaged in collaboration with his brother Carlo Cittadini to paint fresco decorations of fruit and flowers in the Villa Estense at Sassuolo. He further expanded his repertory to include an extensive production of portraits, in which his Lombard roots are clearly evident, and of landscapes influenced alternately by Pier Francesco Mola and by Francesco Albani.

Luigi Crespi (1769) concludes his brief biography of Cittadini with a rhetorical question, 'In which house, in which palace in Bologna is there not some work of his? In his own day and still today, Cittadini's best known pictures were four allegories of the *Four Seasons* which were described by Crespi in the collection of Count Legnani (now divided between the Museo Comunale, Bologna, and the Galleria Estense, Modena).

Luigi Crespi used the term 'merenda' to describe Cittadini's paintings like this *Picnic Basket*, adding 'in this genre he was remarkable.' The artist has portrayed in appetizing detail the fruits, meats, and sweets, as well as the plates, wine and tablecloth, that have been brought by an elegantly dressed couple (seen at left) for their refreshment following a pleasant stroll in the countryside. The gnarly skinned melon (right) was a favorite fruit of the *Milanese* who copied it in pictures in the museums in Modena and in Trieste (Spike 1983, cat. no. 26 and fig. 27). As Daniele Benati (in Benati, Peruzzi, 2000) has observed, Cittadini introduced an 'aristocratic preciosity' into Emilian still lifes; his works would have a formative influence on Cristoforo Munari, who was born in Reggio.

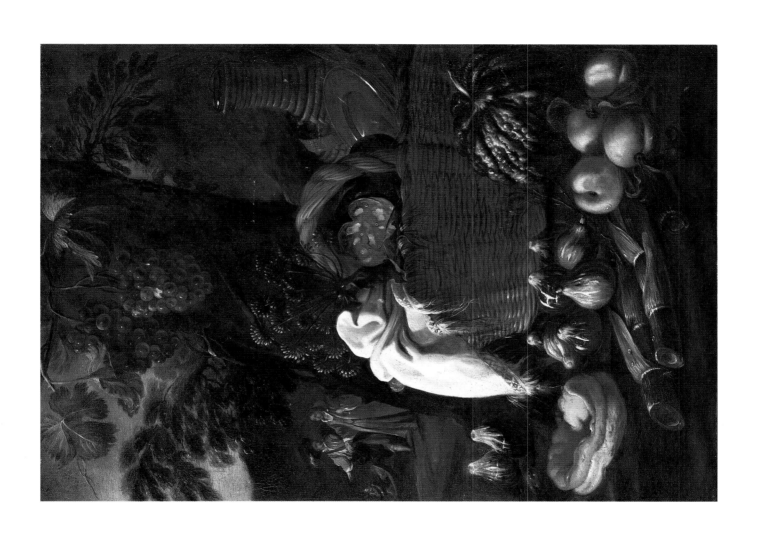

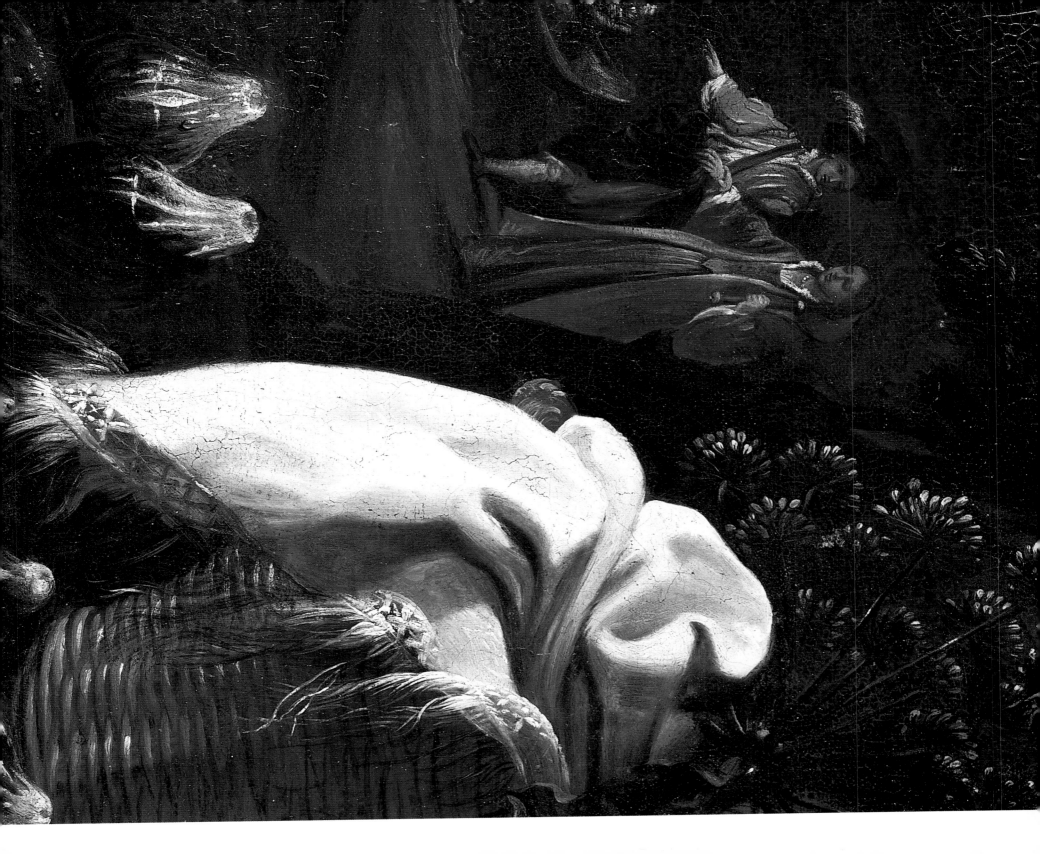

Still Life with a Silver Ewer, Gold Cup and Fruits

Meiffren Conte
(Marseilles ca. 1630–1705)
Oil on canvas, 73 × 96 cm
Bibliography: Sestieri 1990, pp. 48–49

Born in Marseilles into an old and respected family, whose name was also written as Leconte or Lecomte, Meiffren Conte studied in Rome. In 1651, he was living in the house of a Genoese painter in the parish of Sant'Andrea delle Fratte. Conte was probably trained in the workshop of Francesco Fieravino, called Il Maltese, whose closest follower he became. He was already an accomplished specialist in the latter's style of trophy paintings with carpets and goldsmithery when he returned to France.

Conte was in the vanguard of the transition in French still lifes from the intimate and humble compositions of Jacques Linard and Louise Moillon, usually painted on panel, to the grandiose and rich subjects favored in the Age of Louis XIV. His success with the leading collectors in Marseilles and Aix-en-Provence (where he was married in 1654) resulted in several calls to the court of Paris. During the 1670s Conte was employed by the Louis XIV to paint the silver and gold treasures from the Royal Collection. In 1679 Félibien cited him among the leading painters in Paris although not a member of the Académie royale. Conte returned home to Marseilles in 1680 with the title *Peintre du Roi pour les galères du roy;* his occasional employment on special decorations for the Sun King's ships did not inhibit his productivity, however; his still lifes were included

in the most important private collections in Paris and Provence, and his fame was known in Italy. Pierre-Jean Mariette, one of the greatest connoisseurs of the next century, singled out 'Ephren Le Conte' for praise in his *Abécédario:* 'Il a excellé dans la représentation des tapis, des armures et des ouvrages d'orfèvrerie qu'il a traités en peinture dans un extrème degré de vérité.'

This *Still Life with a Silver Ewer, Gold Cup and Fruits* is a superb example, in beautiful condition, of Conte's aristocratic style. The composition is especially pleasing for its concentration on a few selected motifs, in particular the silver ewer that stands at center. The ewer's frieze represents, with Repoussé chasing, a procession of sea nymphs and tritons. While this piece of Renaissance design may have been too magnificent to have been in the artist's personal possession, it was evidently available to him as he painted it from a variety of angles in several different still lifes (for illustrations of these paintings, see Faré 1974, pp. 206, 208, 213, 215, 216).

Although the chronology of Conte's still lifes has not been thoroughly studied, there is good reason to think that the present still life was painted during his residence in Paris (1671–80). The silver ewer and the same gold cup with cover that lies adjacent to it are both to be seen, for example, in a still life signed by Conte, which contains a basket of flowers painted by Nicolas Baudesson (private collection, Paris; Faré, p. 215). In 1666, Baudesson (1611–80) returned to France after living for many years in Rome, where Conte must have known him.

Flowers in a Sculptured Vase with Various Fruits

Giovanni Stanchi or Niccolò Stanchi, attributed to
(Rome 1608–1673 ca.: Rome 1623/26–1690 ca.)
Oil on canvas, 81.5 × 59.3 cm

*D*espite the numerous still lifes that have been attributed in recent years to the Stanchi family, no attempt has yet been made to distinguish between the hands of Giovanni Stanchi and his brother Niccolò (Rome 1623–1690 ca.). This situation dates back to their own day to judge from the numbers of paintings listed, simply, as 'dello Stanchi' in the old Roman inventories. (Still less is known of their brother Angelo (1623–1673 ca.), the youngest member of the Stanchi workshop.) As none of their pictures are signed, the only certain attributions are the mirrors painted with flowers by Giovanni Stanchi, with figures by Carlo Maratti, in the Galleria Grande of the Palazzo Colonna, and the mirrors painted by Niccolò, with figures by Ciro Ferri, in the Palazzo Borghese at Campo Marzio. The present still life could be attributed to Giovanni Stanchi on the basis of its technical similarities to the *A Sculptured Vase with a Bouquet of Flowers* (cat. no. 28). Both paintings display a robust execution that employs dense *impasto* to obtain a sense of firmness and volume. The arrangement of the fruits in front of the sculptured vase has an archaic flavor that we might expect from a painter of Giovanni's generation. On the other hand, the calligraphic quality of the tulips and of the morning glories are comparable to those in paintings by Niccolò, such as the following, cat. no. 57. The question thus remains open.

Flowers in a Glass Vase with Melons, Peaches and Pears on a Table

Niccolò Stanchi
(Rome 1623/26–1690 ca.)
Oil on canvas, 73.5 × 100 cm

Niccolò Stanchi worked alongside his older brother Giovanni Stanchi and eventually succeeded him as the head of one of the leading Roman workshops for paintings of fruit and flowers. As neither Giovanni nor Niccolò Stanchi signed their pictures, the only certain attributions for these artists are Giovanni's two mirrors, with figures by Carlo Maratti, in the Galleria Grande of the Palazzo Colonna, and Niccolò's mirrors, with figures by Ciro Ferri, in the Palazzo Borghese at Campo Marzio. Born in 1623 or 1626 (according to different documents), Niccolò was almost a full generation younger than Giovanni, who must have trained him; both brothers worked for the Chigi, Borghese, Colonna and Pamphilj families, whose inventories rarely distinguish between their hands. In 1656 Niccolò was residing with his brothers Giovanni and Angelo in a house in via Paolina. From 1671 until 1690 Niccolò was steadily employed by the Chigi, even travelling in 1685 and 1686 to paint floral decorations in their palace in San Quirico, near Siena (Golzio 1939, p. 234). After Giovanni's death, Niccolò moved to via Margutta where he appears in the parish records from 1682–90, the probable year of his death. One of his pupils, Paolo Cennini, became a leading specialist in his own right. The documentary evidence was collected by Laura Laureati in an exemplary entry in *La natura morta in Italia* 1989, II, pp. 770–73.

This unpublished still life is by the same hand as a pair of flower vases in Florence which were assigned to 'Stanchi' in the 1713 inventory of Grand Prince Ferdinando de' Medici, and recently associated by Marilena Mosco (Mosco, Rizzuto 1988, cat. nos. 33–34) with three still lifes in the Pallavicini Gallery that Zeri (1959, cat. nos. 370, 373–374, figs. 10–11) recognized as Romano. This painter is readily distinguished from Giovanni Stanchi (cat. no. 28) for his bright pastel tints and elegant contours. Trailing vines of blue morning-glories (convolvulus) are one of his trademarks; the calligraphic, looping petals of his pink roses are another. Perfectly shaped leaves with bright green veining are another leitmotif. Given this emphasis on decorative values, typical of the second half of the seventeenth century, it is reasonable to assume that this talented successor to Giovanni Stanchi is none other than his brother Niccolò. To this initial sketch of the *oeuvre* of Niccolò Stanchi can be added an impressive pair of upright compositions with Altomani, Pesaro (170 × 114 cm each). Salerno illustrated a *Garland of Flowers with Birds* by this hand under the name of Pier Francesco Cittadini (1984b, fig. 97.4)

Fig. 10
Niccolò Stanchi, *Still Life of Flowers*
Rome, Pallavicini Gallery

Fig. 11
Niccolò Stanchi, *Still Life of Flowers*
Rome, Pallavicini Gallery

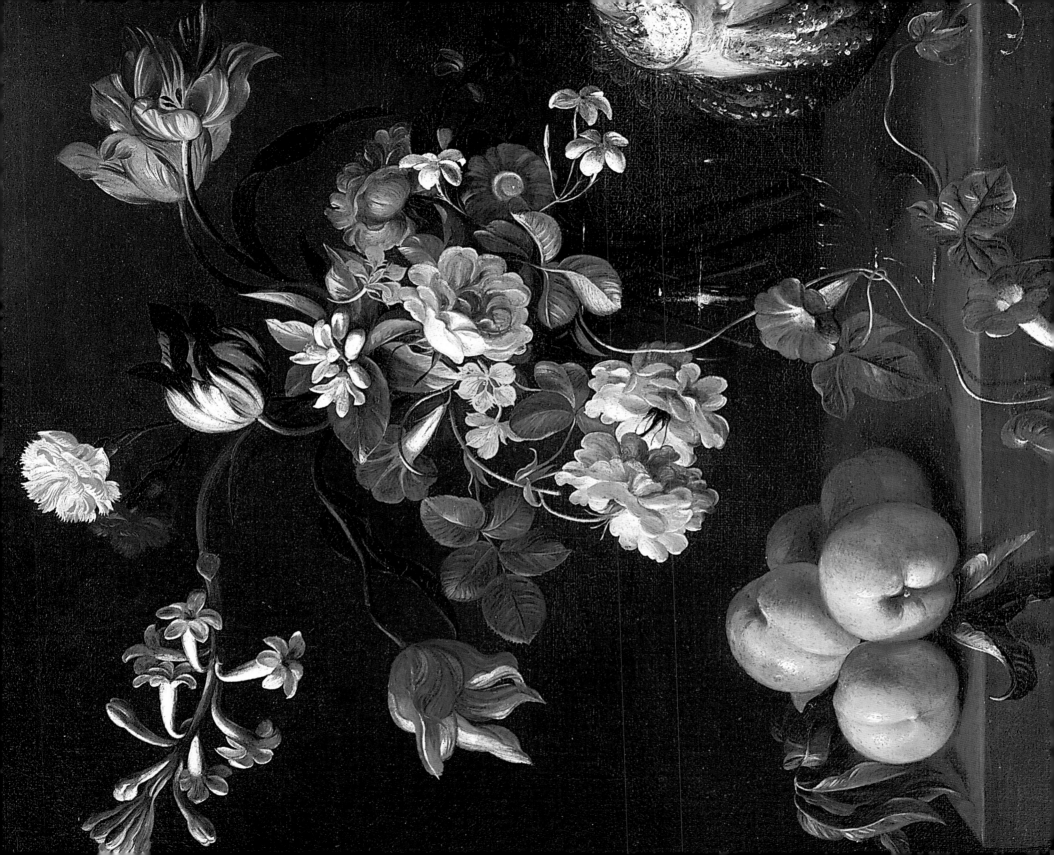

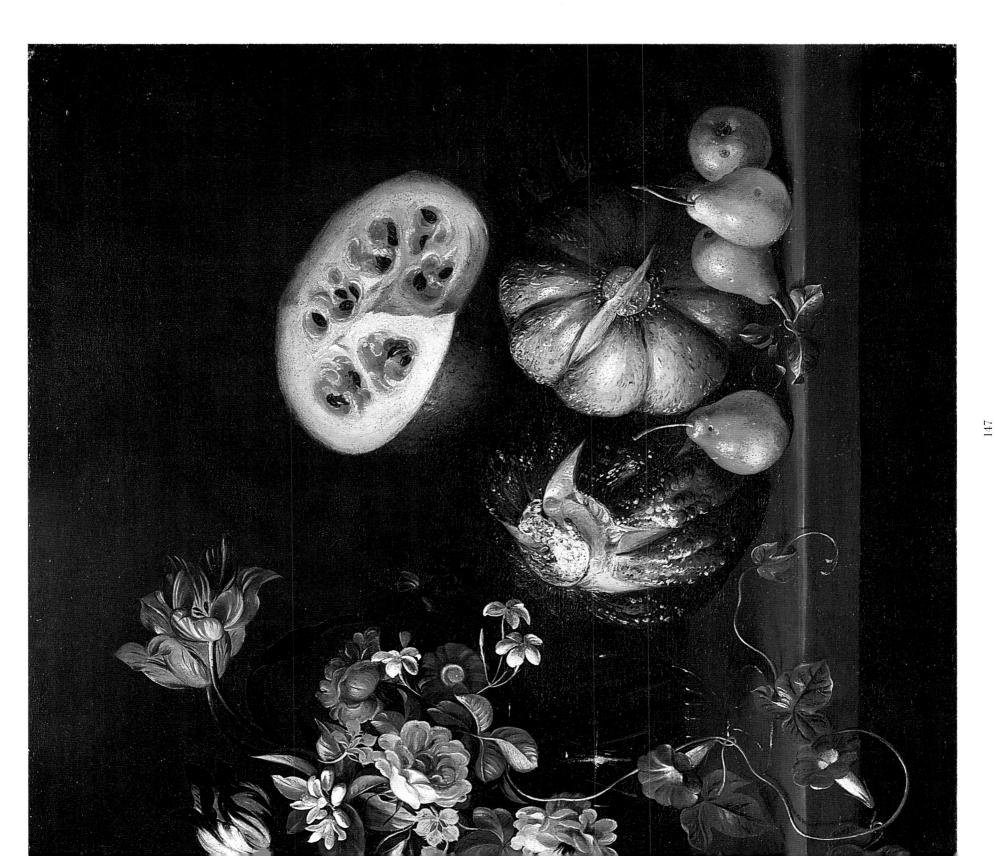

Fruits in a Glass Bowl

Niccolò Stanchi
(Rome 1623/26–1690 ca.)
Oil on canvas, 58 × 44 cm (oval)

*F*or a brief biography of Niccolò Stanchi, see the previous entry, cat. no. 57. The elegant qualities of this Roman artist, here identified as Niccolò Stanchi, are all on display in this charming composition. The fruits are perhaps too good to eat – they seem so perfect. Nearly identical peaches, plums and silky leaves can be found in the other still life in this exhibition. The oval shape was frequently chosen for such paintings as still lifes became the favorite decorations of noble residences towards the end of the seventeenth century.

Various Fruits in a Glass Bowl
A Melon, Peaches, Plums, and Grapes

Bartolomeo Castelli, called Spadino *junior*

(Rome 1696–1738)

Oil on canvas, 17.5 × 31.5 cm each

*T*he youngest of the Castelli-Spadino family of painters was Bartolomeo, called Spadino *junior*. It was due to the research of Ferdinando Bologna (1985, p. 120) that we are able to distinguish his still lifes from those of his celebrated father, Giovan Paolo Spadino (1659–1730). Although short-lived, Spadino *junior* was a prolific artist, in part perhaps of his preference for working in very small formats.

Except for their slightly larger dimensions, these intimate *quadretti* could almost be part of the series of four still lifes (13 × 29.5 cm each) by Spadino *junior* in the Galleria Spada, Roma (Zeri 1959, cat. nos. 291, 292, 299, 200). Such pictures were made in pairs, and sometimes in series, in order to enhance their usefulness as decorations for the interior of a noble residence. The smooth surfaces of the purple-blue plums and other fruits are the characteristic embellishments of this eighteenth-century artist. For illustrations of other pictures by Spadino *junior* see Salerno (1989, pp. 93–96).

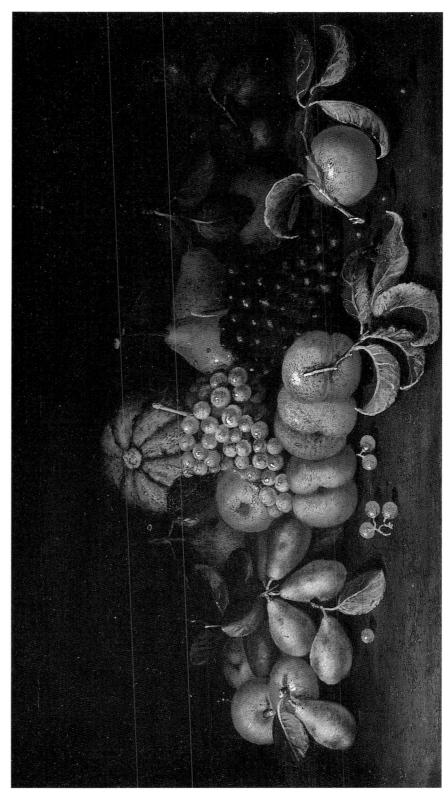

Lemon Tree in a Terracotta Vase
with Oranges

Tommaso Realfonso
(Naples 1677 ca. – post 1743)
Oil on canvas, 76.5 × 43 cm

Tommaso Realfonso, called Masillo by his contemporaries, was the pupil of Andrea Belvedere, whom he followed in reacting against the fanciful decorativeness introduced to Naples by Abraham Bruegel after 1675. Both Belvedere and Realfonso sought to emulate the severe simplicity and dignified realism of the still lifes painted fifty or more years earlier by Luca Forte, Giuseppe Recco, Giambattista Recco, and Giuseppe Ruoppolo. Realfonso's calculated archaisms are shown off to particular advantage in this *Lemon Tree in a Terracotta Vase with Oranges*. Among the earliest still lifes painted in Naples were lemons and oranges in terracotta pots: Luca Forte specialized in them on every scale from small coppers to large canvases. The simplicity, symmetry and sombre tonalities in Realfonso's picture pay homage to those still lifes. The first generation of Neapolitan still life painters adopted Caravaggio's use of dark backgrounds in order to concentrate on the fruits themselves without distraction from the artificial colors and perspective of Mannerist paintings.

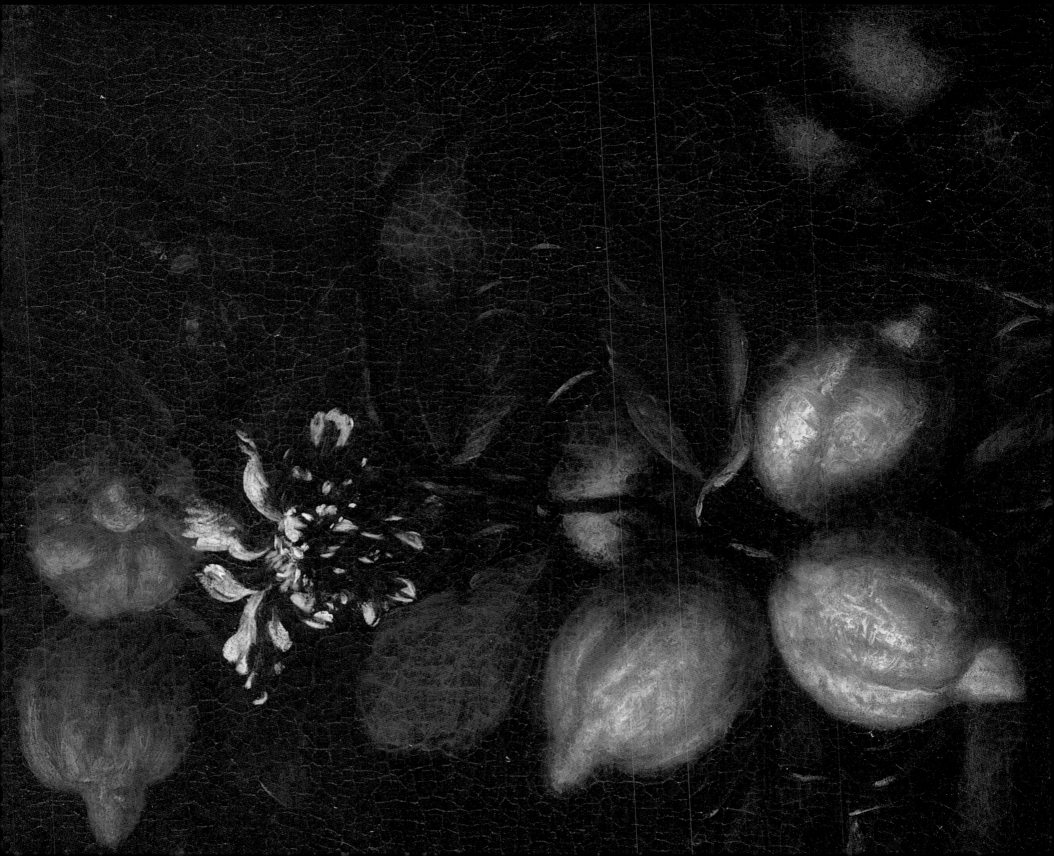

Allegory of the Five Senses

Giovan Paolo Zanardi, attributed to

(Bologna 1658 – post 1718)

Oil on canvas, 54 × 70 cm

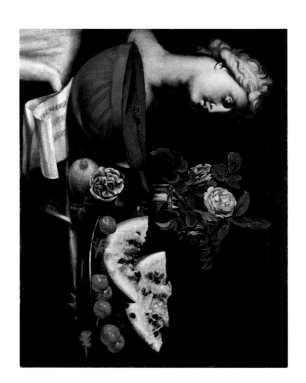

According to Masini (*Bologna perlustrata* 1690), Zanardi had moved on to Verona by 1689, leaving examples of his 'excellent' paintings of fruits and flowers in the palazzo Alamandini and other private houses in Bologna. Crespi (1769) later repeated this notice *verbatim*, remarking as well an altarpiece of *The Holy Family* in a public chapel (formerly Tonelli family) near the Porta di San Mamolo.

The first proposals for the still life paintings of Giovan Paolo Zanardi have recently been published by Daniele Benati (Benati, Peruzzi 2000, p. 100), who illustrated a pair of *Allegories (Spring and Summer)* in a private collection in Verona and a *Flowers, Fruit, a Bust, a Parrot and a Small Dog* that passed through the Roman art market in 1998. It is this last picture that particularly interests us (Benati, Peruzzi 2000, fig. 64), as it appears from the photograph to represent the same classical bust of a woman and to be by the same hand as the present *Allegory of the Five Senses*.

The paintings assigned to Zanardi by Benati are linked by their common dependence on the models of Pier Francesco Cittadini, who often depicted musical instruments together with bouquets of flowers. Zanardi would also have derived his interest in allegorical still lifes from Cittadini's ample examples. In this *Allegory of the Five Senses*, the music symbolizes the sense of hearing, the flowers symbolize smell, the fruits (both sweet and sour) symbolize taste, the sculpture symbolizes the sense of touch, and the art of painting is itself the supreme symbol of sight. Zanardi adds an original play on this motif by posing the classical head so as to seem as though the woman's sculpted eye 'sees' the flower.

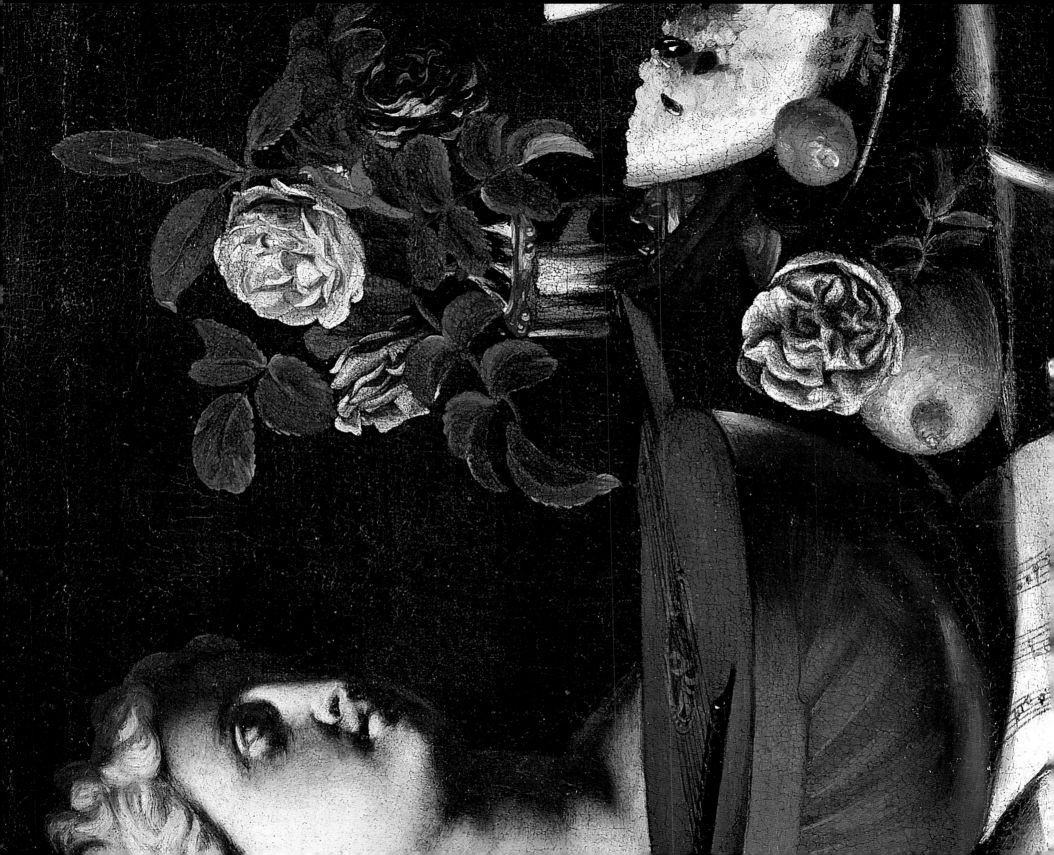

Musical Instruments on a Table

Andrea Pastò
(active in Venice, eighteenth century)
Oil on canvas, 58.5 × 67 cm

Andrea Pastò is a rare painter not cited in the usual dictionaries of art. He was a friend of Carlo Goldoni and one of the sparkling society who sojourned at the Villa Widmann in Bagnoli. Goldoni wrote of him: ' Andrea Pastò is a good painter especially of small figures in the style of the famous Pietro Longhi' (Mariuz 1976, p. 197). His few still lifes are all alike: representing tabletops with a casual arrangement of some pages of music, a stringed instrument or two, and a flask of 'rosolino' wine. To the grandiose flourishes of Francesco Guardi, whose workshop dominated Venetian still lifes in the Settecento, Pastò proposed the Enlightenment alternative of quiet intimacy and a touch of self-deprecating humor. He was certainly aware of Cristoforo Munari's paintings of musical instruments, even borrowing the latter's signature motif of a Delft cup; the difference is that Pastò never seeks to impress — in decadent Venice elegant accoutrements were taken for granted.

Ferdinando Arisi was the first to attribute this *Musical Instruments on a Table* to Pastó, noting its close connection to a pair of his still lifes published by Luisa Tognoli (1976, figs. 173 and 176) in a private collection in Trento. Arisi pointed out the affinities between these three compositions, each one an oval painted on a rectangular canvas, to the illusionism of *trompe l'œil*.

A Basket of Fruit and a Terracotta Jug on a Rock Ledge
A Basket of Fruit on a Rock Ledge

North Italian Painter
(second half of the eighteenth century)
Oil on canvas, 99.5 × 124 cm each

This pair of still lifes were evidently painted by an artist active in North Italy during the eighteenth century. The pictures evoke the precedents of Margherita Crastona in Pavia and Vicenzino in Milan, but are painted with a warmer palette, without strong contrasts, and with far greater attention to establishing a wider stage for the still life to unfold upon. The use of a rock ledge as a 'platform' is a Renaissance device that confirms the painter's awareness of Neoclassicism.

In a third still life by this master (cat. no. 66) that has come to light, the stone ledge occupies a full quarter of the painting's surface: it is clearly to be considered a 'signature' motif. Another appears to be the painter's delight in always selecting a different variety of woven basket to hold the fruits. Some are finer, some are coarser; one has a handle made of wooden lathes. One suspects that a collection of these still lifes would constitute an anthology of North Italian basketweavings; perhaps these baskets will assist us in tracing the origins of this interesting painter.

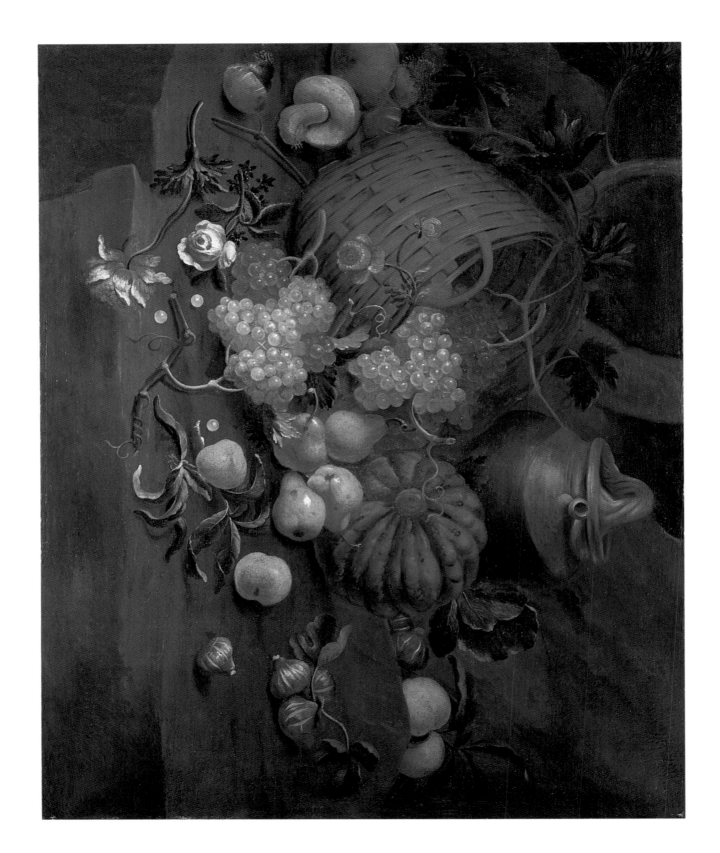

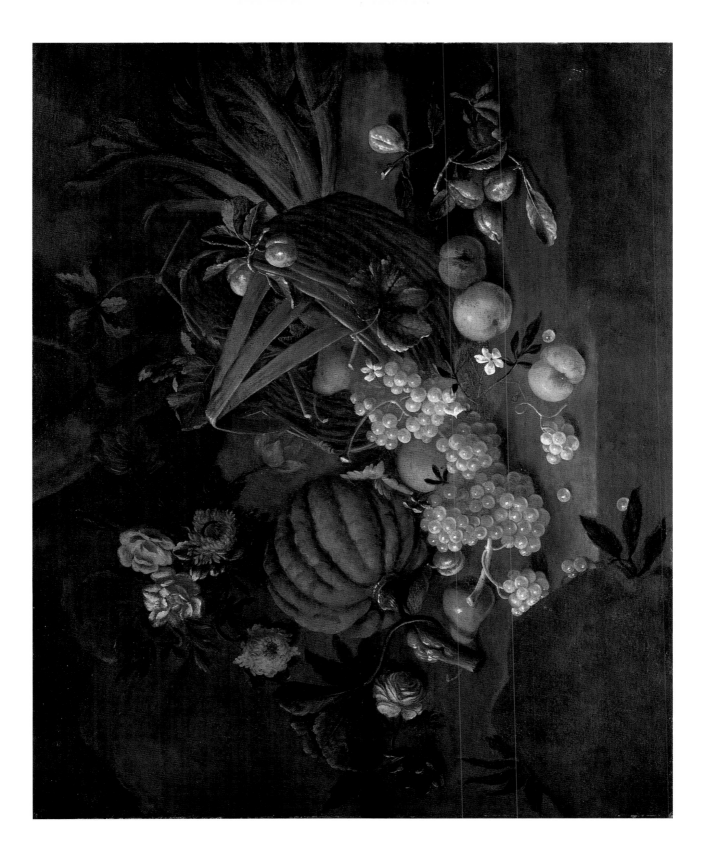

66

*Basket of Fruit with Celery and a Jar
of Olives on a Rock Ledge*

North Italian Painter
(second half of the eighteenth century)
Oil on canvas, 90 × 110.5 cm

T his is another characteristic picture by this painter, for
whom see the precedent entry (cat. nos. 64-65).

THE MYSTERIES OF *Nature*

A Vanitas

Luigi Miradori, called il Genovesino
(Genoa, documented in Cremona 1640–54)
Oil on canvas, 40.5 × 49.5 cm

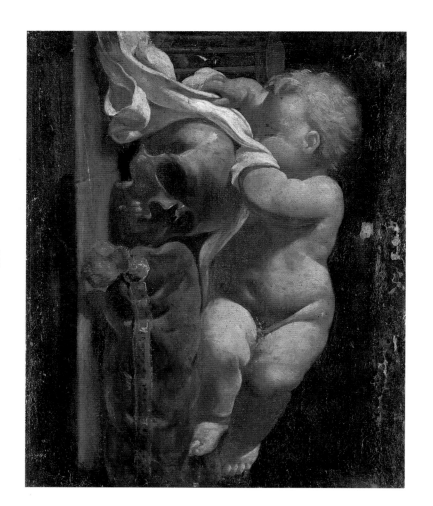

*L*uigi Miradori is a fascinating personality, whose career remains enigmatic in many respects. Called Il Genovesino, he was presumably born and trained in Genoa, but no details about his career are known to us. His earliest dated work, an altarpiece of 1639, was painted in Piacenza. In the next year, he had moved on to Cremona where he worked prolifically, in friendly competition with Pietro Martire Neri, until his premature death in 1654 or 1655. Miradori and Neri shared an unusual appreciation for contemporary Spanish painting (indeed Neri went to Rome to assist Velázquez in 1649–51), which is evinced in many of Miradori's paintings by a 'neo-Caravaggesque' naturalism, illuminated with vivid colors. Cremonese churches and collectors employed Miradori in every genre of art, from sacred subjects to portraits, *bambocciate* to still lifes.

Miradori is among the very few Italian artists to paint *Vanitas* subjects. The motif of a putto asleep on a skull is extremely rare, even in Netherlandish painting, yet Miradori painted it both in the present composition (known in two autograph versions) and in an altogether different picture of a *Sleeping Amor* in the Cremona picture gallery. The unvarying significance of *Vanitas* allegories concerns the inevitable decay and death, over time, of all mortal things. By introducing a white linen shroud to cover the skull, and by portraying a beautiful human infant, without wings, Miradori appears to introduce a Christian interpretation into this antique theme, as if to say that the Child Christ's sleep will overcome human death. See the painting by Baciccio and Porpora (cat. no. 71) in this same exhibition for a traditional representation of this Christian theme.

The flowing, confident brushstrokes in this *Vanitas* and the simple grandeur of the major forms – child, skull and red cushion – make this diminutive masterpiece into a impressive homage to Miradori's admired colleague, Diego Velázquez. A close replica of equivalent quality, but smaller dimensions, was with Trafalgar Galleries, London, in 1983 (cf. Bona Castellotti 1985, fig. 371).

A Kitchen Table with a Rooster, a Basket, and Copper Basins

Neapolitan Painter
(first half of the seventeenth century)
Oil on canvas, 75.5 × 162.5 cm

T he excellence of Neapolitan still lifes of the first half of the seventeenth century was already pointed out before 1667 in an art treatise written by Camillo Tutini. Of the four specialists singled out for praise — Luca Forte, Giacomo Recco, Ambrosiello Faro and Angelo Mariano — only Luca Forte is understood today. Archaic flowerpieces of every description have been indiscriminately ascribed to Giacomo Recco, while Faro and Mariano are completely unknown. No still lifes have yet been identified by Carlo Sellitto, who left nine 'small pictures of fruit with fish and other things' in his studio at his death in 1614. Angelo Turcofella is another specialist whose still lifes are cited in Neapolitan inventories, none of which can be identified. With the sole exception of a few signed by Luca Forte, Neapolitan still lifes of the first half of the seventeenth century never bear signatures regardless of their importance. A perfect example is this *Kitchen Table* of imposing dimensions and superb state of conservation. We find ourselves in the presence of a master who is contemporary to Luca Forte, but more sensuous and more mysterious. There is something about the way the woven basket is isolated in the darkness by a ray of light that reminds us that its contents of a white cloth and loafs of bread are Christian symbols. As is the rooster, who urges us to vigilence. While we cannot be sure of the artist's intention, at least one masterpiece by Luca Forte, a *Basket of Fruit and a Fish* (Spike 1983, cat. no. 14), has been shown to conceal mystical symbolism. The Spanish followers of Caravaggio, chiefly Velázquez and Zurbarán, also used austere compositions and descending light to direct the viewer towards contemplation. This fascinating *Kitchen Table* constitutes a direct precedent for the still lifes by Giambattista Recco, the sole protagonist of this mystical strain in the second half of the century until its revival by Andrea Belvedere.

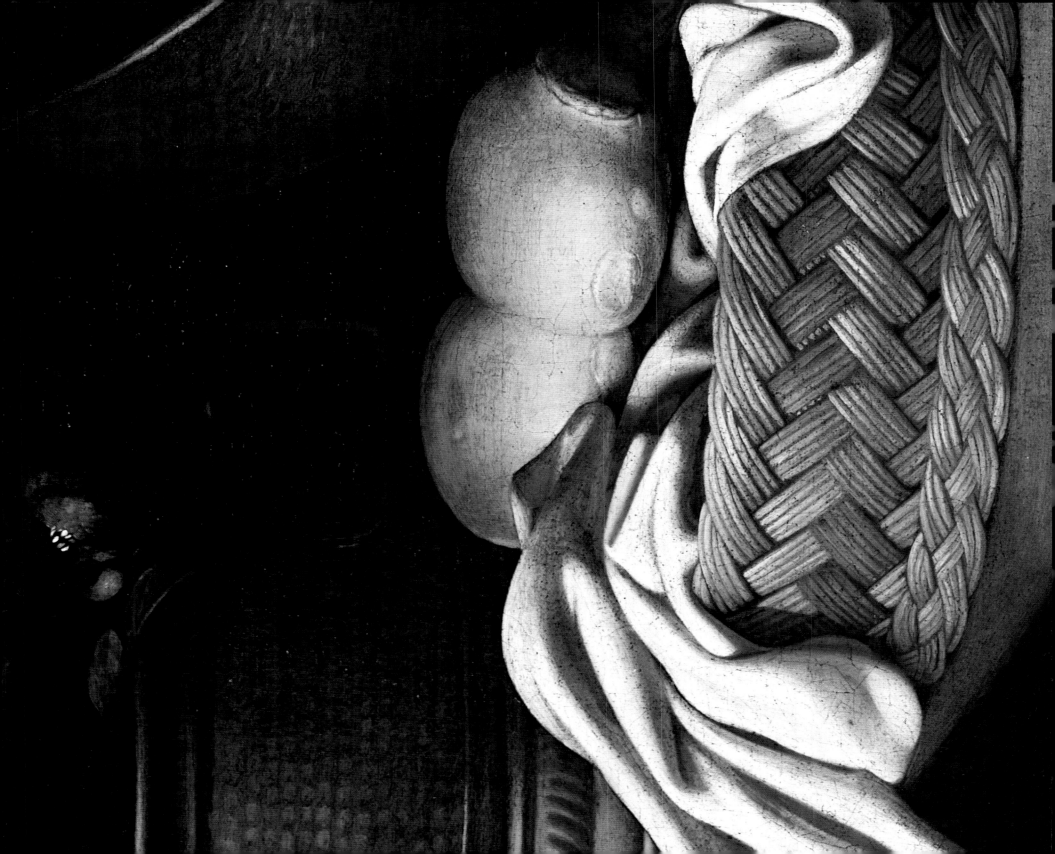

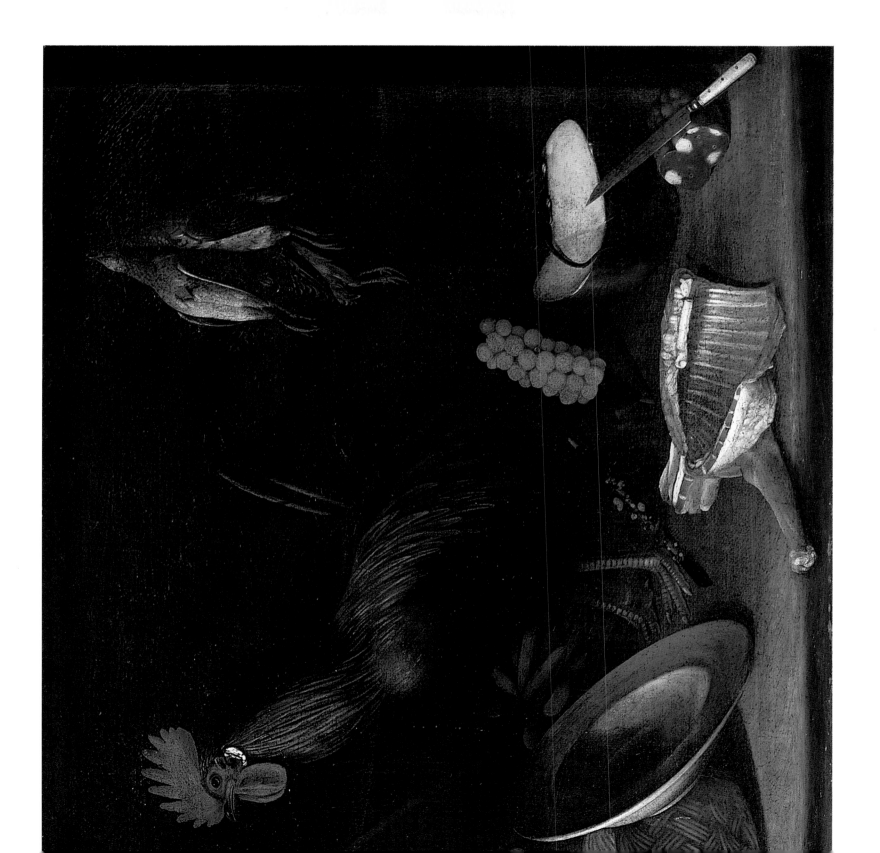

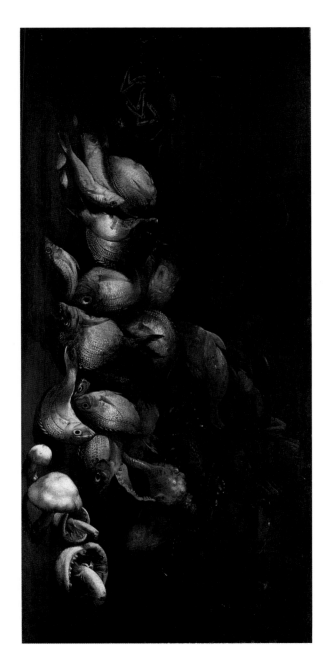

69

A Catch of Fish

Giambattista Ruoppolo [?]
(mid-seventeenth century)
Oil on canvas, 60.5 × 131.5 cm

The evening's catch of fish is shown glistening and writhing in the inky darkness of the nocturnal coastline. Rarely did the painters of marine still lifes depict their appetizing subjects still alive as in this remarkable painting. Giuseppe Recco and the other Neapolitans, like Giambattista Ruoppolo, were drawn to the boggling variety and exoticism of the fruits of the sea. The painter of this *Catch of Fish* appears to have been a Roman painter influenced by Paolo Porpora, who shared Porpora's interest in representing his subjects as living creatures and even in arousing our sympathy for those shown *in extremis*. The painting thus offers a deeper level of meaning than a simple kitchen still life. The execution of the painting belongs to a masterful hand distinct from Porpora, however, not to mention Giuseppe Recco, The Neapolitan painter of fish *par excellence*. Among their peers, Giambattista Ruoppolo (1629–93) is the most likely author of this work based on its affinities with the large signed *Fish on a Beach* in the Museo di San Martino in Naples.

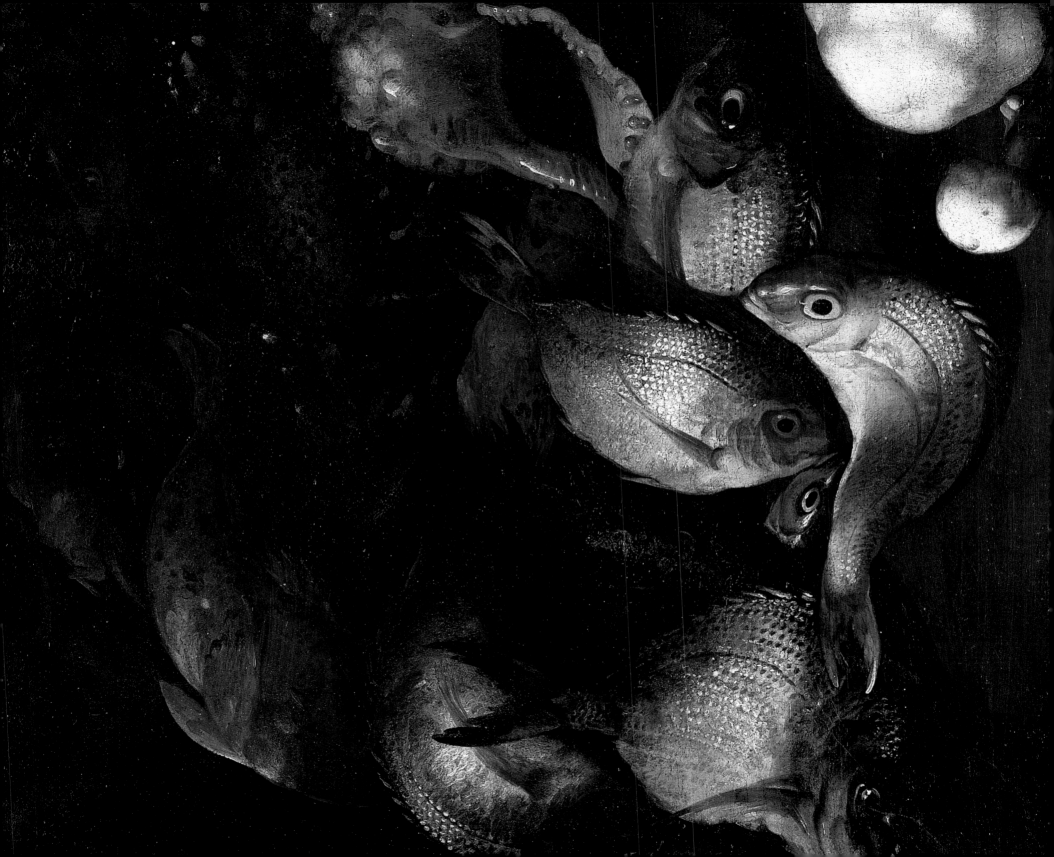

Melon, Grapes, Plums, Peaches and Other Fruits
Bartolomeo Guidobono
(Savona 1654 – Turin 1709)
Oil on canvas, 42 × 57 cm

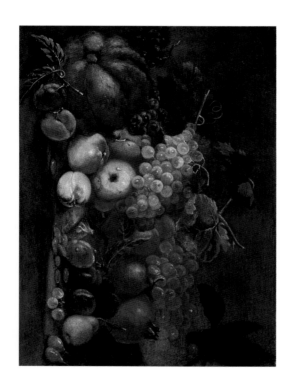

*T*he artist's father, Giovanni Antonio Guidobono, was a painter of ceramics in Savona, where Bartolomeo was born. The young artist's interest in literature developed into a deep attraction to the Church, and he was ordained a priest. 'Il prete savonese', as he was called, did not lose his love for painting, however. He went to Parma where he spent a year and greatly admired Correggio. Around 1680 he moved to Genoa, where his sweet style immediately attracted the attention of local collectors. In 1685 he made his first visit to Piemonte, whence he was called again at the end of his life to paint frescoes in several churches and in the Palazzo Reale.

The tremulous touch of Guidobono's brush is unmistakable in this small canvas, which takes on an exceptional importance as one of only independent still life composition. Nearly the same apples and peaches can be found in a detail of his *Lot and His Daughters* in the Palazzo Rosso, Genoa (cf. *La natura morta in Italia* 1989, figs. 153–54). Guidobono seems to imbue the fruits of the earth with a spiritual essence; the darkness around them seems to harbor secrets beyond our comprehension.

The great expert on the Genoese school, Bertina Suida Manning (*Art in Italy...* 1965, p. 158) once evaluated Guidobono's style in terms that seem especially appropriate here: 'his paintings show a certain pastel-like quality, where the lights appear as though filtered through nebulous clouds, extremely soft and sweet, the forms seem to float and the shadows are softened.'

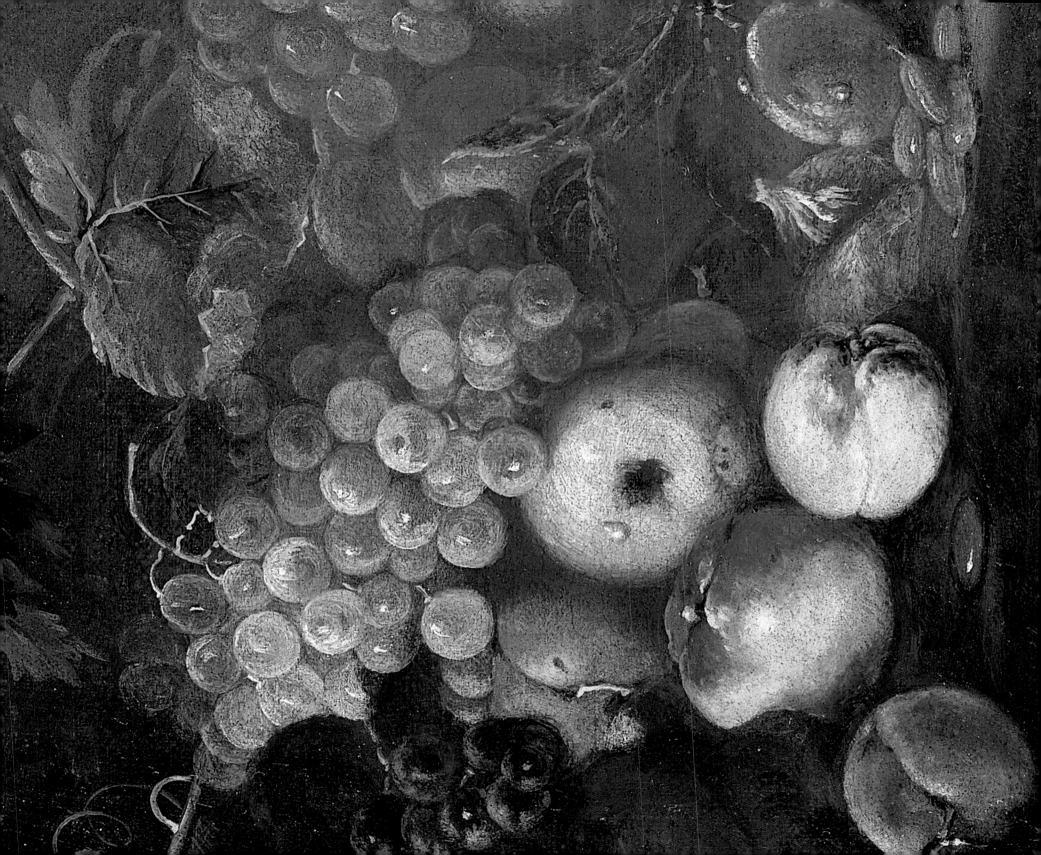

Garland of Flowers with the Christ Child Asleep

Giovan Battista Gaulli, called Baciccio (Christ Child Asleep)
(Genoa 1639 – Rome 1709)

Paolo Porpora (Garland of Flowers)
(Naples 1617 – Rome 1673)

Oil on canvas, 94.2 × 72 cm

Bibliography: Spike 2001ᵇ, pp. 71–72

Gaulli was a precocious young talent when he arrived in Rome in the mid-1650s. Within a few years, he had found his niche as the protégé of Giovan Lorenzo Bernini, the unchallenged leader of the Roman school. Their association was mutually beneficial; Baciccio was assured of prestigious commissions, while Bernini had found a gifted artist capable of translating his ideas into paintings.

This *Garland of Flowers with the Christ Child Asleep* is one of the most important Roman flowerpieces to come to light in past decades. The scene inside the garland represents the sleeping Christ Child adored by two angels; these figures are superbly rendered in the Berninesque style of Giovanni Battista Gaulli, called Baciccio. The splendidly hued and scintillating flowers are unmistakably from the brush of Paolo Porpora. Born and trained in Naples under Giacomo Recco, Porpora was traditionally considered one of the pillars of Neapolitan still lifes, even though relatively few of his paintings remained in the city Parthenopean. It was not suspected by anyone prior to 1983, when the present writer published the relevant documentation, that Porpora had

worked for almost the entirety of his career in Rome, where he was married in 1654. He was accepted into the Accademia di San Luca in April 1656 and faithfully attended the *congregazioni* in nearly every year between 1656 and 1670. He was admitted into the Virtuosi al Pantheon in 1666. Roman archives, and Chigi inventories in particular, cite numerous still lifes by Porpora, including floral garlands.

A collaboration between Baciccio and Porpora would have been almost inevitable. Both artists owed their greatest successes to the patronage of the Chigi family during the pontificate of Alexander VII Chigi. As Baciccio was chiefly employed to paint frescoes, portraits and altarpieces, his paintings for private collections are notably rare; we can assume that this *Garland* was a special commission for a special patron, very possibly a Chigi. Porpora has framed Baciccio's sacred subject, which alludes to the Passion of Christ, with a tulips, anemones and chrysanthemums of various shades of red, a Passion color. The other prevailing color, white, refers to the Child's divine purity. Red and white together symbolize the Resurrection.

The Significance of Still Lifes in the Baroque Era
Religion, Allegory, Science, Museum

Maurizio Fagiolo dell'Arco

Frontispiece of C.B. Ferrari, *Flora sive de florum cultura*, Rome 1638, second edition

Death or Life?

T he term *natura morta* [literally, 'dead nature'] is today exclusively reserved for that pictorial genre comprising paintings of flowers, fruits, animals, plants and all that belongs to the natural world. While now well established, the term was a late arrival and elsewhere we find almost opposing expressions: *Still life*, *Stilleben*, *Stilleven* (life rather than death). It was this conjuncture that suggested to Giorgio de Chirico a well known reprimand accompanied by the evocative definition: 'Remember that the ugly term "natura morta" with which today we classify in painting the depiction of dead animals and inanimate things, corresponds, in another language, to a far more profound and true and a much kinder term pervaded with poetry: "still life". Listen, comprehend, learn to express the remote voice of things, this is the road and the aim of art.'[1]

In effect, that term *natura morta* (just like the term Baroque) was never used in the seventeenth century. In the theoretical texts and in the inventories generic definitions were employed. Only in an inventory of the painting gallery of Vittorio Amedeo I of Savoy, compiled by Antonio della Cornia in 1635, does a particularly apt designation appear: 'Paintings of fruits, flowers and similar.'[2]

In contrast, the painters and their clientele were very well aware of the fact that a precise operation was being undertaken; that is to say, in painting (or commissioning) a *natura morta* eminent paths such as Allegory, the Sacred and even Science were being followed. This awareness has been wholly obscured in recent times, to the point that it has been lost: in the last century the revival of the 'still life' has relied only on pleasantness and what is easy on the eye.

Macrocosm and Microcosm

The successful book by the Jesuit priest Giovan Battista Ferrari, *Flora sive de florum cultura*, that appeared in Rome in 1633 (translated into Italian in 1638 as *Flora ovvero Cultura di fiori*) was a very precise example of the diverse meanings

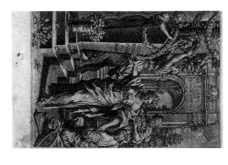

of *natura*. It was published within the ambit of the Barberini court and Rome's Accademia dei Lincei, the institute that saw the alternation of such figures as Federico Cesi, Fabio Colonna and Galileo Galilei, and it shows us the living presence of nature in at least three strata of thought:

a) True scientific illustration in the form of the beautiful plates portraying natural specimens embellished with garlands and inscribed cartouches that reflect the taste of one Cassiano dal Pozzo who recent studies have shown to be behind this publishing venture too.[3] The author would appear to be Nicolas de la Fleur, a friend of Poussin from Lorraine.[4]

b) Allegorical emphasis. There are no less than forty-six plates splendidly engraved by Johann Friedrich Grueter and Claude Mellan from drawings by Pietro da Cortona (the frontispiece, the *Banquet of the Gods*, the *Dispute Between Art and Nature*, the *Night*, *The Metamorphosis into Flowers and Bees of Florilla and Melissa*), Andrea Sacchi (*Limace and Bruco transformed by Flora*), Giovanni Lanfranco (*Banquet of the Gods*), Guido Reni (*Neptune*). These illustrations embellish the book but also represent a moral reflection that sees the *Metamorphoses* shade almost into the morality of a sermon.

c) Transposition into a picture. The most singular illustrative fact regarding the book is the presence towards the end of two plates with vases containing carefully arranged and explicitly signed flowers (by the specialist painter Anna Maria Vaiana).[5] In short, the awareness of a floral world transposed into a painting. The *natura morta* as a microcosm representative of the cosmos.

The Religion of Nature

Still today, there is a widespread conception of the still life as a straightforward decorative exercise, attractive and unproblematic. In reality, for some years now there has been increasing recognition that those fruits and those flowers, those animals and those insects aspire to nothing less than the composition of a symbolic, mystical or religious, sacred and allegorical picture. From prayer to litany.

I tre livelli di significato della natura all'interno del libro by G. B. Ferrari, Flora overo Cultura dei Fiori, Rome, 1638, second edition

Scientific illustration (plate by Nicolas de la Fleur?)

Allegorical illustration (plate drawn by Pietro da Cortona and engraved by Friederich Greuter)

Pictorial illustration (Still Life by Anna Maria Vaiana)

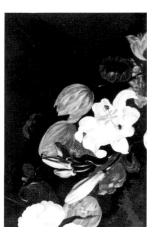

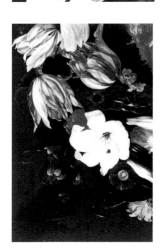

Giuseppe Recco
*Garland of Flowers with Christ
as a Child* (whole picture
and details)
private collection

The destination of these studies (as well as the indispensable point of departure) is the admirable *The Garden of Renaissance – Botanical Symbolism in Italian Painting* (Olschki, Florence, 1977). It was Mirella Levi d'Ancona who indicated the primary role of certain botanical motifs in the work of painters who were apparently concerned with very different matters. In Michelangelo's *The Holy Family*, for example, on the very edge of the perfect curvature of the base, there is a clover plant exhibited with suspect casualness: in the biblical tradition clover is a devout allusion to none other than the Holy Trinity, the theme that Michelangelo represented in the tondo commissioned by Agnolo Doni. In Raphael's *Deposition* (taken by Scipione Borghese from the church of San Francesco al Prato, Perugia) an emblematic dandelion appears alongside the signature in block capitals, a biblical allusion to the passion of Christ.[6]

Naturally, the Baroque century, in which the macrocosm flowed into the microcosm, in which attempts were made to transform the universe (visible and invisible) into speaking images, appears to have taken a great interest in the composition of a parallel nature in the sense of a mirror of devotion or an allegory of the sacred. Naturally, there was an alibi. Artists could no longer continue to fill galleries with pictures with religious or allegorical subjects alone: paintings of *vedute* or landscapes, those 'fruit, flowers and similar' were thus designated as a religious, that is to say allegorical, representation even though they brought the comprehensible world of nature within the palazzi. The landscape was thus adopted as an allusion to the beauties of creation; the still life was

181

Giuseppe Recco
*Garland of Flowers with John
the Baptist as a Child*
private collection

Michelangelo
The Holy Family (whole picture and detail of the cloverleaf, symbol of the Trinity)
Florence, Galleria degli Uffizi

accepted as a translation of the virtues or the vices, of the Virgin or of sin; the painting of ruins assumed a role as *vanitas vanitatum*.

This natural imagery thus became an alibi either for the patron or the painter. And yet the fact remains that the underlying foundation was sacred. Among the first patrons and collectors of still lifes in Italy at the threshold of the new century, whether the art spoke a Flemish or Lombard-Roman idiom (Jan Bruegel or Caravaggio), was none other than a representative of the Holy Roman Church, Cardinal Federico Borromeo.[7]

'There is nothing casual in the *natura morta* of the seventeenth century (only in the following century was the decorative prerogative to triumph), as indicated in the cartouche of a 'still life' conserved in the museum of Münster: 'IN HERBIS, IN VERBIS ET IN LAPIDIBUS DEUS.' Now that the coordinates of that school of thought (both captious and ingenuous), in this agnostic third millennium the picture has been restored to enigmatic silence, and only through history may we reveal those once patent and even obvious meanings. It would be akin to trying to explain today that the cypress stands for 'death,' the ivy for 'tenaciousness,' the rose for 'beauty' and 'transience' (*vanitas vanitatum*)...

The Allegory of Nature

Allegory, that is to say the central canon of the Baroque idiom, is a parallel world, but one that mirrors our own: it doubles and reflects like a *speculum salvationis*. In the late sixteenth century, the 'pictures of fruits, flowers and similar' were also created as dual images, a party to that microcosm that was continually to allude to the macrocosm.

The painter Jan Bruegel 'the Velvet' (Brussels, 1568 – Antwerp, 1625) was the son of the great Pieter and therefore born into an atmosphere of complex iconography: the four elements, the Tower of Babel or the seasons, the senses and the temperaments...

Raphael
The Deposition (whole picture and detail of the dandelion, symbol of the Resurrection)
Rome, Galleria Borghese

182

Jan Bruegel 'the Velvet'
The Garden of Eden
London, Victoria and Albert
Museum

His Italian sojourns, firstly at Naples in 1590 and then at Rome where he was protected by Cardinal Federico Borromeo, helped confirm his idea that painting had to be modelled on nature, but that the naked nature than had to be moralized an seen from behind the mirror (and alibi) of allegory. A painting of a series of birds is required? Imagine then two slim branches, choosing as a subject *The Element of Air* and *The Element of Water* (dated 1611, the pictures appeared at Sotheby's in London in the July of 1993). You wish to group a number of free-ranging animals? Give life then to *The Garden of Eden* (the painting is in the Victoria and Albert Museum, London), or *Noah's Ark* (The Walters Art Gallery, Baltimore).

The animals represented are configured as a sample or a zoo, a form of classification (far in advance of Linnaeus), a vision ranging from farmyard animals to the bird of paradise that had reached Europe aboard the ships of Ferdinand Magellan. A scientific treatise, but also a poetic montage that communicates with great facility.

However, Bruegel's work is first and foremost 'scientific.' When he painted a vase with almost one hundred different flowers for Cardinal Federico Borromeo (the painting is conserved in the Pinacoteca Ambrosiana) he wrote a series of letters (April–May, 1606) stating that he has identified the greater part of the flowers unknown in Lombardy and failing to find them all at Antwerp he had roamed as far as Brussels to seek them.

The Science of Nature

Natura morta as a decorative device? As facile, banal painting? As a negation of history? No, at least initially, the story of this genre of painting is quite the opposite. Developments of this type were also born of rigorous scientific analysis. One has to bear in mind

Jan Bruegel 'the Velvet'
Noah's Ark
Baltimore, The Walters
Art Gallery

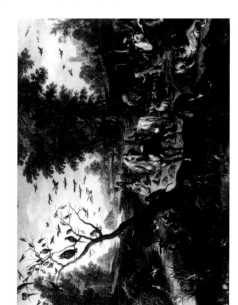

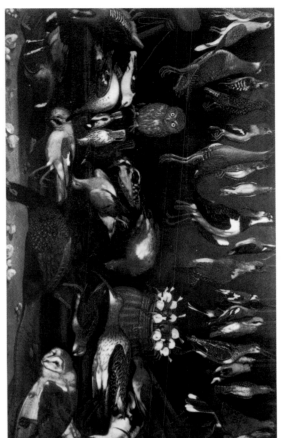

that most of the early seventeenth century books devoted to the natural world came out of the extremely learned circle of the Accademia dei Lincei: the inspiration of Galileo and an awareness of exoticism are the two poles between

which the authors of these illustrated repertories operated. There was a need for direct exploration of nature, just as one observed with one's own eyes (exalted by scientific instrumentation) the ancient mystery of the night sky. The ascent to the throne of a Florentine poet, Maffeo Barberini (subsequently Urban VIII), reinforced the group that congregated around Federico Cesi and Cassiano dal Pozzo: writers and engravers such as Fabio Colonna worked on the problems of the sky just as they were turning their attention to the nuances of terrestrial botany.

Science, then, but also an extremely lively parascientific world. I found two large vases of flowers in the frontispiece to a beautiful book dedicated to Cassiano dal Pozzo in 1622: they are set either side of a small altar with the Borghese family emblems (an eagle and a dragon) and below the title *Pharmacopea Spagiri-ca*, a book written by Pietro Poteri, counsellor and physician to the 'Re Cristianis-simo.' Clearly, this is an alchemical text, like those we find a few decades later at the court of Queen Christina of Sweden.

However, in order not to stray too far from painting, I believe that there is also a scientific side to many still lifes from the late sixteenth century and early seventeenth centuries. I am thinking, for example, of that remarkable sideboard painted in the workshop of the Cavalier d'Arpino (Federico Zeri attributes it to a young Caravaggio) which features a lavish display of birds, all dead except for a vigilant (wise) owl located in the centre.[8] In this 'picture with diverse dead game

Workshop of the Cavalier d'Arpino (also attributed to Caravaggio, to the Master of Hartford and to Franz Snyders)
Picture with various dead birds
Rome, Galleria Borghese

Upper row of birds: quail, turtledove, woodcock, woodpecker, starling, finch, moorhen, lark, greenfinch, lapwing, kingfisher, wren, green woodpecker, goldfinch, jack snipe, chaffinch [?], robin, snipe [?], male chaffinch [?], turtledove[?]. Lower band: owl, plucked wheatears on a basket. On the middle shelf: Greek partridge, golden oriole, teal [?], thrush, blackbird, woodpecker, wood pigeon, partridge, plover, curlew, dove, duck. In the foreground: wild duck, jay, pheasant, barn owl

184

Nature in an hermetic key
Frontispiece of F. Poteri,
Pharmacopea spagirica,
Bologna, 1622
(an alchemical text dedicated to Cassiano dal Pozzo)

Frontispiece of F. Colonna Linceo, *Minus cognitarum rariorumque*, Rome, 1616

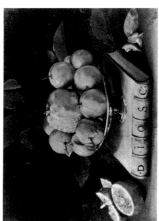

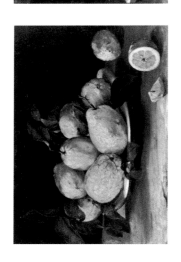

Luca Forte
Still Life with Citrus Fruits and *Still Life with Citrus Fruits and a Book by Dioscorides*
private collection (courtesy of Angelo di Castro)

Dioscorides was a Greek physician of the 1st century B.C., a master of pharmacology

Frontispiece of G. P. Bellori, *Nota delli Musei, Librerie, Galerie et ornamenti di statue e pittura ne' Palazzi nelle Case e ne' Giardini di Roma*, 1664

birds' (as it is defined in the inventory) I have, with the help of an expert, counted no less than forty-four species, almost all of them identified. Does this mean that it is but a short step from the hanging of the sideboard to the dinner table? No, the picture represents much more: I believe that it can be seen as a kind of scientific classification, in the manner of Linnaeus.

The Museum of Nature

The attitude of the Baroque academic and scientist, or even that of a curious amateur, to the worlds of flora or fauna, was one of both analytical investigation and wonder. The classification of a natural world almost emblematically coincided with that of the historical world: botany assumed the same dignity as archaeology or history in Renaissance painting. One example among many; when Giovan Pietro Bellori compiled his *Nota delli Musei, Librerie, Galerie et ornamenti di statue e pitture, ne' Palazzi, nelle Case e ne' Giardini di Roma* (1664) he devoted ample space to nature.' He catalogued all the 'gardens of simples' (medicinal herbs), from that of the Sapienza and that of San Pietro in Montorio to those in private hands. He provided a list of the collections of 'foreign and rare trees' (in Palazzos Falconieri, Pio and Mattei), just as he carefully catalogued the collections of antiquities and those of 'modern' paintings.

To return to the botanical world, it should be noted that Tobia Aldini used the methods of a museum cataloguer when in 1625 he compiled his *exactissima descriptio* of the plants contained in the kitchen garden of Cardinal Farnese (down to the new species of acacia that is today known as 'Farnesiana'). There is, however, also a contrasting case. Alongside his ponderous and encyclopaedic treatises on nature, Ulisse Aldrovandi of Bologna, the prophet of this science, was also the author of the volume *Le statue antiche di Roma* (1556). The 'great museum' of nature marries the museum of antiquity.

This epilogue is a revision of a text that appeared in a catalogue published (ten years ago) by Paolo Sproviero, friend and collector. It is dedicated to both him and John T. Spike.

185

[1] G. de Chirico, 'Metafisica dell'America', in *Omnibus*, Rome, 1938 (now in *Il meccanismo del pensiero – critica, polemica, autobiografia 1911–43* edited by M. Fagiolo dell'Arco, Einaudi, Turin, 1985, pp. 349–56).

[2] See the article by M. di Macco in *Storia dell'Arte*, studies in honour of G. C. Argan, Florence, 1994.

[3] A useful introduction to scientific still lifes is provided by the text by G. Olmi in *La natura morta in Italia*, Milan, 1989, pp. 69–91. With regards to the milieu of Cassiano dal Pozzo, see the *Quaderni Puteani*, published by Olivetti between 1989 and 1993, as well as the studies by F. Solinas (cf. *Cassiano del Pozzo*, the acts of the International Study Seminary, De Luca, Rome, 1989) and D. Freedberg, 'Cassiano del Pozzo's Drawings of Citrus Fruits' in *Il museo cartaceo di Cassiano dal Pozzo*, 'Quaderni Puteani' 1, Milan, 1989. See also the exhaustive study by D. L. Sparti, *Le collezioni dal Pozzo – storia di una famiglia e del suo museo nella Roma seicentesca*, Modena, 1992.

[4] 'The name of Nicolas de la Fleur was mentioned to me in 1994 by Bruno Contardi who was about to publish an academic study in a series I edited. The Frenchman's name appears frequently in Cassiano dal Pozzo's papers (see with regards to this painter, J. Bousquet, *Recherches sur le séjour des peintres français a Rome au XVII^me siècle*, Montpellier 1980, p. 178). With regards to the engravings in Ferrari's book see finally L. Ficacci, *Claude Mellan, gli anni romani*, exhibition catalogue (Palazzo Barberini), Rome, 1989.

[5] With regards to Anna Maria Vaiana, see G. Bocchi, U. Bocchi, *Naturalia: Nature morte in collezioni pubbliche e private*, Casalmaggiore, 1992, pp. 194–97 (two decorated vases with flowers, signed). There is a portrait of the Florentine artist by Claude Mellan (L. Ficacci, *op. cit.*, p. 259). Her husband Jacques Courtois joined the Jesuit order after her death. One of her paintings appears in the Barberini collection: 'A picture, with an Indian plant, the Jerusalem cherry, with a finch and 3 bees and a grasshopper, 7 spans high and 5 wide, made by the daughter of Vaiano.'

[6] In the previously cited book by M. Levi d'Ancona, see the texts on pp. 100–101, 127.

[7] With regards to Federico Borromeo, see P. M. Jones, *Federico Borromeo and the Ambrosiana – Art Patronage and reform in Seventeenth Century Milan*, Cambridge, 1993.

[8] With regards to the circle of the Accademia dei Lincei, see the exhibition catalogue, *L'Accademia dei Lincei e la cultura europea del XVII secolo – Manoscritti, libri, incisioni, strumenti scientifici*, Accademia dei Lincei, Rome, 1992. For the still life with birds in the Galleria Borghese, see F. Zeri, 'Sull'esecuzione di "nature morte" nella bottega del Cavalier d'Arpino, e sulla presenza ivi del giovane Caravaggio' in the book *Diari di lavoro 2*, Einaudi, Turin, 1976, pp. 92–103.

[9] A facsimile edition of Bellori's book has been published, with an exhaustive commentary by E. Zocca, Istituto Nazionale di Archeologia e Storia dell'Arte, Rome, 1976.

Annexes

Bibliography

A

Arcangeli 1961
F. Arcangeli, 'Il fratello del Guercino,' in *Arte antica e moderna*, 13/16, 1961, pp. 325–53.

Arisi 1973
F. Arisi, *Felice Boselli*, Rome 1973.

Arisi 1979
F. Arisi, 'Felice Boselli,' in *L'Arte del settecento emiliano, L'Arte a Parma dai Farnese ai Borbone*, exhibition catalogue, Bologna 1979, pp. 30–34.

Arisi 1995
F. Arisi, *Natura Morta tra Milano e Parma in età barocca: Felice Boselli, rettifiche e aggiunte*, Piacenza 1995.

Art in Italy... 1965
Art in Italy 1600–1700, exhibition catalogue, Detroit 1965.

B

Baglione 1642
G. Baglione, *Le vite de' pittori, scultori, architetti ed intagliatori, dal pontificato di Gregorio XIII dal 1572, fino a' tempi di Papa Urbano VIII*, Rome 1642 [ed. 1649].

Barbolini Ferrari, Boccolari 1995
E. Barbolini Ferrari, G. Boccolari, *I colori del Rame vicende dell'arte dei ramai estensi*, Correggio 1995.

Barocco Italiano... 1995
Barocco Italiano: due secoli di pittura nella Collezione Molinari Pradelli, exhibition catalogue (Palazzo Te), Mantua 1995.

Bartoli 1793
F. Bartoli, *Le pitture sculture ed architetture della città di Rovigo*, Venice 1793.

Benati, Peruzzi 2000
D. Benati, L. Peruzzi (eds.), *La natura morta in Emilia e in Romagna* (Banca Popolare dell'Emilia Romagna), Milan 2000.

Bergamini, Bergamini 1983
G. Bergamini, A. Bergamini, 'Leopoldo Zuccolo e il suo manoscritto sui pittori Friuliani,' in *Studi fo-*

rogiulesi in onore di C. G. Mor, Udine 1983, pp. 259–80.

Bigongiari 1982
P. Bigongiari, *Il Seicento Fiorentino*, Florence 1982.

Bini, Strinati, Vodret 2000
A. Bini, C. Strinati, R. Vodret (eds.), *Colori della Musica: Dipinti, strumenti e concerti tra Cinquecento e Seicento*, Milan 2000.

Bocchi, Bocchi 1992
G. Bocchi, U. Bocchi, *Naturalia. Nature morte in collezioni pubbliche e private*, Casalmaggiore 1992.

Bocchi, Bocchi 1998
G. Bocchi, U. Bocchi (eds.), *Naturaliter*, Casalmaggiore 1998.

Bona Castellotti 1985
M. Bona Castellotti, *La pittura lombarda del '600*, Milan 1985.

Boschini 1660
M. Boschini, *La carta del navegar pittoresco*, Venice 1660.

C

Causa 1972
R. Causa, 'La natura morta a Napoli nel Seicento e nel Settecento,' in *Storia di Napoli*, vol. II, 1972, pp. 995–1055.

Chiarini 1987
M. Chiarini, *Natura morta Italiana del Sei e Settecento* (Corsi Gallery, Museo Bardini), Florence 1987.

Chiarini, Navarro, Passalacqua 1998
M. Chiarini, F. Navarro, R. Passalacqua, *La natura morta in Villa. Le Collezioni di Poggio a Caiano e Topaia*, exhibition catalogue, Florence 1998.

Cirillo, Godi 1996
G. Cirillo, G. Godi, *Le Nature Morte del "Pittore di Carlo Torre" (Pseudo Fardella) nella Lombardia del secondo Seicento*, Parma 1996.

Cohen 1983
R. Cohen, *Trafalgar Galleries at the Royal Academy III*, London 1983.

Cottino 1995
A. Cottino, '"Dipinger fiori e frutti sì bene contrafatti...": la natura morta caravaggesca a Roma', in *La natura morta al tempo di Caravaggio*, exhibition catalogue, Museo Capitolino, Rome 1995, pp. 59–65.

Crespi 1769
L. Crespi, *Vite de' pittori bolognesi non descritte nella Felsina Pittrice*, Bologna 1769.

D

D'Addosio 1920
G. B. D'Addosio, 'Documenti inediti di artisti napoletani dei secoli XVI e XVII dalle polizze dei Banchi,' in *Archivio storico per le province napoletane*, Naples 1920.

Danesi Squarzina 1998
S. Danesi Squarzina, 'Natura morta e collezionismo a Roma nella prima metà del Seicento. Il terreno di elaborazione dei generi,' in *Storia dell'Arte*, 93–94, 1998, pp. 266–91.

De Renaldis 1738
C. de Renaldis, *Della Pittura Friulana, Saggio storico*, Udine 1738 [ed. 1798].

Dézailler D'Argenville 1742
A. J. Dézailler D'Argenville, *Abrégé de la vie des plus fameux peintres*, 2 vols, Paris 1742 (II. 2a ed., 1762).

F

Fantelli, Lucco 1985
P. L. Fantelli, M. Lucco, *Catalogo della Pinacoteca della Accademia dei Concordi di Rovigo*, Venice 1985.

Faré 1974
M. Faré, *Le Grand Siècle de la Nature Morte en France, le XVIIe siècle*, Paris 1974.

Ferino-Pagden 1996
S. Ferino-Pagden, *I cinque sensi nell'arte: Immagini del Sentire*, exhibition catalogue, Venice 1996.

Ferino-Pagden 2000
S. Ferino-Pagden, *Dipingere la muscia: Strumenti*

in posa nell'arte del Cinque e Seicento, exhibition catalogue, Milan 2000.

Fiori 1967
C. Fiori, 'Le Nature Morte del misterioso Arbottoni,' in *Libertà*, 27 ottobre 1967.

Fumagalli 1995
E. Fumagalli, 'Dipinti di natura morta tra Firenze e Roma,' in *La natura morta al tempo di Caravaggio*, exhibition catalogue, Rome 1995, pp. 67–73.

G

Ghirardi 1986
A. Ghirardi, 'Bartolomeo Passerotti,' in V. Fortunati Pietrantonio, *Pittura Bolognese del '500*, Bologna 1986, II, pp. 543–94.

Godi 2000
G. Godi (ed.), *Fasto e rigore. La Natura Morta nell'Italia settentrionale dal XVI al XVIII secolo*, Milan 2000.

Colzio 1939
V. Colzio, *Documenti artistici sul Seicento nell'Archivio Chigi*, Rome 1939.

Gregori 1960
M. Gregori, *Mostra dei tesori segreti delle case fiorentine*, Florence 1960.

Gregori 1986
M. Gregori, 'Tradizione e novità nella genesi della pittura fiorentina del Seicento,' in *Il Seicento fiorentino. Pittura*, Florence 1986.

Gregori 1997
M. Gregori, 'Una svolta per Tommaso Salini pittore di nature morte,' in *Paragone*, XLVIII, 15–16, 1997, pp. 58–63.

H

Horticulture as Art 1990
Horticulture as Art, exhibition catalogue, Florence 1990.

L

La Mattina 1997
F. P. La Mattina, *La natura morta in Sicilia nell'I-conografia sacra del Seicento*, Palermo 1997.

L'anima e le cose... 2001
L'anima e le cose: Natura morta nell'Italia pontificia nel XVII secolo, exhibition catalogue, Modena 2001.

La natura morta a Napoli 1964
'La natura morta a Napoli,' in *Antichità viva*, III, nos 7–8, 1964, pp. 59–68.

La natura morta al tempo... 1995
La natura morta al tempo di Caravaggio, exhibition catalogue, Naples 1995.

La natura morta in Emilia... 2000
La natura morta in Emilia e in Romagna, exhibition catalogue, Milan 2000.

La natura morta in Italia 1989
La natura morta in Italia, 2 vols, Milan 1989.

La natura morta italiana 1964
La natura morta italiana, exhibition catalogue (Palazzo Reale), Naples 1964.

La raccolta Molinari Pradelli... 1984
La raccolta Molinari Pradelli: Dipinti del Sei e Settecento, exhibition catalogue, Bologna 1984.

M

Mariuz 1976
A. Mariuz, 'La villeggiatura di Bagnoli e il pittore Andrea Pastò,' in *Arte veneta*, 1976, pp. 197–200.

Martinioni 1663
G. Martinioni, *Venetia città nobilissima et singolare*, Venice 1663.

Masini 1690
A. Masini, *Aggiunta alla Tavola e Catalogo dei Pittori e Scultori moderni della Scuola di Bologna* (in *Bologna perlustrata 1690*, Bologna 1686).

Meijer 1990
F. Meijer, 'Enige schilderijen met vee in C. B. A. Ruthart,' in *Oud Holland*, 104, 1990, pp. 331–35.

Miotti 1951–1954
T. Miotti, 'Le Nature Morte di Paolo Paoletti,' in *Atti dell'Accademia di Scienze Lettere e Arti di Udine*, 1951–1954, pp. 13–32.

Miotti 1988
T. Miotti, 'Due Nature Morte inedite di Paolo Paoletti,' in *Studi in omaggio a Giuseppe Marchetti*, Udine 1988, pp. 597–600.

Miotti 1995
T. Miotti, 'Altri dipinti inediti di Paolo Paoletti,' in *Sot la Nape*, XLVII, 1995, pp. 55–58.

Morandotti 1989
A. Morandotti in *La natura morta in Italia*, 2 vols, Milan 1989.

Moretti 1968
M. Moretti, *Museo Nazionale d'Abruzzo*, L'Aquila 1968.

Mosco 1988
M. Mosco, M. Rizzotto, *Floralia*, exhibition catalogue, Florence 1988.

N

Natura viva... 1986
Natura viva. Animal Paintings in the Medici Collection, exhibition catalogue, New York 1986.

P

Pascoli 1730–1736
L. Pascoli, *Vite dei pittori, scultori et architetti moderni*, 2 vols, Rome 1730–1736, ed. 1768.

Pegazzano 1997
D. Pegazzano, 'Documenti per Tommaso Salini,' in *Paragone*, XLVIII, 15–16, 1997, pp. 131–46.

Porzio 1979
F. Porzio, *L'Universo illusorio di Arcimboldi*, Milan 1979.

R

Ravelli 1978
L. Ravelli, 'Polidoro Caldara da Caravaggio,' in *Monumenta Bergomensia*, XLVIII, 1978.

Ravelli 1988
L. Ravelli, 'Bartolomeo Arbotoni piacentino, maestro di Evaristo Baschenis. Ipotesi sulla formazione del pittore bergamasco,' in *Atti dell'Ateneo di Scienze Lettere ed Arti*, 2nd ed. 1988.

Rizzi 1968
A. Rizzi, *Mostra della Pittura Veneta del Seicento in Friuli*, exhibition catalogue (church of San Francesco), Udine 1968.

Rizzi 1969
A. Rizzi, *Il Seicento. Storia dell'Arte in Friuli*, Udine 1969.

Roli 1964
R. Roli, in *La Natura Morta Italiana*, exhibition catalogue, Naples 1964.

Romagnolo 1981
A. Romagnolo, *La pinacoteca dell'Accademia dei Concordi*, Rovigo 1981.

Ruffo 1916
V. Ruffo, 'La Galleria Ruffo nel secolo XVII in Messina,' in *Bollettino d'Arte*, 1916, pp. 21–64.

S

Safarik 1981
E. A. Safarik, *Catalogo sommario della Galleria Colonna di Roma*, Busto Arsizio–Rome 1981.

Salerno 1984[a]
L. Salerno, *Natura Morta Italiana. Tre secoli di natura morta italiana. La raccolta Silvano Lodi*, exhibition catalogue, Florence 1984.

Salerno 1984[b]
L. Salerno (translations by R. E. Wolf), *Still Life Painting in Italy 1560–1805*, Rome 1984.

Salerno 1989
L. Salerno, *New Studies on Italian Still Life Painting*, Rome 1989.

Sestieri 1990
G. Sestieri, *Nature morte italiane ed europee dal XVI al XVIII secolo* (Cesare Lampronti Gallery), Rome 1990.

Sestieri 1991
G. Sestieri, *Pittori di nature morte dal XVI al XVIII secolo* (Menaguale Gallery), Verona 1991.

Silos 1672
I. M. Silos, *Pinacotheca sive Romana Pictura et Sculptura*, Rome 1672 (ed. M. Basile Bonsanti 1979).

Spike 1983
J. T. Spike, *Italian Still Life from Three Centuries*, exhibition catalogue, New York–Florence 1983.

Spike 2001[a]
J. T. Spike, *Caravaggio*, New York 2001.

Spike 2001[b]
J. T. Spike, 'La riscoperta di un Bambino Gesù entro una ghirlanda di fiori di Baciccio e Paolo Porpora,' in *Arte viva*, 2001, IX, 25/26, pp. 71–72.

Suida–Manning 1965
B. Suida–Manning, *Art in Italy*, Detroit 1965.

Symbolique & botanique... 1987
Symbolique & botanique: le sens caché des fleurs dans la peinture au XVII° siècle, exhibition catalogue, Musée des Beaux Arts de Caen, 1987.

T

Tognoli 1976
L. Tognoli, *G. F. Cipper*, Bergamo 1976.

Trezzani 1989
L. Trezzani, in *La natura morta in Italia*, 2 vols, Milan 1989.

V

Veca 1981
A. Veca, *Vanitas Il simbolismo del tempo*, (Lorenzelli Gallery), Bergamo 1981.

Veca 1982
A. Veca, *Paràdeisos dall'universo del fiore* (Lorenzelli Gallery), Bergamo 1982.

W

Wind 1974
B. Wind, 'Pitture ridicole: Some Late Cinquecento Comic Genre Painting,' in *Storia dell'Arte*, 20, 1974, pp. 25–35.

Z

Zeri 1959
F. Zeri, *La Galleria Pallavicini in Roma*, Florence 1959.

191

List of Works

The Rediscovery of Nature

1
Allegory of Summer
Francesco Zucchi
(Florence 1562 – Rome 1622)
Oil on canvas, 95 × 78.5 cm

2-3
*A Basket of Fruit, a Watermelon,
and a Bird Eating a Cherry*
*Still Life with a Basket of Lettuce,
Celery, Cucumbers, and Figs*
Roman Painter
(1600 ca.)
Oil on canvas, 54 × 66.5 cm; 54 × 67.5 cm

4
*A Farmer Bringing Baskets of Fruit
to a Table with a Large Fruit Basket
and Sliced Watermelons*
Pseudo Pietro Paolo Bonzi
(active in Rome ca. 1600–10)
Oil on canvas, 133 × 171.5 cm

5-6
*A Pair of Terracotta Vases
with Bouquets of Flowers*
*A Pair of White Vases
with Bouquets of Flowers*
Jacopo Ligozzi
(Verona 1547 – Florence 1627)
Oil on canvas, 50 × 62 cm; 49 × 62.5 cm

7
*A Child Playing with a Beetle
and a Vase of Flowers*
Emilian or Lombard Painter
(first half of the seventeenth century)
Oil on canvas, 56.5 × 72 cm

8
A Vase of Flowers
Anonymous Painter of the circle
of Daniel Seghers
(first half of the seventeenth century)
Oil on canvas, 53.5 × 36.5 cm

9
Studies of Aquatic Birds
Carl Borromäus Andreas Ruthart
(Danzig ca. 1630 – L'Aquila 1703)
Oil on canvas, 32 × 57 cm

The Flavors of Nature

10
Still Life with Fish
Alexander Adriaensen
(Antwerp 1587–1661)
Oil on panel, 67.5 × 106 cm

11
*Kitchen Scene with Christ
in the House of Martha and Mary*
Adriaen van Utrecht
(Antwerp 1599–1652)
Oil on canvas, 171 × 210 cm

12
Kitchen Still Life
Painter close to Francisco de Herrera,
called lo Spagnolo dei pesci
(Seville 1627 – Madrid 1685)
Oil on canvas, 62.5 × 102 cm

13
*A Bunch of Grapes with Various Fruits
on a Ledge*
Michelangelo Cerquozzi
(Rome 1602–60)
Oil on canvas, 47 × 35 cm

14-15
*Wooden Tub with Onions, Basket
with Cherries, Peaches and Pears*
*Turnips, Radishes, Savoy Cabbage, Artichokes
and Mushrooms*
Emilian Painter
(second half of the seventeenth century)
Oil on canvas, 79.5 × 117.5 cm each

16
*Melons, Lemon Slices, Apples, Figs,
Pears and Pomegranates*
Paolo Paoletti
(Padua ca. 1671 – Udine 1735)
Oil on canvas, 76 × 98.5 cm

17
*Lemon Slices, Apples, and Apricots
in a Landscape*
Paolo Paoletti
(Padua ca. 1671 – Udine 1735)
Oil on canvas, 96 × 73 cm

18
*Squashes, Mushrooms, Lettuce,
and Fruit Jars*
Emilian Painter
(second half of the seventeenth century)
Oil on canvas, 65.5 × 102 cm

19
Melons and other Fruits under a Grape Arbor
North Italian Painter
(mid-seventeenth century)
Oil on canvas, 100 × 75.5 cm

20

Still Life with Poultry, Game,
Squash, Lemons and Garlic
Jacob van de Kerckhoven,
called Giacomo da Castello [?]
(Antwerp 1637 – Venice 1712)
Oil on canvas, 88 × 122 cm

21

Still Life with Fish and Fruit
Simone del Tintore
(Lucca 1630–1708)
Oil on canvas, 76.5 × 97 cm

Nature in Flower

22

Sculptured Vase with a Bouquet of Flowers
Bartolomeo Ligozzi
(Florence ca. 1630–95)
Oil on canvas, 70 × 115 cm

23

Three Amorini Arranging Flowers in a Basket
Astolfo Petrazzi [?]
(Siena 1580–1653)
Oil on canvas, 56 × 45 cm

24

Flowers in a Golden Vase sculpted
with the Judgement of Paris
Francesco Mantovano [?]
(documented in Venice 1636–63)
Oil on canvas, 45.5 × 29 cm

25

Flowers in a Vase decorated
with a Grotesque Mask
Francesco Mantovano
(documented in Venice 1636–63)
Oil on canvas, 65 × 50 cm

26

A Blue Vase with a Bouquet of Flowers
Mario Nuzzi, called Mario de' Fiori [?]
(Rome 1603–73)
Oil on canvas, 77.5 × 63.5 cm

27

A Girl Tying a Festoon of Flowers to a Tree
Giovanni Stanchi
(Rome 1608 – ca. 1673)
Oil on canvas, 96 × 73 cm

28

A Sculptured Vase with a Bouquet of Flowers
Giovanni Stanchi
(Rome 1608 – ca. 1673)
Oil on canvas, 46.2 × 54.4 cm

29

A Vase of Flowers toppled over
Florentine Painter
(mid-seventeenth century)
Oil on canvas, 97.5 × 220 cm

30

A Sculpted Vase with a Bouquet
of Flowers
Andrea Scacciati
(Florence 1642–1710)
Oil on canvas, 95 × 72 cm

31

Vase of Anemones and Other Flowers
Nicola van Houbraken
(Messina 1660 – Leghorn 1723)
Oil on canvas, 63.5 × 48 cm

32

Still Life with Flowers and Cherries
Milanese Painter of the circle of Vicenzino
(active ca. 1690–1700)
Oil on canvas, 73 × 91.5 cm

33-34

Two Vases, a Platter and a Basket of Flowers
Two Vases, a Platter and a Basket of Flowers
Elisabetta Marchioni
(Rovigo † 1700 ca.)
Oil on canvas, 144 × 190 cm each

Nature's Harvest

35

Young Woman with Harvest Fruits
Pittore della Vendemmiatrice
(active in Cremona, ca. 1600)
Oil on canvas, 94 × 73.5 cm

36

Fruits, a Partridge and a Boar's Head
Jacob van de Kerckhoven,
called Giacomo da Castello
(Antwerp 1637 – Venice 1712)
Oil on canvas, 73 × 99.5 cm

37

Flowers, Fruit, Mushrooms,
a Parrot and a Monkey
Abraham Bruegel
(Antwerp 1631 – Naples 1697)
Oil on canvas, 89 × 98.5 cm (oval)

38

Fruits and Flowers in a Glass Vase
in a Landscape
South Italian Painter
(second half of the seventeenth century)
Oil on canvas, 73.5 × 100 cm

39

Watermelon, Lemons, Plums and a Peach
The 'Metropolitan Master'
(1700 ca.)
Oil on canvas, 28.5 × 46.5 cm

40
Pomegranates, Grapes and Figs
Franz Werner von Tamm,
called Monsù Daprait
(Hamburg 1658 – Vienna 1724)
Oil on canvas, 41 × 65.5 cm

41
Grapes, Pomegranates and Pears
Roman Painter
(1675 ca.)
Oil on canvas, 39.2 × 69 cm

42
A Gilt Vase with Flowers and Fruits
Giovanni Saglier, attr.
(active in Milan, in the late seventeenth century)
Oil on canvas, 37.5 × 48 cm

43
A Glass Bowl with Fruit and Roses
Giuseppe Vicenzino
(Milan 1662 – post 1700)
Oil on canvas, 34.5 × 43.5 cm

44
Melon, Quinces, Pears, and Prunes
Pittore di Carlo Torre
(active in Milan, late seventeenth
century / early eighteenth century)
Oil on canvas, 47 × 71 cm

45-46
Melon, Plums, Pears, Quinces,
Apples and Grapes
Plate of Strawberries, Citrons, Mandarin
Oranges, Pears and Asparagus
Master of the Second Molinari Pradelli Pendant
(Lombardy, seventeenth century)
Oil on canvas, 80 × 100 cm each

47
A Peeled Apple with Other Fruits and Flowers
Marcantonio Rizzi
(Pralboino 1648 – Montemartino 1723)
Oil on canvas, 38.5 × 48 cm

48-49
Dwarves Cutting Roses (Spring)
Signed lower right: 'FAUST' BOCCHI'
Dwarves Slicing a Melon (Summer)
Faustino Bocchi
(Brescia 1659–1741)
Oil on canvas, 47.5 × 73.5 cm each

50
Lemons, Apples, Medlars and a Savona Plate
Bartolomeo Bimbi
(Settignano 1648 – Florence 1729)
Oil on canvas, 42 × 57 cm

51
Terracotta Vases with White Grapes
and Other Fruits on a Terrace
Aniello Ascione
(Naples, documented 1680–1708)
Oil on canvas, 104.5 × 138 cm

52
A Platter of Fruit on a Stone Wall,
Flowers, and Watermelons
Aniello Ascione
(Naples, documented 1680–1708)
Oil on canvas, 97.5 × 87.5 cm

53
Bouquet of Flowers, Platter of Strawberries,
Cherries and a Rabbit
Lorenzo Russo
(Naples, documented 1696)
Oil on canvas, 77 × 102 cm

Nature Ennobled

54
Picnic Basket
Pier Francesco Cittadini
(Milan 1613/16 – Bologna 1681)
Oil on canvas, 108 × 75.5 cm

55
Still Life with a Silver Ewer,
Gold Cup and Fruits
Meiffren Conte
(Marseilles ca. 1630–1705)
Oil on canvas, 73 × 96 cm

56
Flowers in a Sculptured Vase
with Various Fruits
Giovanni Stanchi or Niccolò Stanchi, attr.
(Rome 1608–1673 ca.;
Rome 1623/26–1690 ca.)
Oil on canvas, 81.5 × 59.3 cm

57
Flowers in a Glass Vase with Melons,
Peaches and Pears on a Table
Niccolò Stanchi
(Rome 1623/26–1690 ca.)
Oil on canvas, 73.5 × 100 cm

58
Fruits in a Glass Bowl
Niccolò Stanchi
(Rome 1623/26–1690 ca.)
Oil on canvas, 58 × 44 cm (oval)

59-60
Various Fruits in a Glass Bowl
A Melon, Peaches, Plums, and Grapes
Bartolomeo Castelli, called Spadino junior
(Rome 1696–1738)
Oil on canvas, 17.5 × 31.5 cm each

61
Lemon Tree in a Terracotta Vase
with Oranges
Tommaso Realfonso
(Naples 1677 ca. – post 1743)
Oil on canvas, 76.5 × 43 cm

62
Allegory of the Five Senses
Giovan Paolo Zanardi, attr.
(Bologna 1658 – post 1718)
Oil on canvas, 54 × 70 cm

63
Musical Instruments on a Table
Andrea Pastò
(active in Venice, eighteenth century)
Oil on canvas, 58.5 × 67 cm

64-65
A Basket of Fruit and a Terracotta Jug
on a Rock Ledge
A Basket of Fruit on a Rock Ledge
North Italian Painter
(second half of the eighteenth century)
Oil on canvas, 99.5 × 124 cm each

66
Basket of Fruit with Celery and a Jar
of Olives on a Rock Ledge
North Italian Painter
(second half of the eighteenth century)
Oil on canvas, 90 × 110.5 cm

The Mysteries of Nature

67
A Vanitas
Luigi Miradori, called il Genovesino
(Genoa, documented in Cremona 1640–54)
Oil on canvas, 40.5 × 49.5 cm

68
A Kitchen Table with a Rooster,
a Basket, and Copper Basins
Neapolitan Painter
(first half of the seventeenth century)
Oil on canvas, 75.5 × 162.5 cm

69
A Catch of Fish
Giambattista Ruoppolo [?]
(mid-seventeenth century)
Oil on canvas, 60.5 × 131.5 cm

70
Melon, Grapes, Plums, Peaches and Other Fruits
Bartolomeo Guidobono
(Savona 1654 – Turin 1709)
Oil on canvas, 42 × 57 cm

71
Garland of Flowers with the Christ
Child Asleep
Giovan Battista Gaulli, called Baciccio
(Christ Child Asleep)
(Genoa 1639 – Rome 1709)
Paolo Porpora (Garland of Flowers)
(Naples 1617 – Rome 1673)
Oil on canvas, 94.2 × 72 cm

With thanks to their contribution
to the making of this book